PORTRAIT
of a PEOPLE

PORTRAITS

PICTURING AFRICAN AMERICANS IN THE NINETEENTH CENTURY

of a PEOPLE

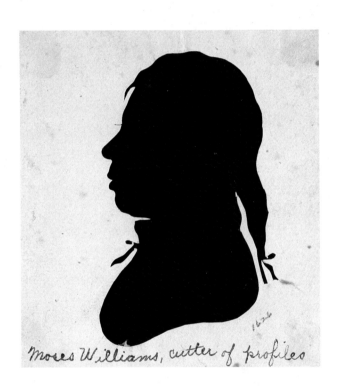

Moses Williams, cutter of profiles

GWENDOLYN DuBOIS SHAW

CONTRIBUTIONS BY EMILY K. SHUBERT

ADDISON GALLERY OF AMERICAN ART | PHILLIPS ACADEMY, ANDOVER, MASSACHUSETTS

IN ASSOCIATION WITH
UNIVERSITY OF WASHINGTON PRESS | SEATTLE AND LONDON

This book is published with the assistance of a grant from the Jacob Lawrence Endowment.

Portraits of a People: Picturing African Americans in the Nineteenth Century
Organized by the Addison Gallery of American Art, Phillips Academy, Andover, Massachusetts

This exhibition is generously supported by Foley Hoag, LLP, and other contributors, in memory of Charles J. Beard, II.

EXHIBITION DATES:
Addison Gallery of American Art
Andover, Massachusetts
14 January – 26 March 2006

Delaware Art Museum
Wilmington, Delaware
21 April – 17 July 2006

Long Beach Museum of Art
Long Beach, California
25 August – 26 November 2006

Published by the Addison Gallery of American Art, Phillips Academy, Andover, Massachusetts.

Addison Gallery of American Art
Phillips Academy
180 Main Street
Andover, Massachusetts 01810
www.addisongallery.org

in association with
University of Washington Press
P.O. Box 50096
Seattle, WA 98145-5096
www.washington.edu/uwpress

front cover:
ETHAN ALLEN GREENWOOD (1779–1856)
Portrait of Charles Jones, 1815
Oil on panel
26 x 18 3/4 IN. (66 x 47.6 CM)
Addison Gallery of American Art, Phillips Academy, gift of William Vareika

front cover flap:
UNKNOWN
Sojourner Truth, N.D.
Albumen print on card
4 x 2 1/4 IN. (10.2 x 5.7 CM)
American Antiquarian Society, Worcester, Massachusetts

frontispiece:
Attributed to RAPHAELLE PEALE (1774–1825)
Moses Williams, Cutter of Profiles, AFTER 1802
Hollow-cut profile
3 3/8 x 3 1/4 IN. (8.6 x 8.3 CM)
The Library Company of Philadelphia

back cover flap:
CHARLES PAXSON (ACTIVE 1860s)
Learning is Wealth. Wilson, Charley, Rebecca, and Rosa. Slaves from New Orleans, 1864
Albumen print on card
4 x 2 1/4 IN. (10.2 x 5.7 CM)
American Antiquarian Society, Worcester, Massachusetts

EDITED BY: Joseph N. Newland, Q.E.D.
DESIGNED BY: Bill Anton | Service Station
PRINTED AND BOUND IN: Canada by Friesens

Library of Congress Cataloging-in-Publication Data
Shaw, Gwendolyn DuBois, 1968-
Portraits of a people : picturing African Americans in the nineteenth century / Gwendolyn DuBois Shaw; with contributions by Emily K. Shubert.—1st ed.
p. cm. – (The Jacob Lawrence series on American artists)

Catalog of an exhibition held at the Addison Gallery of American Art, Andover, Massachusetts, 14 January – 26 March 2006; Delaware Art Museum,Wilmington, Delaware, 21 April – 17 July 2006; and the Long Beach Museum of Art, Long Beach, California, 25 August – 26 November 2006.
Includes bibliographical references and index.

ISBN 0-295-98571-2 (pbk. : alk. paper)
1. African-Americans–Portraits–Exhibitions.
2. Portraits, American–19th century–Exhibitions.
3. Art, American– 19th century–Exhibitions.
I. Shubert, Emily K. II. Addison Gallery of American Art.
III. Delaware Art Museum. IV. Long Beach Museum of Art.
V. Title. VI. Series.

N7593.2.S53 2006
704.9'42'08996073–dc22 2005022144

CONTENTS

LENDERS TO THE EXHIBITION

Addison Gallery of American Art Phillips Academy, Andover, Massachusetts

Allen Memorial Art Museum Oberlin College, Oberlin, Ohio

American Antiquarian Society Worcester, Massachusetts

The American Museum in Britain Bath

Atwater Kent Museum of Philadelphia The Historical Society of Pennsylvania Collection

Beinecke Rare Book and Manuscript Library Yale University, New Haven, Connecticut

Bishop Museum Honolulu, Hawai'i

Boston Public Library/Rare Book Department Massachusetts

Bowdoin College Museum of Art Brunswick, Maine

Ann and Jack Brittain and children

Delaware Art Museum Wilmington

Albion and Lynne Fenderson

Fenimore Art Museum, Cooperstown New York

Fogg Art Museum Harvard University Art Museums, Cambridge, Massachusetts

Hallmark Fine Art Collection Hallmark Cards, Inc., Kansas City, Missouri

The Historical Society of Pennsylvania Philadelphia

The Hyde Collection Glen Falls, New York

Herbert F. Johnson Museum of Art Cornell University, Ithaca, New York

Kenkeleba Gallery New York, New York

The Library Company of Philadelphia Pennsylvania

Library of Congress Washington, D.C.

The Maryland Historical Society Baltimore

Massachusetts Historical Society Boston

Museo Thyssen-Bornemisza Madrid

The Museum of Afro-American History Boston and Nantucket, Massachusetts

Museum of Fine Arts Boston, Massachusetts

Nantucket Historical Association Massachusetts

Newport Art Museum Rhode Island

Private collection

Schomburg Center for Research in Black Culture New York, New York

Shelburne Museum Vermont

Diplomatic Reception Rooms, U.S. Department of State Washington, D.C.

The Valentine Richmond History Center Virginia

Virginia Historical Society Richmond

Special Collections, Margaret Clapp Library, Wellesley College Wellesley, Massachusetts

Stanley-Whitman House Farmington, Connecticut

DIRECTOR'S FOREWORD

*I*N 1942, AT THE END OF THE ADDISON GALLERY OF AMERICAN ART'S FIRST DECADE, the remarkable portrait of Abraham Hanson painted by Jeremiah Pearson Hardy was acquired from the artist's daughter. Its lively and generous depiction of a well-respected African American barber working in Bangor, Maine, in the 1820s has held a place of honor in the Addison's collection ever since. When Gwendolyn DuBois Shaw arrived at the museum during her study of nineteenth-century images by and of African Americans, it was with pleasure that we showed her this painting, and we then jumped at her proposal to mount an exhibition of the extraordinary works she had uncovered in her research. As a fitting coda, while the final checklist was being assembled, the Addison was the recipient of a significant portrait of an African American sitter. The gift of a good friend of the museum, William Varieka, the portrait of Charles Jones is a perfect example of the way a valuable project such as this can unearth previously unknown treasures and foster fresh scholarship and interest.

It has been with exciting to watch the unfolding of this exhibition under the knowledgeable and perceptive eye of Gwendolyn Shaw, who has worked on the exhibition and publication with Addison curator Susan Faxon, whose experience has been invaluable. The groundbreaking scholarship of this endeavor has also been recognized by our colleagues at the Delaware Art Museum and the Long Beach Museum of Art, who have joined us as venues of the exhibition. Both Dr. Shaw and the Addison have been heartened by the enthusiasm and generosity of the lenders; we are immensely grateful to all who have been willing to part with their treasured possessions for the duration of the exhibition.

We are pleased to be copublishing this volume with the University of Washington Press, Pat Soden, director, who will be producing and distributing the book. The graphic design and the editing of the manuscript have been in the very capable hands of designer Bill Anton, Service Station, and editor Joseph N. Newland, Q.E.D. As always it is a distinct pleasure to work with such dedicated and talented people.

On the Addison staff both curatorial associate Juliann McDonough, who has ably gathered information and images for the book, and registrar Denise Johnson, who has tracked the paperwork and made the shipping and travel arrangements, have brought their consummate skills, enthusiasm, and good humor to this project. Emily Shubert, Charles H. Sawyer Curatorial Fellow for 2003–5, was an essential part of the project from the beginning. Not only did she assist with every level of the project's organization, but she also wrote a significant number of the entries for the book. All have demonstrated once again the strength and dedication of the extraordinary Addison staff.

Both Ms. Shubert and Dr. Shaw have asked me to offer our sincere thanks to the following individuals and institutions for enriching this project with their information and expertise. On behalf of the Addison, I am pleased to thank for their assistance to Ms. Shaw: at Stanford University, Wanda M. Corn, Alexander M. Nemerov, Cherise Smith, and Roger Stein; in Massachusetts, John P. Axelrod, Georgia Barnhill, Patricia Hills, Richard Newman, and Marilyn Richardson; colleagues and assistants at Harvard University, Monique Bell, Rebecca Keegan, Robin Kelsey, Katie Mullis Kresser, Betsey A. Robinson, Gabriella de la Rosa, and Tommie Shelby; and especially, Benjamin B. Bolger. Ms. Shubert wishes me to thank also Alison Ferris, Bowdoin College Museum of Art. In addition, we are very grateful to Karen C.C. Dalton, Director and Curator, Image of the Black in Western Art Research Project and Archive, Harvard University, for her perceptive introduction.

Gwendolyn DuBois Shaw's enthusiasm for this project has made it a delight to work on, and her knowledge and scholarship assure that a significant aspect of nineteenth-century art and social history will become known to scholars, students, and the interested public.

BRIAN T. ALLEN
Mary Stripp and R. Crosby Kemper Director

*E*XHIBITIONS, EVEN THOSE THAT EXPLORE NEW PATHS, have antecedents that inform their content and
perspective and in some ways make them possible. The underpinnings of research and interpretation that
informed the "ancestor" exhibitions become the foundations contemporary curators can build upon,
question, even destroy in order to construct a fresh view of a body of material assembled for presentation to an
audience. Among the precedents for *Portraits of a People: Picturing African Americans in the Nineteenth Century*
are two exhibitions, both created to present and critique a panoramic view of the visual images of African
Americans in American art, and an archive.

In 1964, in the thick of the U.S. Civil Rights Movement and partially in response to it, Marvin S. Sadik
curated *The Portrayal of the Negro in American Painting* at the Bowdoin College Museum of Art, an "exhibition
of eighty paintings, spanning a period of two and a half centuries, in which the Negro is portrayed."[1] The arc of
the exhibition began with Justus Engelhardt Kühn's *Portrait of Henry Darnall III* of about 1710, in which
an anonymous black youth wearing a slave collar attends his boy master; it ended with Jack Levine's large canvas
Birmingham, 1963, 1963, in which five African American children stand their ground in the face of attack dogs
let loose on the Southern Christian Leadership Conference's mass protest against segregation. The works
selected for this survey and Sidney Kaplan's accompanying commentary in the catalogue posit a progression from
an image—and a social reality—of a slave deferring to a young aristocrat to a depiction of the young members
of an oppressed minority asserting their right to first-class citizenship. Kaplan articulates this intention:
"these works are here for us to see…that the bright tradition of Homer and Eakins is in the hands of painters
who are responding as artists and men to the troubled present, whose vision of humanity, both black and white,
must be part of the future."[2]

In 1990, Guy C. McElroy curated for the Corcoran Gallery of Art a similar but more comprehensive
exhibition titled *Facing History: The Black Image in American Art 1710–1940*. Comprising approximately 120
paintings, sculptures, drawings, and prints, *Facing History* was designed to "document comprehensively the
variety of ways artists created a visual record of African-Americans that reinforced a number of largely restrictive
stereotypes of black identity."[3] Surveying the same material Sadik and Kaplan considered plus many additional
works that had been brought to light in the intervening quarter of a century, McElroy did not arrive at an
exhibition that would convey a continuum of progress from slavery and its abolition to affirmative action. Rather,
he conceived an exhibition that would deconstruct the social and economic structures undergirding the images
of people of African descent in American art. In the curator's own words:

> The aim of *Facing History* is to provide a panorama that illuminates the shifting, surprisingly cyclical natures of the
> images white men and women created to view their black counterparts. The repeated use of these pictorial images
> gave them the powerful immediacy of symbols. Prosperous collectors created a demand for depictions that fulfilled
> their own ideas of blacks as grotesque buffoons, servile menials, comic entertainers, or threatening subhumans….
> This vicious cycle of supply and demand sustained images that denied the inherent humanity of black people by
> reinforcing their limited role in American society. More fundamentally, these images expressed an inability to compre-
> hend a people whose appearance and behavior were judged to be different from their own, and thus inferior.[4]

McElroy wanted to do more than "provide a panorama," according to discussions and correspondence
with this writer dating from 1987. He wanted to show the entire picture in all its complexity. He wanted to "out"
the stereotypes buried in eighteenth- and nineteenth-century artistic conventions by exhibiting Currier & Ives's
caricatural Dark Town Comics and later "black memorabilia" alongside their "fine arts" contemporaries.
These works did not make it into the exhibition,[5] but they figured prominently in the catalogue, in McElroy's
introduction and in Henry Louis Gates, Jr.'s essay, "The Face and Voice of Blackness." Both texts emphasized
the role of visual images in shaping self-identity, whether positively or negatively.

In 2005, fifteen years after *Facing History*, Gwendolyn DuBois Shaw is looking critically at images made
of and by African Americans in the exhibition organized by the Addison Gallery of American Art, *Portraits of a*

People: Picturing African Americans in the Nineteenth Century. In her examination of the role these images have played in establishing and fostering racial identity during a period of radical social change, Shaw acknowledges two significant precursors to her project. The first was McElroy's *Facing History*, which, she states, "was a germinal force in my conception of *Portraits of a People*." For Shaw, "The images and essays that McElroy assembled... helped shape my scholarship in general and my thinking about race and portraiture in particular. In many ways I see this exhibition as an extension of the work on race and representation that was begun by McElroy; it is a testament to his impact on the study of African American visual representation and cultural production."[6]

The other antecedent for Shaw's work was one she shared with McElroy, namely, the Image of the Black in Western Art Research Project and Photo Archive. Begun in 1960 and now integrated into the W.E.B. Du Bois Institute for African and African American Research at Harvard University, the Image of the Black Archive has catalogued and documented more than thirty thousand works of art, dating from early dynastic Egypt to the present, that include depictions of people of African descent. This visual resource served as a springboard and a backdrop for both McElroy's and Shaw's conceptualization of their respective exhibitions.

In defining *Portraits of a People*, Shaw diverged from the survey nature of *Portrayal of the Negro* and of *Facing History*. She opted to leave aside the large body of genre works in American art, many of which reinforce visual stereotypes of African Americans. Instead, she narrowed her focus to the portrait. A portrait is an artist's attempt to create the visual identity of an individual, usually a person whose name and background are known. Because a portrait is the visual definition of the complexities of a unique individual, by nature it explores the humanity of the sitter; it eschews the preconceptions of stereotype and seeks to penetrate the superficialities of skin color and facial features in search of the inner characteristics that define a person and that come through in successful portraits. By offering us a gallery of portraits, Shaw invites us to encounter, one by one, not only the faces but also the personalities and souls of almost one hundred African Americans, in their humanity and their individuality.

KAREN C.C. DALTON
Director and Curator
Image of the Black in Western Art Research Project and Photo Archive
Harvard University

NOTES

1. *The Portrayal of the Negro in American Painting*, essay by Sidney Kaplan (Brunswick, Maine: Bowdoin College, 1964), unpaginated.

2. Sidney Kaplan, "Notes on the Exhibition," in *The Portrayal of the Negro*, n.p.

3. Guy C. McElroy, "Introduction: Race and Representation," in *Facing History: The Black Image in American Art 1710–1940* (San Francisco and Washington, D.C.: Bedford Arts Publishers in association with the Corcoran Gallery of Art, 1990), p. xi.

4. Ibid.

5. The exhibition did include mid- and late-nineteenth-century drawings caricaturing blacks by Alfred R. Waud, Edward Potthast, and Arthur Burdett Frost.

6. Gwendolyn DuBois Shaw to author, letter, 5 April 2005.

Negro Portraits

Signifying Enslavement and Portraying People

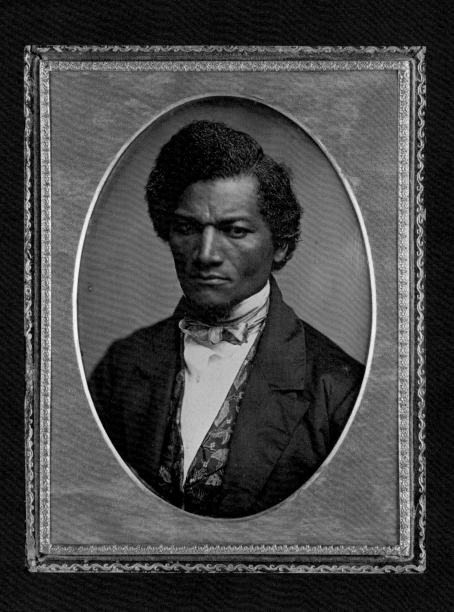

We shall venture one remark, which we have never heard before, and which will, perhaps, be set down to the account of our negro vanity; and it may be, not unjustly so, but we have presented it for what it may be worth. It is this: negroes can never have impartial portraits at the hands of white artists. It seems to us next to impossible for white men to take likenesses of black men, without most grossly exaggerating their distinctive features. And the reason is obvious. Artists, like all other white persons, have adopted a theory respecting the distinctive features of negro physiognomy. We have heard many white persons say that "negroes look all alike," and that they could not distinguish between the old and the young. They associate with the negro face, high cheek bones, distended nostril, depressed nose, thick lips, and retreating forehead. This theory, impressed strongly on the mind of an artist, exercises a powerful influence over his pencil, and very naturally leads him to distort and exaggerate those peculiarities, even when they scarcely exist in the original. The temptation to make the likeness of the negro rather than of the man, is very strong; and often leads the artist, as well as the player, to 'overstep the modesty of nature.' There is the greatest variety of form and feature among us, and there is seldom one face to be found which has all the features usually attributed to the negro; and there are those from which these marks of African descent (while their color remains unchanged,) have disappeared entirely, 'I am black, but comely,' is as true now, as it was in the days of Solomon. Perhaps we should not be more impartial than our white brothers, should we attempt to picture them. We should be as likely to get their lips too thin, noses too sharp and pinched up, their hair too lank and lifeless, and their faces altogether too cadaverous.

—FREDERICK DOUGLASS, 1849[1]

NINETEENTH-CENTURY PORTRAITS, whether paintings, cut-paper silhouettes, or photographs, are valuable windows on the past. They reveal not only how their subjects may have looked in real life but also how they wanted to be seen in the surrogate representation of themselves. In so doing they disclose important aesthetic and cultural information about the world in which their subjects lived and the technologies of the visual that were either ascendant or merely available when they were created. By revealing information about the society in which they were produced, such images of the self provide precious information about the status and aspirations of their sitters, their place within the dominant hierarchy, and their anticipated or imagined potential for movement beyond it. In the case of people of African descent in the United States, the way that one wanted to be presented was often at odds with the dominant culture's portrayal of one's people. As Frederick Douglass observes in the epigraph, from *The Liberator* in 1849, often African Americans found their facial features, the key content of portraiture, to be perceived by whites as interchangeable and undistinguished, and that by invoking such racist assumptions white artists actively created and perpetuated a visual tradition of negative or thoughtlessly stereotyped representation of blacks. Douglass argues that until African Americans began to represent themselves they would not find artists capable or interested in portraying them with the sensitivity that the serious representation of individuals required.

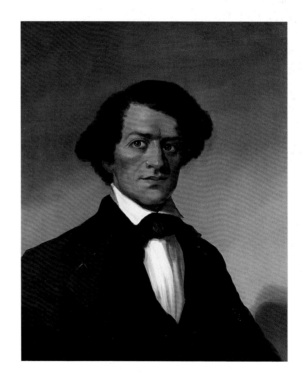

1. *opposite:*
SAMUEL J. MILLER (American, 19th century)
Frederick Douglass, 1847–52
Daguerreotype in case
5 1/2 x 4 3/16 IN. (14 x 10.6 CM)
The Art Institute of Chicago,
Major Acquisitions Centennial Endowment

2. UNKNOWN
Frederick Douglass, circa 1844
Oil on canvas
27 1/2 x 22 1/2 IN. (69.9 x 57.1 CM)
National Portrait Gallery, Smithsonian Institution

While Douglass, a man who commissioned numerous photographic portraits of himself and was painted in oil at least once [figs. 1, 2], may have been overstating the case to the readers of the anti-slavery *Liberator* for dramatic effect—for there are many portraits of African American sitters by non-black artists that are dignified, distinct, and far from stereotypical—his comments reveal the legitimate concern that freeborn and formerly enslaved blacks had about how they desired to be seen during a period of profound social change.

Over the course of what is sometimes today called the "long eighteenth century," the African presence in America became an indisputable part of what made the British and French colonies in the New World the prosperous and productive places that

they were. The black bodies that worked the fields on plantations throughout North America and the Caribbean became ubiquitous signs of an increasingly global economy linked by labor, migration, and trade that was increasingly predicated on notions of difference and racial exception. And while they had always been present in that world, they were rarely represented within it. One such image that purports to be a portrait of a black sitter, and yet is probably more of a caricature, is the portrait in London by an unknown painter and called *Francis Williams, the Negro Scholar of Jamaica*, of about 1745 [fig. 3]. Literary historian Vincent Carretta has shown that, with his spindly arms, legs, and his disproportionate head, the image of Williams is a derisive and demeaning fantasy of its proposed subject, a freeborn Jamaican of African descent who studied in England during the mid-1700s.[2]

If the portrait of Francis Williams indicates a rare and somewhat specious presentation of the black self, it is important to note that it was not as alone in the world in which it was created as it is today. Surely there were once far more portraits of Africans in New World contexts than are extant today; and the paintings that are no longer to be found may have suffered rather unsavory ends. Paintings originally created to commemorate the loved ones of one generation soon became strangers to later descendants. After losing their original identities, and with the sentimental importance naturally associated with the sitters' visages rendered mute, the disposal of such objects, either through sale or destruction, would have been easy. And for many African Americans—whose broader contribution to the American enterprise was not a priority for many academics and historians until the current era—the preservation of the material culture of the self and the family was not always a viable or a valued activity. Only in the last half-century have there been institutions specifically charged with preserving the artifacts of the everyday lives of African Americans and other non-white or non-elite citizens.

The exhibition *Portraits of a People: Picturing African Americans in the Nineteenth Century* and the essays and object entries that follow in this catalogue are concerned not only with elucidating these rare

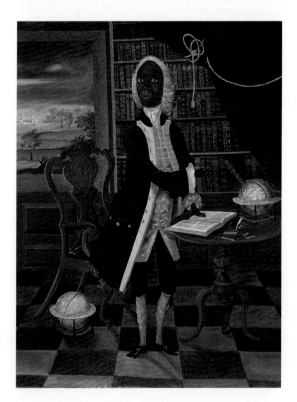

3. Unknown
Francis Williams, the Negro Scholar of Jamaica, c. 1745
Oil on canvas
26 x 19 3/4 in. (66 x 50.1 cm)
Victoria and Albert Museum, London,
Given by Visc. Bearsted MC and Spink and Son Ltd.,
through the National Art Collections Fund

4. WILLIAM MATTHEW PRIOR (American, 1806–1873)
Mrs. Nancy Lawson, 1843
Oil on canvas
30 X 25 IN. (76.2 X 63.5 CM)
Shelburne Museum, Shelburne, Vermont

5. *right:*
WILLIAM MATTHEW PRIOR (American, 1806–1873)
Mr. William Lawson, 1843
Oil on canvas
30 X 25 IN. (76.2 X 63.5 CM)
Shelburne Museum, Shelburne, Vermont

and often enigmatic images in order to render a better understanding of how black people in the United States saw themselves and how they wanted to be seen by others, but also with examining the ways that peoples of different races, classes, and economic positions interacted through the practice of personal representation. Portraits of African Americans that have found their way over the past few years from private family collections into the historical societies and other archives around the country join representations of African Americans that were there all along, some buried in boxes, often uncatalogued or understudied, to tell a story of the fundamentally modern concepts of agency, selfhood, and the desire to cheat death by creating lasting evidence of a specific life worthy of remembrance. Many of these portraits are evidence of "border crossing" between black sitters and white artists—while some may reveal the many exaggerations of blackness as described by Douglass, others are evidence (and artifact) of a dominant culture removing agency so severely from blacks that their physical presentation and self-image was impacted—which is important evidence of a

particularly strong form of oppression (and methods of subtle resistance).

By visually examining portraits of free African Americans made prior to the Civil War, during a period when the majority of blacks were not free, we are able to gain a better understanding of the power of representation and its role in the creation of selfhood, the exercise of agency, and the unique currency of identity that such images were able to mobilize against decided odds. For example, in the pendant portraits of William and Nancy Lawson of Boston, Massachusetts, from 1843 by European American painter William Matthew Prior [figs. 4, 5], we are able to see prosperous middle-class clothing merchants who defined themselves by their intellectual abilities, their personal tastes, and their material accomplishments. In one of Prior's most beautifully detailed compositions, Nancy Lawson sits before a deep red velvet curtain that frames a large window, she wears a lace bonnet with delicately embroidered trim, a black neck-ribbon, and a brooch, all demonstrating her fashion sense and her skill with the needle, while her finger is placed between the pages of a book, indicating her literacy. In contrast, her husband William is pictured in a far less elaborate space, casually holding a cigar in his left hand. He is dressed in a dark suit of the 1840s, the only embellishment being the gleam of a gold chain against his vest indicating a watch secreted within the breast pocket. The pair of portraits, which are dated just nine days apart, may have cost as much as twenty dollars each, much more than a week's salary for a man of Lawson's standing in the 1840s, revealing the family's investment in their own portrayal.

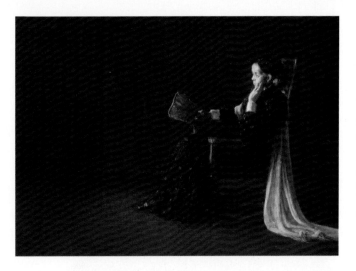

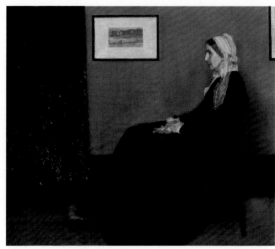

6. Henry Ossawa Tanner (American, 1859–1937)
Portrait of the Artist's Mother, 1897
Oil on canvas
29 1/4 x 39 1/2 in. (74.3 x 100.3 cm)
Philadelphia Museum of Art, partial gift of Dr. Rae Alexander-Minter and purchased with the W.P. Wilstach Fund,
the George W. Elkins Fund, the Edward and Althea Budd Fund,
and with funds contributed by the Dietrich Foundation, 1993

7. *right:*
James Abbott McNeill Whistler (American, 1834–1903)
Arrangement in Gray and Black No. 1, 1871
Oil on canvas
56 3/4 x 64 in. (144.3 x 162.5 cm)
Musee d'Orsay, Paris

Similarly, many of the portraits that were produced from just after the Civil War through the end of the nineteenth century provide additional information on the modes by which well-established, middle-class African Americans were able to distinguish themselves from their freeborn European American and their newly freed African American peers, not solely through the display of material acquisitions but also through the display of more esoteric cultural literacy. The portrait of Sadie Tanner by Henry Ossawa Tanner [fig. 6] is an extreme example of this type of aspiration. The composition and colors of this portrait indicate the painter's desire to not only represent and commemorate his mother but to also place her likeness within a contemporary avant-garde aesthetic by referencing the 1871 painting *Arrangement in Gray and Black No. 1*, by his slightly older colleague James Abbott McNeill Whistler [fig. 7].

However, it is important to note that the type of portraiture witnessed in Prior's paintings of the Lawsons or Tanner's tribute to his mother are rare images that demonstrate the power of those sitters and artists in the creation of the self. From the late seventeenth century through to the period of revolutions in America and France at the end of the eighteenth century, enslaved Africans in Europe and the New World had, with very few exceptions, virtually no agency in the way that they were visually portrayed in the dominant culture's painting and popular print materials. As a result, they were depicted in a small number of very specific and often subordinating or derogatory ways. During the early colonial project, as Douglass observed of his own era, it was rare that enslaved Africans were depicted as individual subjects in visual images created by Europeans and European Americans. Instead blacks were most often shown as peripheral to the main subject, as ancillary figures subordinated to a dominant white figure. "The black person was rarely dignified with individuality in works of art," by dominant-culture artists during the colonial, antebellum, and Reconstruction periods, explains literary historian and cultural critic Henry Louis Gates, Jr., "because depictions of individuals would attest to the full range and variety of human characteristics and abilities."[3] As Barbara Lacey and Marcus Wood have argued separately in scholarly studies, late-eighteenth- and early-nineteenth-century American print culture, particularly early broadsides and other popular print media, almost exclusively provided physiological descriptions or ideographic images of African Americans that depicted them in reductive, proscribed ways.[4] In the regularized and stereotyped forms of printer's blocks of runaways, or as caricatured, subhuman creatures held up for derision or advertised for sale, the common representations of African Americans were visually controlled by the press and other ideological apparatuses of the dominant culture. Such images reduced the black body to a rote visual sign in which one stylized body could function metonymically for a varied multitude in the newly abundant printed media of the British colonies and the succeeding American states during the eighteenth and nineteenth centuries.

But prior to the rise of the fourth estate and the creation of a public sphere[5] in the Americas, the trope of the black body was used in an alternate mode as a prop to establish the identities of the colonizing bodies that sought to control it. During this very early period in the New World colonial project, painted portraits, like slaves, were rare and high-status commodities, they were objects that only the very wealthy colonists could afford. This important usage of the black body, one which shaped all those to come after it, is witnessed as early as the seventeenth century in European and European American paintings, in which elaborately clad, enslaved black servants are shown as exotic attendants and accessories to their white owners. The painting *Henry Darnall III* by Justus Englehardt Kühn of about 1710 [fig. 8] images a member of one of Maryland's first families standing in an elaborate setting. The subject is a young scion of the Tidewater aristocracy, prepubescent and with a soft, hairless face that is rounded out with baby fat. Darnall, a distant relation of the Calvert family who founded Maryland and a Catholic, stands in front of a carved wooden balustrade, dressed in a long, yellow brocade coat that nearly covers his breeches, with a white linen cravat and high banded stockings. He holds an arrow in his right hand while his left rests on the tip of a quiver and bow. In the upper right of the picture, just behind the balustrade and beneath the framing element of a red and gold-fringed curtain, a formal English-style

8. JUSTUS ENGLEHARDT KÜHN (American, b. Germany, d. 1717)
Henry Darnall III, c. 1710
Oil on canvas
54 1/16 x 44 3/8 IN. (137.4 x 112.2 CM)
The Maryland Historical Society, Baltimore,
Bequest of Miss Ellen C. Daingerfield

9. *lower left:*
EDWARD SAVAGE (American, 1761–1817)
The Washington Family, 1789–96
Oil on canvas
84 3/4 x 111 7/8 IN. (213.6 x 284.2 CM)
National Gallery of Art, Washington,
The Andrew W. Mellon Collection

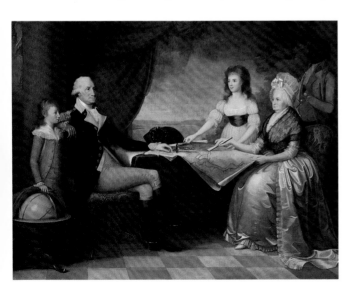

manicured garden extends into the background toward some buildings. To the left of Darnall is the figure of a black adolescent, who appears a little older than he, in a position that signifies his subordinate and servile status. The black youth wears a red coat and a white shirt, but the rest of his body is concealed behind the balustrade. He tilts his head up toward that of his master as he offers the younger boy a small bird that he apparently has retrieved for him. In addition to the unreturned adoring gaze, the silver collar worn by the black figure marks him as an enslaved person and reduces him to the status of an object within the portrait.

Similarly, the group portrait *The Washington Family* by Edward Savage and dating from 1789–96 [fig. 9], pictures George Washington, Martha Dandridge Custis Washington, and her two children, John Parke Custis and Martha Parke Custis, grouped around a table and attended by a liveried black servant, who has been identified as Washington's enslaved valet and butler, William Lee. Both paintings demonstrate the ways in which black servants are often found inhabiting the margins of paintings of famous families in British colonial and early American republican portraiture. They also illustrate how the black servants present in such images moved from compositional devices as anonymous, ancillary figures to being portrayed as essential members of plantation households. The catalyst for the transition that allowed blacks to move toward the center of the canvas was the increasing number of talented and educated African Americans (most often free but sometimes enslaved) who lived their lives within the spotlight of the colonial and American public sphere. Prior to the time when Phillis Wheatley began to publish her poems, Benjamin Banneker assembled his *Almanac,* and James Armistead Lafayette served bravely in the Continental Army, the majority of painted portraits that contained black bodies held them as subservient and subhuman company for the white subject of the painting.

To say that either image of these two enslaved Africans could constitute a portrait, even though we know the name of the black figure in *The Washington Family*, is to misunderstand what separates a portrait from a painting of a figure. Figures, the shapes of bodies, of human forms, can be represented without being actual portraits. In western culture, a portrait is the presentation of the physical attributes associated with a particular individual, most often a named person, and taken at least initially from life. Through the artistic process, by employing visual tropes, specific iconography, or emblematic elements, the artist will attempt to communicate various attributes of the sitter so that the viewer will be able to "read" the image and understand something about the person at whom they are looking. The artist will represent both the self and the society in which the subject lives.

The roots of such New World representations may be found in Dutch, English, and French portraiture traditions and have recently been examined by scholars of literature and history, including Allison Blakely, Kim Hall, and Beth Fowkes Tobin.[6] However, the American descendants of this portrait tradition, exemplified by paintings by Kühn, Savage, John Hesselius, and others, have to date received little attention. And they should not be overlooked, for such images of blacks first helped to strengthen the connection between the colonial gentry of the Mid-Atlantic and their British royal ancestors and then, as the colonial project shifted from one of exploration and exchange to one of agrarian empire and cultural hegemony, began to emphasize the distinctive nature of the American system of race-based African slavery. Because these images provide the first painted representations of black bodies in America that demonstrate a visual rhetoric of racial difference and slavery, they are a significant part of the world of images that would inform the ways free African American's came to be portrayed as individuals in formal, painted portraiture.

The origins of the marginalized black body in American portraiture has its roots in the French tradition of the *page noir*, in which a black page or servant is included as an accessory in an allegorized portrait of an identifiable Frenchwoman. Such black figures are featured prominently in a number of allegorical portraits by the late-Baroque painters Nicolas de Largillièrre (1656–1746) and Pierre Mignard (1612–1695). Working toward the end of the seventeenth century, both artists created images of black bodies positioned solely to enhance the rarified white bodies of women who had become rich off transatlantic colonial expansion and a new global economy based on triangular trade in sugar, rum, and human flesh. In his *Portrait of a Woman, Perhaps Madame Claude Lambert de Thorigny (Marie Marguerite Bontemps, 1668–1701)*, from 1696 [fig. 10], Nicolas de Largillièrre presents the viewer with a fanciful figure who is draped in silks, garlanded with fruit and flowers, and attended by a large South American parrot and a little child whose blackness serves to set off her mistress's whiteness. Similarly, Pierre Mignard's 1682 portrait

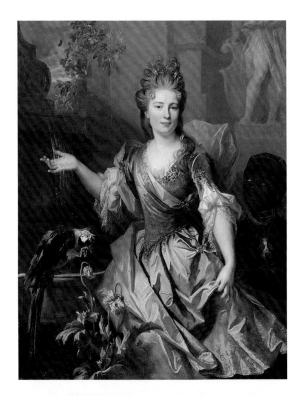

10. NICOLAS DE LARGILLIÈRE (French, 1656–1746)
*Portrait of a Woman, Perhaps Madame Claude Lambert
de Thorigny (Marie Marguerite Bontemps, 1668–1701)*, 1696
Oil on canvas
55 x 42 IN. (139.7 x 106.7 CM)
The Metropolitan Museum of Art, New York,
Rogers Fund, 1903

11. *below:*
PIERRE MIGNARD I (French, 1656–1746)
Duchess of Portsmouth, Louise de Kéroualle, 1682
Oil on canvas
47 1/2 x 37 1/2 IN. (120.7 x 95.3 CM)
National Portrait Gallery, London

of the French-born Louise de Kéroualle [fig. 11], the mistress of Charles II and a spy for Louis XIV who was elevated to Duchess of Portsmouth, presents a woman of beauty and means seated on a porch before a ledge that looks out onto a light blue sea. A large column flanks her on the left, and a balustrade, upon which a bush of climbing roses has sought its rest, frames the view of the sea that stretches behind her to the right. She wears a gold brocade dress with large blue sleeves and a cream-colored sash. Her left hand rests absentmindedly on the shoulder of a young black child who eagerly seeks her attention and approval by offering up full hands that hold sprigs of rare red coral and a shell full of pearls. The child, who herself wears a pearl necklace fastened at the back by a pink ribbon and a dress held together by brass clasps, is not unlike the items that she proffers. An exotic object, a pet, a token, she is a product of the colonial endeavor and a privilege of the white woman whom she attends. This enslaved girl exists in the role of the childlike colony to present the treasures of empire to her mistress, the mother country.[7] In creating such images Mignard and Largillièrre helped create a trope of the African body as a cosmetic for the white female sitter, with the contrasting presence of the black body making the white body appear more so; it is as an accessory, and a symbol of status for a colonizing elite. And as Kim Hall has noted, and akin to what Douglass asserts above, there is less the black child's sentiment from the Song of Songs, "I am black but comely," than of the vanity of the white colonialist, "I am comely because she is black."[8]

A later English version of this mode is found in a portrait from the 1660s by the Dutch-born Sir Peter Lely of Barbara Villiers Palmer, Countess of Castlemaine and Duchess of Cleveland, who was Charles II's mistress before the Duchess of Portsmouth. The elaborately dressed and bejeweled Duchess of Cleveland gazes directly into the eyes of the viewer as she pets a Cavalier King Charles Spaniel with one hand and reaches into a shell full of flowers being offered up to her by a black child who wears a gold collar.[9] The black attendant looks reverently upward, her head echoing that of the spaniel, thereby equating the role of the enslaved servant with that of the dog.

This European mode of portraying aristocracy with black attendants seems to have made its way across the Atlantic with the Calvert family, whose male heir held the title of Lord Baltimore beginning in the early 1600s. The Calverts, along with the Carrolls and the Darnalls, were the Catholic founders of the colony of Maryland and saw themselves connected both politically and ideologically to the court of Charles II and the Restoration government. Charles Calvert, the 5th Lord Baltimore, was the great grandson of King Charles II and Barbara Villiers Palmer through their American-born granddaughter Charlotte Lee, who married Benedict Calvert, the 4th Lord Baltimore. The Calverts, however, had a slightly different tradition of using the presence of small black bodies to signify wealth and power in their family portraits than did the mistresses of Charles II. Beginning with Gerard Soest's portrait of Cecil Calvert, the 2nd Lord Baltimore and governor of Maryland, painted in 1669–70, a more masculine usage of the black body is put into play in a portrait that is more about power than beauty. In the painting Cecil Calvert stands on an oriental carpet beside a draped table on which he has placed his hat. Flanking him on his right is a small white child, possibly one of his children or grandchildren, who gestures toward a map of Maryland held by the older man. Behind this child, at the base of large rumpled curtain, stands a black attendant who casts his gaze downward onto the child. This pairing of unequal bodies under American slavery's visual rhetoric of power was clearly adopted by his descendants and is witnessed a century later in the 1761 portrait *Charles Calvert and His Slave* by John Hesselius [fig. 12]. The young and privileged Calvert, heir to founders of the colony of Maryland, is also attended by a black servant who awaits his bidding. He turns to the right and gestures with his left hand out toward the country landscape that stretches into the background. His right hand holds a pair of drumsticks while the enslaved African youth who attends him holds a drum between his bent knees. Calvert's pose echoes one taken by his distant cousin, Charles Calvert II, the 5th Lord Baltimore, in a portrait of about 1732 by Hermann van der Myn [fig. 13] in which the figure of a similarly vanquished

12. John Hesselius (American, 1728–1778)
Charles Calvert and His Slave, 1761
Oil on canvas
50 1/4 x 39 7/8 in. (127.7 x 101.3 cm)
The Baltimore Museum of Art, Gift of Alfred R. and Henry G. Riggs, in memory of General Lawrason Riggs

Native American man lurks in a dark and mysterious wilderness that extends into the background. Such images of the Calvert family help to establish the manner in which enslaved African servants were envisioned in American painting of the eighteenth century and specifically within Mid-Atlantic visual traditions of the elite.

The Calvert family's usage of the black body and tropes within their formal portraits inform the way in which Justus Englehardt Kühn participated in a broader, Mid-Atlantic tradition that stretched back to the Catholic founders of Maryland and the court of Charles II. The position of the black servant in Kühn's 1710 painting of Henry Darnall III is echoed in the placement of a Cavalier King Charles Spaniel in a pendant portrait of Darnall's sister Eleanor [fig. 14]. Shown as a child, Eleanor rests her diminutive hand

upon the obedient dog's head, in much the same way that Barbara Villiers Palmer is shown stroking the head of her spaniel in the Lely portrait. By using the device of the Cavalier King Charles Spaniel, more than simple fidelity is being expressed; rather, a connection to the reign of Charles II and the family's origins is being underscored. Eleanor would grow up marry Daniel Carroll, and their son John Carroll would become the founder of Georgetown University.[10]

A portrait also by Kühn of Daniel's cousin Charles Carroll [fig. 15] features a similar visual device. Kühn once again uses a subordinate figure to signify his white subject's dominion. Carroll, who is dressed and posed similarly to Henry Darnall III, rests his right hand on a silver collar, a collar not unlike the one throttling the enslaved youth who accompanies Darnall, which is on the neck of a wide-eyed faun that stands patiently behind him.[11]

In comparing these three portraits of children by Kühn, it becomes clear that the figure of the black servant could be easily compared to and even exchanged for that of spaniel or a faun. This interchangeability highlights not only the subhuman status of enslaved Africans in America at the end of the seventeenth century but it also draws attention to the same pictorial strategies at play in the work of Catholic colonial American painting in the plantation-dominated Mid-Atlantic region where social imperatives leaned more toward the emulation of British aristocratic ideals than did the inclinations of the mercantile Puritans in New England, from whose paintings African American bodies are nearly entirely absent.

The Kühn portrait of Henry Darnall III with his enslaved attendant is significant also because it features the first known depiction of a black figure in a painting that was made in the British American colonies. Like the earlier Largillièrre and Mignard paintings, the portrait foregrounds its subject before a classicizing balustrade that separates him from an elaborate formal garden, so magnificent and ostentatious that it never could have existed in Maryland of 1710. The Grand Manner landscape depicted in the background is clearly a painterly device employed by Kühn, who immigrated to Maryland from the Rhine

Valley in 1706, to enliven and to enhance the station of the sitter as well as to embellish the provincial reality of the developing Tidewater region in which the painting was made. As Darnall poses for the viewer with a small bow and arrow in his hands, his young body sheathed in an elaborate yellow silk waistcoat and jacket, the silver buckles on his shoes shining in the imaginary light of a new day in a new world, his black attendant is placed below and behind the balustrade, in the world of nature. The black youth offers up a bird that his master has most probably

13. HERMANN VAN DER MYN (Dutch, 1684–1741)
Charles Calvert II, c. 1732
Oil on canvas
94 x 57 3/4 IN. (238.8 x 146.7 CM)
The Maryland Historical Society, Baltimore,
City Life Museums Collection, Gift of the Louis and Henrietta
Blaustein Foundation in memory of Henry A. Rosenburg

just dispatched with his trusty bow and arrow. In so doing the black boy is serving a purpose here, a purpose more important in some ways than that of Mignard's female *page noir*, a body that exists in her blackness to heighten the whiteness of his mistress. Here in Kühn's world of early-eighteenth-century Maryland the black servant in the role of the human retriever exists to collect the game, he functions in the role of Fido the faithful dog, doing his master's bidding without damaging or eating up the goods. And like Daniel Carroll's captive faun that must be physically controlled in order to be disciplined and domesticated, Darnall's black servant wears a shiny silver collar that designates his enslaved status. He is visually and materially connected to his master in this way and there can be little doubt that his sole purpose is to serve. This last point is particularly apparent when the viewer realizes that the enslaved and dehu-

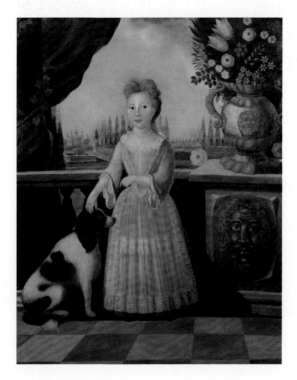

14. Justus Englehardt Kühn (American, b. Germany, d. 1717)
Eleanor Darnall, c. 1710
Oil on canvas
54 x 44 in. (137.2 x 11.8 cm)
The Maryland Historical Society, Baltimore,
Bequest of Ellen C. Daingerfield

manized black youth, partially obscured by and bracketed behind the balustrade, has no visible legs. His body is rendered in Kühn's painting only as it is needed to serve its master.

Images such as these made by the naturalized German artist Kühn in the first decades of the 1700s, and later by John Hesselius (whose father Gustavus had emigrated from Sweden) in the second half of the century, provide insight into the desires of the dominant society that controlled both the lives and the representation of many of the Africans in America during the eighteenth century and which subsequently affected the ways that African Americans would choose to present themselves once freedom and the ability to act on free will had been obtained. The important move from the margins of somebody else's portrait into the center of one's own cannot be overstated, and the selection of images that are included in this catalogue demonstrate the wide variety of media and modes that free Africans in America chose as sites of representation for themselves.

Paintings of black attendants in this eighteenth-century tradition, whether they are British, French, or German American creations, provide today's viewer with black faces from the past, while they simultaneously withhold and resist the possibility of individual identity for enslaved Africans. They depict the African body in the colonial context as a peripheral and a conditional one, beholden to the European body for its purpose and its presence, included solely to heighten the beauty of a mistress' alabaster skin through the contrast of their own ebony, or to exculpate the rhetoric of power and the accomplishments of a boy being bred to embody and deploy repressive ideological and hegemonic power discourses. In this world, both Mignard's page and Hesselius's drummer are nameless, beyond and below subjectivity, without agency and perhaps without aim; they are vacant, hollow shells into which the desire of the colonial gaze can be relocated. As conceived by the painters discussed here, these bodies must have appeared endlessly youthful and utterly malleable. They had not simply been removed from one continent and placed within a European context as a sort of imported trophy, instead they were made to hold within their generic,

black skin all the significance of the black bodies that labored beyond the middle North Atlantic, in the cane and rice fields of the New World, to create the wealth that made possible the ostentatious displays that the paintings celebrated.

It was not until the rise of revolutionary ferment and attendant Enlightenment rhetoric of the individuality and freedom had germinated within late-colonial and early-republican American life that figures of blacks could begin to come out of the artistic margins and be seen as full individuals. And while the position of the black figure in painted portraits did change over the course of the eighteenth century, the tradition and desire of white artists to use black bodies as descriptive elements did not disappear from American artistic practice. Despite this positive philosophical inundation, throughout the nineteenth century such figures could still be seen haunting the corners of genre and history paintings by highly lauded artists, including William Sidney Mount and Winslow Homer.

As Frederick Douglass argued presciently in *The Liberator*, the negative ways that African physiognomy was presented in art, and more specifically in portraiture, would remain a key issue for the reception and advancement of African Americans in the public sphere though the end of the nineteenth century. Due to the ingrained tradition of dehumanizing black bodies in representation, Douglass saw that a change in the way that black bodies appeared in the visual world of the nineteenth century would only occur after artists and writers of African descent began to be concerned with their own and others' depictions. He recognized that due to the inequity of most interracial power relations in the United States the opportunity to create or commission an accurate and sympathetic likeness of the self, to give form to a specific and empowered identity, was a type of treatment that was unavailable to black sitters during the antebellum and Reconstruction periods unless they had themselves commissioned the portrait from an artist who was sensitive to their needs and desires.

It is significant that the painted portrait as it was understood in the nineteenth century was not a typically African art form, and therefore by urging

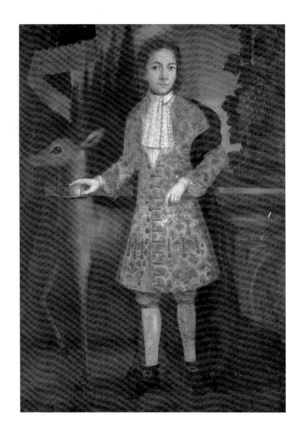

15. Justus Englehardt Kühn (American, b. Germany, d. 1717)
Charles Carroll, c. 1712
Oil on canvas
53 7/64 x 38 21/32 in. (134.9 x 98.2 cm)
The Maryland Historical Society, Baltimore,
Gift of J. Gilman D'Arcy Paul

the active participation of African Americans in the discourse of formal European portraiture Douglass was encouraging the transformation of dominant conventions as a necessary aspect of their assuming tangible, visual identities as fully endowed Americans. Perhaps heeding Douglass' cry, economically successful people of African descent in America, like their white counterparts, were quick to take advantage of myriad strategies of representation, including the silhouette and the photograph, which were much less expensive than professional paintings and offered more rapid gratification. Unfortunately many of these portraits no longer exist today, or if they do, they have been divorced from their original context and their sitter's names and identities.

Art historian Jack Larkin has observed of similarly forsaken portraits of white New Englanders from the same period that "none of theses paintings was a disembodied image at the time of its making," but in losing the name of the sitter, so much of a portrait's importance is also lost.[12] For this reason, the portraits that are included in this catalogue and the exhibition that it accompanies were chosen not only because they have specific identities attached to them but also because they operate in dynamic ways to help create unique identities for their sitters. It is important to note that it was not until African Americans had begun to demonstrate that they did indeed possess "the full range and variety of human characteristics and abilities" by mastering the dominant culture's creative forms that they wrested a place to counter the visual discourse through the act of portraying themselves and controlling the dispersal of their images. The identities that were engendered and popularized by such representations enabled the freeborn or the formerly enslaved individual of African descent in America to establish a self that was separate from his or her personal or ancestral relationship to the institution of slavery, a relationship without which the visual language of the paintings of the Darnalls and the Carrolls by Kühn and Hesselius could never have been articulated.

1. Frederick Douglass, "Negro Portraits," *The Liberator* 19, no. 6 (20 April 1849): 62. I would like to thank my colleague Barbara McCaskill of the University of Georgia for sharing this important quotation with me.

2. Vincent Carretta, "Who Was Francis Williams?" *Early American Literature* 38, no. 2 (2003): 213–37.

3. Henry Louis Gates, Jr., "The Face and Voice of Darkness," in Guy C. McElroy et al., *Facing History: The Black Image in American Art 1710–1940* (San Francisco: Bedford Arts, in conjunction with the Corcoran Gallery of Art, Washington, D.C., 1990), p. xxix.

4. Barbara E. Lacey, "Visual Images of Blacks in Early American Imprints," *The William and Mary Quarterly*, 3rd ser., 53, no. 1 (January 1996): 137–80; Marcus Wood, *Blind Memory: Visual Representations of Slavery in England and America* (London: Routledge, 2000), Chapter 3, "Rhetoric and the Runaway: the Iconography of Slave Escape in England and America."

5. In *The Structural Transformation of the Public Sphere* (1962) Habermas argues that the public sphere is a realm of discourse in which ideas can be exchanged and public opinion can be formed.

6. See Allison Blakely, *Blacks in the Dutch World: The Evolution of Racial Imagery in a Modern Society* (Bloomington: Indiana University Press, 1993), pp. 78–170, for a wide-ranging discussion of race in Lowland painting and visual arts. See Kim F. Hall, *Things of Darkness: Economies of Race and Gender in Early Modern England* (Ithaca: Cornell University Press, 1995) for a concise analysis of the presence of black figures in paintings and jewelry, specifically carved gems, during the sixteenth and seventeenth centuries. See Beth Fowkes Tobin, *Picturing Imperial Power: Colonial Subjects in Eighteenth-Century British Painting* (Durham, N.C.: Duke University Press, 1999) on the use of the black page as the exotic embodiment of commercial success in the colonial endeavor.

7. Kim Hall in *Things of Darkness*, p. 253, cites the work of David Dabydeen in *Hogarth's Blacks: Images of Blacks in Eighteenth-Century English Art* (Athens: University of Georgia Press, 1987) to explain such a relationship: "'Finally the aesthetic image of Madonna and Child mirrors the political, imperial notion of Mother Country and Child Colony: a political statement, however unintentional, is being transmitted via art.'"

8. Hall, *Things of Darkness*, p. 252.

9. Hall has argued that such portraits of the Duchess of Cleveland (this is one of at least four that show her being attended to by a black page) and the Duchess of Portsmouth may be read as highly coded images that allude to their gendered sexual power over Charles II, who was often referred to as "the black boy" because of his dark complexion (*Things of Darkness*, p. 248).

10. It is interesting to note that a portrait of John Carroll in his robes as the Bishop of Baltimore of 1810–15 (Archidiocese of Baltimore, Maryland) has been attributed to Joshua Johnston (sometimes called Johnson), who is believed to have been of African descent. If this image of Carroll portrayed as both dignified and distinguishable, is by a black painter, he was able to negotiate painting a white subject without succumbing to the exaggerations of "whiteness" that Douglass, in his comments on race and portraiture, suggests might have been the case when he argues that exaggerations occur in the portraits of blacks by white artists because they are not part of the dominant culture; but the success of Johnston's portrait would assert that representation is a problem of negotiation between the sitter and the subject, as seen in Prior's portraits of the Lawsons, regardless of culture dominance.

11. A painting in the New-York Historical Society that has been attributed to the Dutch-American painter Gerardus Duyckinck (1695–1746), *DePeyster Boy with Deer*, demonstrates the common use of the deer as a trope within the portraiture of children in the New York area.

12. Jack Larkin, "The Faces of Change: Images of Self and Society in New England, 1790–1850," in *Meet Your Neighbors: New England Portraits, Painters, and Society, 1790–1850* (Sturbridge, Mass.: Old Sturbridge Village, distributed by the University of Massachusetts Press, 1992), p. 10.

"On deathless glories fix thine ardent view"

Scipio Moorhead, Phillis Wheatley, and the Mythic Origins of Anglo-African Portraiture in New England

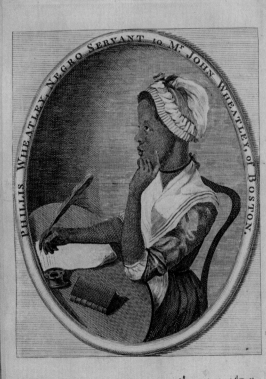

Published according to Act of Parliament, Sept.ʳ 1, 1773 by Archᵈ Bell, Bookseller Nᵒ 8 near the Saracens Head Aldgate.

PHILLIS WHEATLEY NEGRO SERVANT to Mr. JOHN WHEATLEY, of BOSTON.

POEMS

ON

VARIOUS SUBJECTS,

RELIGIOUS AND MORAL.

BY

PHILLIS WHEATLEY,

NEGRO SERVANT to Mr. JOHN WHEATLEY,
of BOSTON, in NEW ENGLAND.

LONDON:
Printed for A. BELL, Bookseller, Aldgate; and sold by
Messrs. COX and BERRY, King-Street, BOSTON.
MDCCLXXIII.

MYTHS ABOUT THE ORIGINS of the arts are abundant in Western history and create the Ur stories that launch canon formation. In Greek art, for example, there is the story of the Corinthian maid who is credited by Pliny the Elder in chapter 35 of his *Natural History* with the invention of painting. Shown here in an image by Joseph Wright made during the eighteenth century when the story was receiving renewed attention [fig. 2], she is credited with making the first drawing of a human body by tracing the outline of her sleeping lover's head using only candlelight and charcoal. In this way she was able to create a mimetic memento of him before his departure for war. This is one origination myth that has persisted through time, engaging scholars at different moments in different ways, some of them clinging to it as fact while others dismiss it as conjecture. Similar explanations for the historical origins of other histories and subhistories of artistic traditions also exist, most of them much younger than that of the Corinthian maid, but no less romantic or problematic. One important example of such a mythic story in the comparatively new history of American art is that of the origins of the African American entry into the European portrait tradition. It has traditionally been understood as having come with the creation of this engraved portrait frontispiece [fig. 1][1] of the African-born poet Phillis Wheatley (c. 1754–1784) that was first published in her 1773 book, *Poems on Various Subjects, Religious and Moral.*[2] This unsigned image has frequently been attributed, using speculation and conjecture, by both literary historians and historians of African American art and culture to another enslaved African in Boston, a young man named Scipio Moorhead.

Over the years the once-speculative ideas about this image's creation have been repeated so many times that they have ceased to be questioned and have become a New World Ur story. The image and its myth have become so embedded in the canonical history of American and African American art that the portrait itself is threatened with becoming a mere trace of an historic sitting.

It is important to note that there is no direct precedent for this image. Not only was Wheatley the first person of African descent from New England to have her poetry published in English in the British public sphere, but she was also the first colonial American woman of any race to have her portrait printed alongside her writings. No woman from the Anglo-American colonies prior to Wheatley can claim such a distinction.

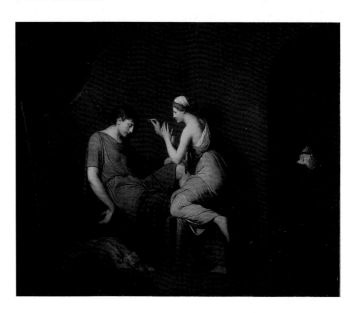

1. *opposite:*
 Attributed to SCIPIO MOORHEAD (lived in Boston c. 1750)
 Phillis Wheatley, Negro Servant to Mr. John Wheatley, of Boston,
 1773, frontispiece to *Poems on Various Subjects, Religious and Moral,*
 PUBLISHED 1773
 Engraving
 5 1/16 x 4 IN. (12.9 x 10.2 CM)
 Massachusetts Historical Society, Boston

2. *above:*
 JOSEPH WRIGHT (British, 1734–1797)
 The Corinthian Maid, 1782–84
 Oil on canvas
 41 7/8 x 51 1/2 IN., (106.3 x 130.8 CM)
 National Gallery of Art, Washington, Paul Mellon Collection

Along with her writings, it is an achievement that has been much touted by scholars of African American arts and letters. Literary historian and critic Henry Louis Gates, Jr., cites the importance of Wheatley's volume of poems for marking the beginning of a canon, which "unlike almost any other literary tradition … was generated as a response to eighteenth- and nineteenth-century allegations that

persons of African descent, did not, and could not create literature."[3] Social critic Paul Gilroy concurs, stating that the publication of "Wheatley's volume represented the beginning of a process in which the attributes of universal humanity for which the production of imaginative literature was emblematic [was] seen to be within the grasp of Negroes."[4] Other critics have similarly argued that the portrait frontispiece and the physical existence of the book itself were revolutionary: "Within the discourse of racial inequality in the eighteenth century," states Betsy Erkkila, "the fact of a black woman reading, writing, and publishing was in itself enough to splinter the categories of white and black, and explode a social order grounded in notions of racial difference."[5]

It is significant that despite the continued interest of literary scholars in Wheatley's writing, art historians have become complacent with the Ur story of the creation of the frontispiece, and since the 1940s close to nothing has been done to investigate the compositional strategies at work in the artistic construction of her portrait. Despite the inherent power of the image, it has become so obscured by its role in canon formation that its original transatlantic sources, context, and impact as an innovative image of an Anglo-African woman writer have never been studied. Instead, the image is only mentioned in passing by authors of studies of American and African American art as an early example of portraiture of a named African in America. Important questions about what models it was based upon and what impact it may have had on subsequent portraits of other authors go unanswered. James Porter, the pioneering historian of African American art, wrote in his 1943 survey *Modern Negro Art*:

> We may conjecture that [Moorhead] may have tried his hand at portraiture and even surmise that he is the author of the unsigned portrait of Phillis Wheatley that adorns several of her published works. The work is of provincial character and exhibits several naïve traits of design...[and] these traits are the strongest reasons for attributing the work to an amateur, which Scipio undoubtedly was. The conjecture is strengthened by the fact that this portrait and the poem to Scipio first appeared in the 1773 London edition of the poems.[6]

Beyond this poem, "To S.M., a young African Painter, on seeing his Works," next to nothing is known about Scipio Moorhead's personal life.[7] There is no informative archive of personal letters, and no signed works of art by him have ever been located.[8]

Despite the lack of evidence, and out of what may be a misplaced need to have a black artist present at the moment of canon formation, many art historians have unquestioningly repeated Porter's narrative. Because of this the image has remained under-discussed in surveys of American art and African American art published in the last twenty years by Romare Bearden and Harry Henderson, Samella Lewis, Frances Pohl, Wayne Craven, and others.[9] Like the story of the Corinthian maid and her epiphanic wall tracing, it has become important as an event rather than as an object. Consequently its importance to American art history is reduced to a novel commission between an artist and a sitter. Sharon Patton's discussion of the portrait in her survey text *African-American Art* from the year 1998 is arguably the most imaginative recitation of this event. Patton writes:

> Wheatley was required to have her portrait engraved on the frontispiece, ostensibly to verify the author's race. She remembered that the Reverend John Moorhead of Boston, where she had spent her youth, owned a slave named Scipio Moorhead, who was a poet and an artist. Scipio Moorhead had learned the craft from the Reverend's wife, Sarah, who was a drawing instructor and painter. Wheatley requested that Scipio Moorhead render her portrait. The ink drawing that Moorhead did of Ms. Wheatley (untraced) was engraved in London.[10]

Patton, like most other historians of American art who have taken notice of this image, clings to the Ur story that casts the desired artist, Scipio Moorhead, and the designated sitter, Phillis Wheatley, as the Adam and Eve of African American portraiture: he brilliantly drawing a portrait of his good friend before her imminent departure for London on a tour to promote the impending publication of her book. In order to engage her reader Patton speculates about the commission, creating memories for Wheatley and invents a conveniently untraced ink drawing and, through such a narrative, by providing a sort of gender reversal of the Corinthian maid and her lover, a canon

of African American art history is reinforced. By focusing too heavily on establishing a mythic moment of creation and ignoring the evidence, or simply taking for granted the actual construction of the image, the possible sources for its composition, and its subsequent impact on the practice of portraiture in late-eighteenth-century Britain and what would soon become the United States, Patton and previous art historians lost sight of the importance of the actual work of art. In so doing, Wheatley's agency in the creation of her portrait is undermined, the image becomes a mere trace of a sitting, and our conception of the sitter becomes a mere shadow of the real self.

The obsession with the need for established canons and Ur stories to support their origins is a big part of what makes the academic practice of art history so terribly frustrating while also being incredibly interesting at the same time. Because of the discipline's reliance on national and other sorts of geographical boundaries, specific chronological demarcations, and cultural traditions as ways to subdivide an otherwise untenably broad area of study, scholars in younger subfields have often felt compelled to actively engage in this sort of activity in order to establish an equitable footing for the locus of their intellectual interests. But ultimately, if such fields as American art history, and the various hyphenated micro-fields that it contains, are to continue to expand and prosper in the twenty-first century, it will only be through the re-examination of the problematic myths that have been formed out of a necessity to assuage a misplaced sense of national, racial, or cultural inferiority. Art historians must turn their attention to finding the fragments of history that have been ignored and reconnect them. Only by rejecting the urge to construct such creation myths can the important and difficult work of detailed archival research and good, close looking be done.

By examining the under-studied historical evidence that surrounds the portrait frontispiece of Phillis Wheatley, this essay will argue for the manu-mission of this image from its traditional, arrested place at the beginning of the African American art-historical canon. It will show that it is valuable visual evidence of a heterocultural Atlantic world: that it is evidence of a dynamic moment when African,

European, and American bodies navigated the ocean together, moving within and between continents and societies, and in concert creating myriad new forms of material and visual culture. This image is a remarkable and highly influential depiction of an early transatlantic woman's body, a depiction that was conceived and created using a revolutionary and defiant visual rhetoric.

It is a portrait not of an objectified and subordinated woman, but of an empowered wielder of agency. It is a portrait of subject.[11] In the confines of the engraved oval frame, Wheatley sits alone. She is a slim, dark-skinned young woman with a long face. Shown in profile, her head is well-shaped, with a pronounced forehead. Her elbows rest on a small oval writing table on which a pewter inkwell, a book, and a sheet of paper attend her poetic impressions. She wears an elaborately beribboned lace bonnet, full of pleats and accented with a colored ribbon at its top. A black band encircles her neck, ending in a bow at the back, while a white shawl covers her shoulders. The extended index finger of her left hand rests against her cheek, and the other fingers curl inward in support of her chin. She directs her gaze upward, toward heaven, as if searching for inspiration to direct the long quill pen she holds in her right hand. In turn, the top of the feather points back up at her head.

Considerable effort has been taken to balance the composition. For example, the shape of the bonnet that she wears rhymes with the curving back of the wooden chair upon which she sits, which in turn follows the line of her shoulder down to her waist before merging with her skirt. Despite this, many of the elements within the image seem at odds with one another. The oval of the table echoes the oval of the frame. But it slants upward, hard against the picture plane. In so doing, the space of writing seems to actively compete with the space of drawing, as if to equate the power of both types of creative presentation.

Similarly, the quill pen hovers a bit above where it last marked the paper, and gestures toward the edge of the frame. Like the rebellious table, it too seems to challenge the confines of a frame that would contain it, a frame that has inscribed upon its perimeter: "Phillis Wheatley, Negro Servant to Mr. John Wheatley, of Boston."

In order to fully understand the tremendous importance of what Wheatley's portrait achieved, it is necessary to consider the intellectual formation of the sitter and her considerable interest in fine art, the life of the mind, and the world of British visual culture that surrounded her in eighteenth-century colonial Boston. At the time of the publication of Phillis Wheatley's writings and the accompanying frontispiece, the nineteen-year-old author was, as the inscription implies, enslaved. As a child she had been abducted from the Senegambian coast and taken to Boston in 1761.[12] She was seven or eight years old when she experienced the Middle Passage. And when Susannah Wheatley, the wife of a well-to-do Boston tailor, John Wheatley, bought her either off the boat that had transported her or from a nearby slave market she was just "shedding her front teeth." In a memoir that was included in an 1834 printing of Phillis Wheatley's poems, Margaretta Odell, a much-younger relation of the white Wheatley family, recalled that Susannah Wheatley's choice of the child was influenced by "the humble and modest demeanor and the interesting features of the little stranger."[13] Odell chose to remember Phillis as a child prodigy and record that the young enslaved girl soon "gave indications of uncommon intelligence, and was frequently seen endeavoring to make letters upon the wall with a piece of chalk or charcoal."[14] John and Susannah Wheatley, who could have dealt with a property-defacing slave in any manner they saw fit, chose instead to teach her to read and write, allowing their daughter Mary to serve as head tutor. They ensured that she had a wide-ranging yet classical education, one that was far beyond what most white women received, and she flourished. By the time Wheatley was a teenager she was steeped in Ovid and Alexander Pope, and she was writing her own poetry. Susannah Wheatley worked hard to publish her young protégée's work and was successful in having a number of poems, including several funeral elegies, printed in Boston area newspapers during the late 1760s and early 1770s. In 1772 the Wheatleys advertised for subscribers for a volume of poems by Phillis, but they were ultimately unsuccessful in raising the minimum amount needed to finance the book's publication. This failure has been

attributed to a mix of racism on the part of many colonials who did not believe that a person of African origins could compose poetry and on the unwise placement of the initial advertisement in the *Boston Censor*, a short-lived newspaper that was overtly loyalist and locally unpopular.[15] Despite these setbacks the Wheatleys persisted and, after assembling a group of prominent white male Bostonians, both Patriots and Loyalists—including the future revolutionary John Hancock and the Royal Governor Thomas Hutchinson—to "examine" Phillis and sign an attestation to the fact that she was indeed capable of writing the poems that she had claimed to have authored, they were able to secure a printer in London, Archibald Bell (who generally specialized in religious tracts), to advertise for subscriptions, and to undertake the publication of the book.[16]

Poems on Various Subjects, Religious and Moral, was dedicated to Selina Hastings, the Countess of Huntingdon. She was a noblewoman from Bath who, despite having inherited land and slaves in Georgia, in later life had become an active promoter of the abolition of slavery and the repatriation of enslaved Africans to the continent. She was also well known at the time as one of the leading supporters of the Reverend George Whitefield, the force behind what we now call the First Great Awakening. Hastings headed her own religious organization called "Lady Huntingdon's Connexion" that was loosely associated with the Wesley brothers and others who preached a type of upper-class, Calvinistic Methodism.[17] Phillis Wheatley admired the countess and was a dedicated follower of Whitefield, who preached frequently in Boston. When the minister died, the young believer elegized him in a poem that was widely distributed. Because Whitefield had at one time been Selina Hastings's personal minister, Wheatley was able to use the publication of her poem as a way to establish a correspondence with the countess in 1770. "The Occasion of my addressing your Ladiship will I hope, apologize for this my boldness in doing it," Wheatley wrote to Hastings. "It is to enclose a few lines on the decease of your worthy chaplain, the Rev'd Mr. Whitefield, in the loss of whom I sincerely sympathize with your Ladiship: but your great loss which is his

3. THOMAS STOTHARD (British, 1755–1834)
The Voyage of the Sable Venus, from Angola to the West Indies, 1794,
in Bryan Edwards, *The History, Civil and Commercial,*
of the British Colonies in the West Indies, PUBLISHED in 1801
Copper engraving
8 11/16 x 5 7/8 IN. (22 x 15 CM)
Manuscript, Archives, and Rare Books Division, Schomburg
Center for Research in Black Culture, The New York Public
Library, Astor, Lenox, and Tilden Foundation

chosen to follow the countess in issues of fashion; from the shawl around her shoulders to the bonnet with its elaborate ribbons, Phillis's costume is in direct imitation of her benefactress's dress in several portraits from the period. It is unclear whether or not Wheatley would have owned such clothes. As Margaretta Lovell has shown, it was fairly typical during the period for colonial American sitters to wear a costume that was borrowed from the artist who was painting their portrait or copied from the clothing worn by a sitter in a mezzotint engraving that was being used as a model.[20] In a letter written by Susannah Wheatley to the countess in advance of Phillis's arrival in England, she requests that the countess help Phillis to dress appropriately but that she would prefer Phillis's

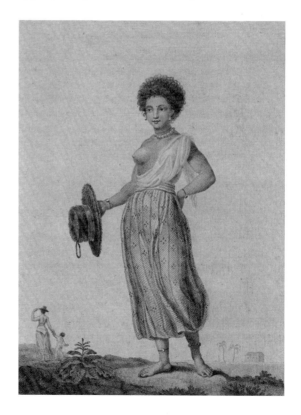

4. *Joanna,* in John Gabriel Stedman, *Narrative of a Five Years'*
Expedition against the Revolted Negroes of Surinam...,
PUBLISHED 1796
Engraving
10 1/2 x 8 1/4 IN. (26 x 21 CM)
Manuscript, Archives, and Rare Books Division, Schomburg
Center for Research in Black Culture, The New York Public
Library, Astor, Lenox, and Tilden Foundation

Greater gain, will, I hope, meet with infinite reparation, in the presence of God, the Divine Benefactor whose image you bear by filial imitation."[18] Hasting's response does not survive, but it must have been encouraging, for when the assembled verses that would become *Poems on Various Subjects, Religious and Moral,* were read to her in late 1772 she was favorably impressed and consented to the Wheatley family's request that the forthcoming book be dedicated to her.

Captain Robert Calef, who commanded the schooner *London,* which was owned by John Wheatley and had transported the poems across the Atlantic to Bell, reported to Susannah Wheatley in a letter dated January 5, 1773, that the countess was honored by their request, however, the "one thing she desir'd which she said she hardly thot would be denied her, that was to have Phillis' picture in the frontispiece. So that, if you would get it done it can be Engrav'd here. I do imagine it can be Easily done, and think would contribute greatly to the Sale of the Book."[19]

Evidently, the Wheatleys heeded the countess's request, and Phillis must have sat for her portrait shortly thereafter. In the image, she appears to have

clothing to be simple and plain. However, looking at the clothes that Wheatley wears in the portrait, it is hard to see her costume as being exactly plain. And it is certainly not the costume of a house servant, let alone that of a slave. The mere fact that she is dressed sets her apart from the typical images of African slave women that were circulating at the time.

Wheatley is pictured as totally self-possessed as well as fully clothed, unlike other representations of enslaved and commodified African women during the late eighteenth century, which show them as objects of sexual desire or painful humiliation. For example, *The Voyage of the Sable Venus, from Angola to the West Indies* [fig. 3] is a 1794 illustration from a painting by Thomas Strothard for a poem by the pro-slavery British historian Bryan Edwards.[21] It plays on age-old images of Venus's birth from the sea by imagining the arrival of a voluptuous, nearly nude African temptress on the shores of the New World. She holds the reins to two magical sea creatures and is surrounded by a young Triton, *amorini*, and a Neptune/Oceanus figure (who waves a Union Jack). A shapely black pearl ensconced in giant scallop shell, she prepares for landfall, ready to embrace enslavement in an unknown land.

In an image from *Narrative of a Five Years' Expedition against the Revolted Negroes of Surinam...*, we see Joanna, the mulatto girl that the mercenary, writer, and artist John Gabriel Stedman took for several years as his mistress in a "Surinam marriage" [fig. 4]. She stands before the viewer with one breast exposed and her head uncovered to reveal a luxuriant mass of curls; a nubile fifteen-year-old, she is ready for ravishing.[22]

The absurd fantasy of the Sable Venus and the sad reality of the exploited young Joanna demonstrate the sexualized nature of images of enslaved African women that were common in the printed materials that circulated in the British public sphere during the period that Wheatley's poems were published. Similarly, the *Flagellation of a Female Samboe Slave*, engraved by William Blake from another drawing by Stedman [fig. 5], explicates the way that sadistic violence was frequently mixed into such objectifying and dehumanizing images. Here the black woman's

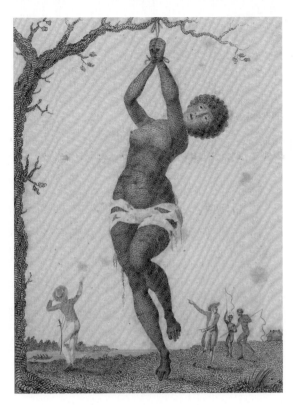

5. WILLIAM BLAKE (British, 1757–1827) after a drawing by JOHN GABRIEL STEDMAN (British, 1744–1797)
Flagellation of a Female Samboe Slave, in Stedman's *Narrative of a Five Years' Expedition against the Revolted Negroes of Surinam...*, PUBLISHED 1796
10 1/2 x 8 1/4 IN. (26 x 21 CM)
Manuscript, Archives, and Rare Books Division, Schomburg Center for Research in Black Culture, The New York Public Library, Astor, Lenox, and Tilden Foundation

bound wrists and the tattered rag that both cover and draw attention to her pudenda heighten the fetishistic nature of the image, while the presence in the far background of men with whips reinforces the violence of the scene and at the same time highlights its voyeuristic nature. Their remoteness and her expression of terror hint at the presence of another flagellator, one who is closer to the bared and bloodied body, one who is perhaps occupying the space of the viewer. Like the Sable Venus, her body twists on its axis as though writhing in sexual ecstasy.

Given the other competing images of women of African descent that were in circulation during the decades that Wheatley's frontispiece was first published, her portrait must be appreciated for the revolutionary visual rhetoric of agency in representation that it both employs and propagates. Wheatley is shown fully and conservatively dressed. Her body is cropped within the composition so that the viewer is only given access to the parts of her that are active in the creative process. She is shown in the portrait as a part of the literary world of her time, not as a commodified object to be taken or traded.

As Marxist literary theorist Terry Eagleton has shown, the power of critical literary discourse in the public sphere during late-eighteenth century England "served the emancipation movement of the middle class as an instrument to gain self-esteem and to articulate its human demands against the absolutist state and a hierarchical society."[23] This is the case with the frontispiece of Wheatley, and the poems that it accompanied, for it serves to visually emancipate Wheatley's middle-class, black, female body from a dehumanized social identity.

In the frontispiece portrait for her book Wheatley is pictured as a respectable young woman who, despite her enslaved condition, is the epitome of learning and refinement. This same sort of pious presentation can be found a decade and a half later in the frontispiece of Olaudah Equiano published with his 1789 book *The Life of Olaudah Equiano, or Gustavus Vassa, the African*, which presents the author dressed in Western clothes and holding a Bible that is open to Acts 12:4 on his lap [fig. 6]. As Paul Gilroy argues, since significant parts of the lives of Wheatley and Equiano "were lived on British soil...it is tempting to speculate here about how an acknowledgement of their political and cultural contributions to England, or perhaps to London's heterocultural life, might complicate the nation's portraits of itself."[24] Certainly other Africans in England had made such a visual impact. Ignatius Sancho was a well-known character within the varied public sphere of late-eighteenth-

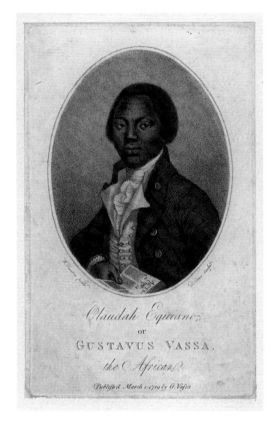

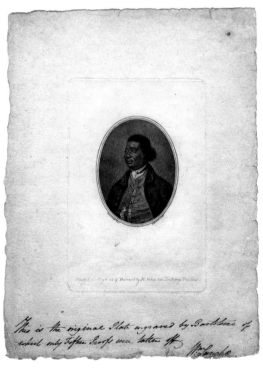

6. *right, top to bottom:*
DANIEL ORME after W. DENTON
Olaudah Equiano or Gustavus Vassa the African,
frontispiece to *The Interesting Narrative of the Life of Olaudah Equiano, or Gustavus Vassa, the African, Written by Himself,*
PUBLISHED 1789 by G. Vassa
Stipple engraving
6 1/8 x 3 3/4 IN. (15.6 x 9.5 CM)
National Portrait Gallery, London, Archive Collection

7. THOMAS GAINSBOROUGH (British, 1727–1788)
Ignatius Sancho (1729–1780),
frontispiece to *The Letters of the Late Ignatius Sancho, an African,*
PUBLISHED 1802
Stipple engraving
Approximately 7 1/2 x 5 IN. (19 x 12.7 CM)
National Portrait Gallery, London, Archive Collection

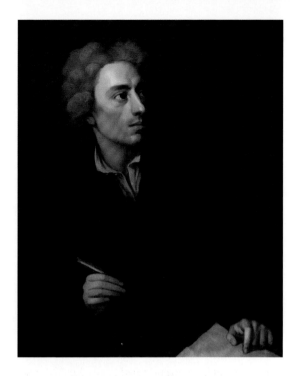

8. Studio of MICHAEL DAHL (Swedish, 1659–1743)
Alexander Pope, c. 1727
Oil on canvas
30 x 25 IN. (76.2 x 63.5 CM)
National Portrait Gallery, London

century England. In 1768 Thomas Gainsborough painted Sancho's portrait, and in 1782, when Sancho's collected letters were published posthumously, the image was engraved so that it could be printed as a frontispiece [fig. 7]. Functioning in a similar way Wheatley's conservative costume, her reflective pose, and the literary props that surround her all advertise her assimilation into British society and show her as decidedly Anglo-African, inhabiting a newly conceived identity, a "hybrid third term meant to mediate between the opposites signified by 'African' and 'Anglo-Saxon.'"[25]

The actual sitting for the portrait must have taken place sometime during the eight months that elapsed between Captain Calef's letter and the book's printing in late August of 1773, but could have occurred either before or after the Wheatleys decided to send Phillis to London to promote the book.[26] It is possible that both the original painting or drawing and the subsequent engraving could have been made in London rather than Boston.

The choice of showing her in the act of composition may have followed the contemporaneous tradition of depicting Alexander Pope, one of Wheatley's other chief influences, who was frequently imaged with pen in hand. Numerous reproductions of portraits of Pope circulated widely in the eighteenth century, and it is likely that Wheatley, whose writing

often echoed the earlier poet's, had access to these in the form of book frontispieces or mezzotints, and she may have asked her portraitist to pose her accordingly. A portrait from 1727 shows Pope with his pen lifted from the paper as though he has just been interrupted by the arrival of someone in his chamber [fig. 8]; Wheatley's pose is similar, but neither Wheatley's body nor her attention turns from the task at hand. Unlike Pope, she is fully focused on her work with pen to paper and eyes raised, poised as if to receive divine inspiration. In many ways Wheatley's pose is a pious one; it signals an intense focus on divine inspiration and closely resonates with Italian Renaissance paintings of studious church fathers, for example, Sandro Botticelli's *Saint Augustine in His Study* (Ognissanti, Florence).

The inspiration that Wheatley worked so hard to receive is in evidence in her ecphrastic poetry. Through ecphrasis, by not only describing what she was seeing but by also addressing the image directly, reflecting upon its context and content, Wheatley was able to enter into a multilevel relationship with a work of art.[27] The poem "To S.M., a young African Painter, on Seeing his works," is an enthusiastic and evocative ecphrasis on a no-longer-extant image. A brief examination of this poem emphasizes just how deeply

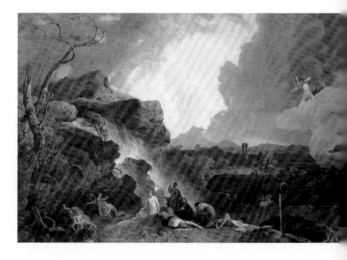

9. RICHARD WILSON (British, 1713–1782)
Apollo Destroying the Children of Niobe, N.D.
Oil on canvas
50 x 70 1/8 IN. (127 x 178.1 CM)
Museum of Fine Arts, Boston, Denman Waldo Ross Collection

the young writer was interested in the denotative and connotative discursive field that can be generated by a rhetorical engagement with an image. It begins:

> To show the lab'ring bosom's deep intent,
> And thought in living characters to paint,
> When first thy pencil did those beauties give,
> And breathing figures learnt from thee to live,
> How did those prospects give my soul delight,
> A new creation rushing on my sight?
> Still, wond'rous youth! each noble path pursue,
> On deathless glories fix thine ardent view:
> Still may the painter's and the poet's fire
> To aid thy pencil, and thy verse conspire!

There is little reason to doubt that Wheatley's ecphrasis with some now-lost painting (or paintings) by Moorhead was written, as the title implies, after having seen his work in person. However, another ecphrasis that Wheatley included in *Poems on Various Subjects, Religious and Moral*, "Niobe in distress for her children slain by Apollo, from Ovid's Metamorphoses, book IV; and from a view of the painting of Mr. Richard Wilson,"[28] was probably not inspired by contact with the original work of art. "Niobe in distress" conflates a textual and a visual version of the mythological story of Niobe, Queen of Thebes, whose hubris toward the goddess Latona resulted in the slaying of all of her children. The poem begins:

> APOLLO'S wrath to man the dreadful spring
> Of ills innum'rous, tuneful goddess, sing!
> Thou who did'st first th' ideal pencil give,
> And taught'st the painter in his works to live,
> Inspire with glowing energy of thought,
> What Wilson painted, and what Ovid wrote.
> Muse! lend thy aid, nor let me sue in vain,
> Tho' last and meanest of the rhyming train!
> O guide my pen in lofty strains to show
> The Phrygian queen, all beautiful in woe.

Wheatley describes her encounter with the image as having been from "a view of the painting." Because there is no evidence that any of the three versions of Wilson's *Apollo Destroying the Children of Niobe* [see fig. 9] were ever in Boston or the American colonies during the eighteenth century, however, it is unlikely that Wheatley saw the painting in person before she left for England in July 1773. The "view of the painting" was probably "a view" of an engraving of one of the three paintings of Niobe done by

Wilson. One such engraving, made in 1761 by William Woollett (1735–1785), was widely distributed in England and the American colonies.[29] This was probably the "view" to which Wheatley had access.

Wheatley's interest in ecphrasis indicates that not only did she wish to see with words, but that she herself may have wanted to be seen beyond words. And because the world in which she was raised, the world within which her sight-filled words operated, was one that had a set of objectifying tropes associated with the bodies of women of African descent, Wheatley and her portraitist had to employ a strategy to manipulate and defy the visual rhetoric associated

10. JOHN BAPTIST MEDINA (Spanish, 1659–1710)
Adam's Story, from Book VII of John Milton's *Paradise Lost: A Poem in Twelve Books.* The Fourth edition adorn'd with sculptures
PUBLISHED 1688
14 1/2 x 9 IN. (36.8 x 22.9 CM)
Department of Printing and Graphic Arts, Houghton Library, Harvard College Library

11. *left to right:*
John Singleton Copley (1738–1815)
Mrs. Richard Skinner (Dorothy Wendell), 1772
Oil on canvas
39 3/4 x 30 1/2 in. (101 x 77.5 cm)
Museum of Fine Arts, Boston,
Bequest of Mrs. Martin Brimmer

12. James McArdell after
Sir Joshua Reynolds (British, 1723–1792)
Amelia Mary Lennox, Duchess of Leinster, 1754
Mezzotint
Approximately 13 7/8 x 9 3/4 in. (35.2 x 24.8 cm)
National Portrait Gallery, London

with these conventions in order to assert control over them and to present the poet as a creative, intellectual, black woman whose self was connected to her text. Wheatley's almost certain use of the Woollett engraving of the Wilson painting as inspiration for "Niobe in distress," is evidence that she was engaged with British print culture of the period.[30]

The importance of mezzotints and other intaglios within the visual culture of the Boston middle-class society the Wheatleys were a part of cannot be understated. And there is little doubt that Phillis

Wheatley's interest in this sophisticated yet popular art form was furthered during her three months in England in 1773 with the receipt of a folio edition of Milton's *Paradise Lost* [fig. 10] as a gift from Brooke Watson (of Copley's *Watson and the Shark* fame) and by her visits to several museums (including the British Museum and Coxes Museum).[31]

Wheatley's experiences with the art world and the print culture of late-eighteenth-century Britain help us understand the construction of her image. In colonial Boston of the mid-eighteenth century there was a long-established and extremely rich portrait tradition in the Anglo-American community of which the Wheatley family was an integral part. As a provincial portrait tradition it drew heavily on the use of engraved or mezzotint reproductions of contemporaneous British and French portraits. From recent work on the Boston-born portraitist John Singleton Copley by Paul Staiti and Aileen Ribiero we know that he trained himself to paint high society portraits using mezzotints as templates and by adapting the work of English and continental artists that he saw in local collections.[32] This practice of adaptation was

common for most British and Continental artists of the day and especially typical for colonial artists who had little opportunity to study portraits of high quality.[33] Mezzotint prints were used with great frequency by Copley as models from which to construct · fashionable portraits until he left the American colonies for Europe the first time in 1774.

Although James Porter claimed that the frontispiece of Wheatley "is of provincial character and exhibits several naïve traits of design," the formal design of the image is actually quite sophisticated and may be compared favorably to mature works by Copley and others that feature subjects seated at tables with occupied hands.[34]

The portrait of Wheatley employs a visual rhetoric that was often used in the presentation of educated, cultured, middle-class and elite women of the period, such as Copley's 1772 portrait of Dorothy Wendell Skinner [fig. 11]. In this enigmatic image done just a year before Wheatley's book was published, Mrs. Skinner sits at a highly polished table. The fingers of her right hand touch her chin, just as Wheatley's left hand does, and her gaze is directed beyond the picture frame. Skinner's left hand, rather than holding a pen, toys absently with sprig of blue Canterbury bell flowers. Copley's use of this pose may have been adapted from mezzotints such as one of Amelia Mary Lennox, Duchess of Leinster, after a painting by Sir Joshua Reynolds [fig. 12].

However, it is important to note that while many seated portraits of elite and middle-class women from this period share a similar reflective pose, none shows the act of writing. Further, there are few if any paintings, engravings, or mezzotints of British women writers made prior to 1773, the year of Wheatley's publication, that feature them at their craft. For example, Peter Cross's 1690 portrait miniature of Ann Finch, Countess of

13. *below:*
PETER CROSS (British, c. 1645–1724)
Ann Finch, Countess of Winchilsea, c. 1690
Watercolor on vellum
Oval, 3 x 2 1/2 IN. (7.6 x 6.4 CM)
National Portrait Gallery, London

14. ISAAC BECKETT after
ANNE KILLIGREW (British, c. 1660–c. 1685)
Anne Killigrew, c. 1683/1729
Mezzotint
9 1/2 x 7 1/2 IN. (24 x 19 CM) (PLATE)
National Portrait Gallery, London

Winchilsea, presents the poet as any other lady of her era but gives no hint at her literacy [fig. 13], while an engraving made during the first decades of the eighteenth century after a self-portrait of Anne Killigrew evinces that the poet and painter chose to present her self in a similar fashion [fig. 14]. Only portraits of women painters such as Angelica Kauffmann reveal an interest in being portrayed with the tools of one's trade [fig. 15]. Given that Wheatley's portrait was the first frontispiece image of an American woman writer, it is interesting that it was so visually innovative in featuring its subject in the act of writing [fig. 16].

When *Poems on Various Subjects, Religious and Moral,* was published in London in August of 1773, Archibald Bell could not print copies fast enough to keep up with the demand. And although he had promised to begin to send them over to Boston within a few weeks, it was actually several months before he was able to do so. The book rapidly entered the British critical discourse and its intellectual merits

15. Angelica Kauffmann (Swiss, 1741–1807)
Angelica Kauffmann, c. 1770–75
Oil on canvas
29 x 24 in. (73.7 x 61 cm)
National Portrait Gallery, London

16. *right:*
Attributed to Scipio Moorhead (lived in Boston c. 1750)
Detail of *Phillis Wheatley, Negro Servant to Mr. John Wheatley, of Boston*, 1773, detail of frontispiece to *Poems on Various Subjects, Religious and Moral*, published 1773
Engraving
5 1/16 x 4 in. (12.9 x 10.2 cm)
Massachusetts Historical Society, Boston

and its political importance were hotly debated. Foes of the institution of slavery trumpeted it as evidence of the African's inherent intelligence and humanity, proof that their commodification and exploitation was morally reprehensible and ought to be outlawed. British politicians used the book to countervail what they saw as the ironic cries for independence and political freedom that were increasingly coming from the colonies, after all, what moral right did "the drivers of slaves" have to make a plea for independence? As a result , pressure soon came to bear on the white Wheatley family for continuing to hold

Phillis in a state of bondage. Rather than be viewed as hypocrites, they chose to legally free her, and as a means of support she was granted a fifty percent royalty from the sale of her books. However, the receipt of this stipend came with the caveat that it was to be her primary source of support, as it was until her early death just ten years later around the age of twenty-nine.

It is remarkable that following the publication of Wheatley's book, with its ground-breaking portrait frontispiece, there occurred a sea change in the way that women writers and poets began to present themselves in British formal portraiture. Robert Edge Pine's portrait from around 1774 of the sour-faced Mrs. Catherine Macauley shows the historian in the costume of a classical muse, her right arm resting on five of the eight volumes of her monumental *History of England*.[35] Her right hand holds a quill pen while she absentmindedly toys with a piece of paper in her left [fig. 17]. A far more beatific example of the probable impact of Wheatley's portrait may be seen in an undated painting and a later mezzotint after it, from 1838, of the religious writer Hannah More [fig. 18]. More's poems against the slave trade, such as "The Sorrows of Yamba, or the Negro Woman's Lamentation," were widely read during the 1780s and 1790s. In the painting by Frances Reynolds, the sister of Sir Joshua Reynolds, we see the author gazing thoughtfully at the viewer as she is about to place pen to paper in the act of composition. Her pose replicates Wheatley's in many ways, with her left hand brushing her cheek, and her quill poised above the paper, but the angle of the view has been shifted considerably. As an abolitionist, More was intimately familiar with Wheatley's book and it is likely that she had

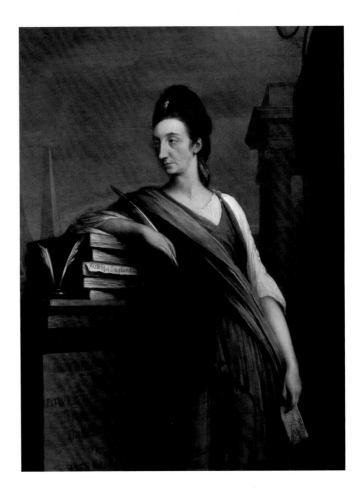

its powerful frontispiece in mind when she had her own portrait made.

Despite the impact that the image seems to have had in England on the portrayal of women writers, it would be a full fifty years before an example of an African American author's emulation of Wheatley's portrait would appear. But we do eventually find one in the 1836 autobiography *The Life and Religious Experience of Mrs. Jarena Lee*, by the first woman to make a career as a licensed preacher in the African Methodist Episcopal Church.[36] Like Wheatley, Lee is shown plainly dressed in a white shawl and bonnet with a quill in her hand and papers and books on the table beside her [fig. 19]. The Holy Bible that is placed beside Lee indicates that she is a religious woman, and a literate one. Just as Wheatley and her portraitist may have turned to certain visual tropes for the construction of her frontispiece portrait, including images of Alexander Pope, in order to fashion an identity that would defy ideologically controlled visual codes in which New World bodies were subjected to structures of social dominance, so too did Lee. But in this case she only had to look to Wheatley. One might say that she was "doing Phillis" when she sat for this portrait. And although her situation as an African American in the nineteenth century would have been vastly different from that of the eighteenth-century Anglo-Saxon Hannah More, her marginal position as an Anglophone woman writer remains one through which all of these women may be connected.

It remains imperative for historians of African American art to move beyond the mythic moment of the creation of this important image. It is necessary to range widely within the study of American and

17. ROBERT EDGE PINE (British, 1742–1788)
 Catherine Macaulay, c. 1774
 Oil on canvas
 54 x 41 1/4 IN. (137.2 x 104.8 CM)
 National Portrait Gallery, London

18. *right:*
 EDWARD SCRIVEN after
 FRANCES REYNOLDS (British, 1729–1807)
 Hannah More, PUBLISHED 1838
 Stipple engraving
 9 1/8 x 5 3/4 IN. (23.1 x 14.7 CM)
 National Portrait Gallery, London

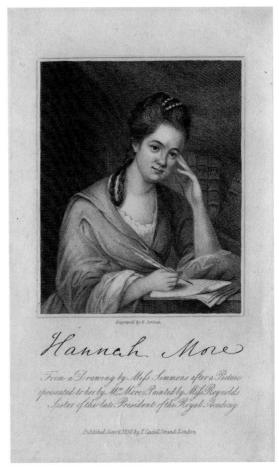

Engraved by E. Scriven.

Hannah More

From a Drawing by Miss Simmons after a Picture
presented to her by Mrs More, Painted by Miss Reynolds
Sister of the late President of the Royal Academy

Published June 4, 1838 by T. Cadell Strand London.

British art to uncover the myriad histories of the broader Atlantic world. The clothing Wheatley wears, her pose, the fine-art and print culture that often inspired her writing, all tell us a great deal about the portrait. Its possible visual sources and its probable visual descendants are of critical importance and show how this image of an Anglo-African woman departed from earlier portrayals of Anglo-Saxon women writers and defied the conventions of portraying enslaved African women. By reassembling and connecting previously ignored pieces of evidence this seemingly unassuming portrait of a nineteen-year-old Anglo-African woman yields many secrets. Wheatley's portrait is a pivotal image that subverts a hegemonic visual culture that would otherwise have depicted her as less than human and incapable of the creativity that defined her life. It is an image that revolutionized the way that numerous writers, including Anglo-Africans, African Americans, and Anglo-Saxon women in Britain, asserted their right to exist as authors in the public sphere.

19. Unknown
Jarena Lee, frontispiece to *The Life and Religious Experience of Mrs. Jarena Lee,* FIRST PUBLISHED 1836
Engraving
3 3/8 x 3 1/4 IN. (8.8 x 8.3 CM)
The Library Company of Philadelphia

1. Many variations on the frontispiece have been reproduced in the nineteenth, twentieth, and the twenty-first centuries. In addition to its publication in the beginning of *Poems on Various Subjects, Religious and Moral*, the original engraving of the frontispiece adorned the cover of Bickerstaff's *Boston Almanack for 1782*. After Bickerstaff's, various adaptations of the portrait were reproduced repeatedly throughout the nineteenth century. The version that accompanied the 1834 edition of the poems, which included Margaretta Odell's anonymous "Memoir" of Wheatley, was relatively faithful to the original, but the book which rests on the table was greatly reduced in size. An unlocated and undescribed portrait of Wheatley, possibly the original painting from which the frontispiece was taken, was displayed at the Columbianum Exhibition in the Pennsylvania State House between May and July 1795 to celebrate the establishment of the new republic's first academy of art (see Wendy Bellion, "Illusion and Allusion: Charles Willson Peale's 'Staircase Group' at the Columbianum Exhibition," *American Art* 17, no. 2 (Summer 2003): 23). In 1856 a hand-drawn version of the image, in which the book and chair were eliminated and the colonial pewter inkstand changed into a more contemporary glass bottle, was included in E. and G. Duykinck's *Cyclopedia of American Literature*, and Benson J. Lossing's volume *Eminent Americans* from 1859 (see William Robinson, *Phillis Wheatley and Her Writings* [New York: Garland Publishing, 1984]) featured a variation that changed the shaped of the table at which Wheatley sits from oval to rectangular and smoothed her wooly hair into gentle waves. However, neither of these later versions faithfully reproduced the upward gaze that so powerfully animates the sitter in the original: an expression of intelligence that establishes Wheatley as a divinely inspired, reflective individual rather than as an enslaved person.

2. *Poems on Various Subjects, Religious and Moral*, by Phillis Wheatley, Negro Servant to Mr. John Wheatley, of Boston, in New England (London: Printed for A. Bell, Bookseller, Aldgate; and sold by Messers Cox and Berry, King-Street, Boston, M DCC LXXIII [1773]).

3. Henry Louis Gates, Jr., *Figures in Black: Words, Signs, and the "Racial" Self* (New York: Oxford University Press, 1987), p. 25.

4. Paul Gilroy, *The Black Atlantic: Modernity and Double Consciousness* (Cambridge, Mass.: Harvard University Press, 1993), p. 153.

5. Betsy Erkkila, "Revolutionary Women," *Tulsa Studies in Women's Literature* 6 (1987): 202.

6. James A. Porter, *Modern Negro Art* (1943; Washington, D.C.: Howard University Press, 1992), pp. 8–9.

7. We know nothing of his work duties as an enslaved African in the household of the Reverend John Moorhead, one of the board of eighteen Boston notables who, along with John Hancock and Governor Hutchinson, "examined" Phillis Wheatley for the attestation that served to authenticate her book.

8. We are told by Wheatley's modern biographer William Robinson that "S.M." was identified as Scipio Moorhead "from a penciled note in a 1773 volume of Phillis's Poems housed at the American Antiquarian Society" (Robinson, *Phillis Wheatley*, p. 274).

9. See Romare Bearden and Harry Henderson, *A History of African-American Artists: From 1792 to the Present* (New York: Pantheon Books, 1993), p. x; Samella S. Lewis, *African American Art and Artists* (1978; 3d ed., rev. and expanded, Berkeley and Los Angeles: University of California Press, 2003), pp. 11–12; Frances K. Pohl, *Framing America: A Social History of American Art* (London and New York: Thames and Hudson, 2002), p. 126.

10. Sharon F. Patton, *African-American Art* (Oxford and New York: Oxford University Press, 1998), p. 44.

11. Beth Fowkes Tobin, *Picturing Imperial Power: Colonial Subjects in Eighteenth-Century British Painting* (Durham, N.C.: Duke University Press, 1999), p. 17.

12. The schooner *Phillis*, under the command of Captain Peter Quinn, arrived in Boston on July 11, 1761, with a cargo of kidnapped Africans to be sold into slavery. An advertisement was placed in the *Boston Gazette* and the *Boston Country Journal* for 29 July that read, "To be Sold: A Parcel of likely Negroes, imported from Africa, cheap for cash, or short credit; enquire of John Avery, at his House next Door to the White-Horse, or at a Store adjoining to said Avery's Distillery House, at the South End, near the South Market; Also, if any Persons have any Negro Men, strong and hearty, tho' not of the best moral character which are proper Subjects for Transportation, may have an Exchange for small Negroes...." See Robinson, *Phillis Wheatley*, pp. 3–5.

13. From the anonymous "Memoir" (p. 1); it was written by the great grandniece of Susannah Wheatley, Margaretta Matilda Odell. A facsimile is included in Robinson, *Phillis Wheatley*, pp. 430–50.

14. "Memoir," p. 2.

15. The 29 February, 14 March, and 18 April 1772 issues of the *Boston Censor* carried a subscription advertisement for Wheatley's poems. "Much supported by Loyalist Governor Hutchinson and his equally Loyalist brother-in-law, Lieutenant-Governor Andrew Oliver, the *Boston Censor* was pointedly ignored by Patriot Bostonians, and the paper ceased publication after only seven months of unheeded existence," explains Wheatley biographer William H. Robinson, but "not enough Boston subscribers—printers usually required 300—could or would agree that the poems of the proposals were written by a Negro" (Robinson, *Phillis Wheatley*, pp. 27–28).

16. The following text, which the Wheatleys hoped would serve to verify Phillis's authorship of her poems and to establish a case for her intellectual abilities, accompanied the book in the form of a printed card that was inserted by the printer, Archibald Bell:

"TO THE PUBLIC: As it has been repeatedly suggested to the publisher, by persons who have seen the manuscript, that numbers would be ready to suspect they were not really the writings of PHILLIS, he has procured the following attestation, from the most respectable characters in Boston, that none might have the least ground for disputing their Original.

"We whose Names are under-written, do assure the World, that the Poems specified in the following page were (as we verily believe) written by PHILLIS, a young Negro Girl, who was, but a few years since, brought, an uncultivated Barbarian,

from Africa, and has ever since been, and now is, under the disadvantage of serving as a Slave in a family in this town. She has been examined by some of the best judges, and is thought qualified to write them."

Among the eighteen signatures were: His Excellency Thomas Hutchinson, Governor; The Hon. Andrew Oliver, Lieutenant Governor; Hon. James Bowdoin; John Hancock, Esq.; Rev. Samuel Mather; and Rev. John Moorhead. Literary historian Henry Louis Gates, Jr., writes extensively on this "examination" in his book, *The Trials of Phillis Wheatley: America's First Black Poet and Her Encounters with the Founding Fathers* (New York: Basic Civitas Books, 2003).

17. See Alan Harding, *The Countess of Huntingdon's Connexion: A Sect in Action in Eighteenth-Century England* (Oxford and New York: Oxford University Press, 2003).

18. Papers of Selina Hastings, Countess of Huntingdon (Churchill College, Cambridge, United Kingdom), reprinted in Sara Dunlap Jackson, "Documents: Letters of Phillis Wheatley and Susanna Wheatley." *The Journal of Negro History* 57, no. 2 (April 1972): 212.

19. Quoted in Robinson, *Phillis Wheatley*, p. 31.

20. Margaretta M. Lovell, "Reading Eighteenth-Century American Family Portraits: Social Images and Self-Images," *Winterthur Portfolio* 22, no. 4 (Winter 1987): 243–64.

21. See Bryan Edwards, *The History, Civil and Commercial, of the British Colonies in the West Indies*, Vol. 3, with plates (London: [printed for John Stockdale], 1801), p. 22.

22. The image of Joanna appears in John Gabriel Stedman, *Narrative of a Five Years' Expedition against the Revolted Negroes of Surinam: Transcribed for the First Time from the Original 1790 Manuscript*, ed. and with introduction and notes by Richard Price and Sally Price (Baltimore: Johns Hopkins University Press, 1988), p. 89.

23. Terry Eagleton, *The Function of Criticism* (London: Verso, 1994), p. 10.

24. Paul Gilroy, *Against Race: Imagining Political Culture Beyond the Color Line* (Cambridge, Mass.: Belknap Press of Harvard University, 2000), p. 121.

25. Henry Louis Gates, Jr., *The Signifying Monkey: A Theory of African American Literary Criticism* (New York: Oxford University Press, 1989), p. 159.

26. Wheatley departed for England on 8 May 1773 and on 17 June 1773 arrived in London, where she stayed until the middle of August.

27. On ecphrasis, see John Hollander, *The Gazer's Spirit: Speaking to Silent Works of Art* (Chicago: University of Chicago Press, 1995); and Daniel H. Garrison, "Melville's Doubloon and the Shield of Achilles." *Nineteenth Century Fiction* 26, no. 2 (September 1971): 172.

28. Wilson (1713–1782) was a Welsh-born painter who began his career as a portraitist before moving into landscape painting and later helping to found the Royal Academy of Arts in London along with Sir Joshua Reynolds, Thomas Gainsborough, and the colonial American Benjamin West. One version of the painting was exhibited in 1760 at the Royal Academy in London

and first appears in auction records in 1810, when it is listed by Christie's in London as a part of the estate of the Hon. Charles Francis Greville (1749–1809), son of the First Earl of Warwick. Today that painting is in the collection of the Museum of Fine Arts, Boston.

29. The engraving of the Niobe painting, which is more notable for its dramatic depiction of landscape than its subject matter, was the first large commission for William Woollett, and it was made for the printer Boydell. Woollett is also known for engraving Benjamin West's 1771 painting *The Death of General Wolfe* in 1776. Mezzotint reproductions of famous portraits by Richard Wilson were widespread in the British public sphere of the eighteenth century; however mezzotints of his paintings whose interest lay in their presentation of landscape were not. At least two examples of Woollett's engraving of Wilson's *The Destruction of the Sons of Niobe* are known today in the U.S., one at the Albright-Knox Art Gallery, Buffalo, N.Y., and the other as a part of the print collection amassed by the art historian Leo Steinberg and given to the Blanton Museum of Art at the University of Texas, Austin.

30. There remains the possibility, although there is no recorded evidence, that while Wheatley was in London she may have viewed one of Wilson's Niobe paintings in the collection of the Earl of Dartmouth. The Earl of Dartmouth was the main supporter and benefactor of her good friend the Native American Reverend Samson Occom (founder of Dartmouth College in New Hampshire). In fact, she may not have composed the poem until after her arrival in London, which would push the date of the poem's composition to that summer. This possibility is supported by the poem's absence from the listing of the original 1772 proposal for the volume, and by its placement toward the rear of the volume on page 101 (the entire volume runs 124 pages and includes Wheatley's poem "A Farewell to America" which was composed sometime en route to England. Significantly, "To S. M." is also absent from the 1772 proposal and placed at the back of the volume, beginning on page 114, just after "Niobe in distress."

31. See Wheatley's letter to Colonel David Wooster of New Haven, 18 October 1773.

32. See Carrie Rebora et al., *John Singleton Copley in America* (New York: Metropolitan Museum of Art, 1995). Copley, who was the leading portrait painter in Boston from the 1750s until 1774 when he and his loyalist in-laws were forced to depart for England, had his first exposure to art and to portraiture through his stepfather, Peter Pelham, who was an engraver and one of the chief producers of mezzotints in New England during the 1720s and '30s. Pelham's prints enjoyed wide distribution throughout Boston, and his son, Copley's half-brother Henry Pelham, also became a printmaker and continued making reproductive mezzotint portraits and scenes.

33. In the past many art historians interpreted American portraitists' borrowing from prints as evidence that colonial painters lacked access to formal training. Trevor Fairbrother claims that Copley "manipulated these sources to suit his pictorial needs" rather than simply being derivative (Trevor Fairbrother, "John Singleton Copley's Use of British Mezzotints for his American Portraits: A Reappraisal Prompted by New Discoveries,"

Arts Magazine 55 [March 1981]: 122). Margaretta Lovell argues that Copley's use of prints is a sign of his sophistication as opposed to his technical limitations (Margaretta M. Lovell, "Mrs. Sargent, Mr. Copley, and the Empirical Eye," *Winterthur Portfolio* 33, no. 1 [Spring 1998]: 22–23).

34. Porter, *Modern Negro Art*, p. 8.

35. Roy Strong et al., *The British Portrait, 1660–1960* (Woodbridge, United Kingdom: Antique Collectors Club, 1991), p. 200.

36. Jarena Lee, *The Life and Religious Experience of Jarena Lee, a Coloured Lady, Giving an Account of Her Call to Preach the Gospel* (Philadelphia: printed and published for the author, 1849).

 It is true that Wheatley's writings, and the portrait frontispiece that accompanied them, have long been important to the work of African American writers and activists because of the manner in which they denied her status as a "slave" and as someone else's property. In her diary entry for 28 July 1854, African American abolitionist Charlotte Forten Grimké recorded that she had just read Wheatley's poems and that "she was a wonderfully gifted woman and many of her poems are very beautiful." Grimké also noted that Wheatley's "character and genius provide a striking proof of the falseness of the assertion made by some that hers is an inferior race" (see *The Journals of Charlotte Forten Grimké*, ed. Brenda Stevenson [New York: Oxford University Press, 1988], p. 92). Half a century later African American education activist Lucy Craft Laney would also cite Wheatley as one of the few early "isolated cases of men and women of high moral character and great intellectual worth...whose work and lives should have taught, or at least suggested to their instructors, the capabilities and possibilities of their dusky slave pupils." See Lucy C. Laney, "The Burden of the Educated Colored Women," an address given at Hampton Negro Conference Number 3, July 1899, in *Black Women in Nineteenth-Century American Life*, ed. Bert James Lowenberg and Ruth Bogin (University Park: Pennsylvania State University Press, 1976), pp. 296–301.

"Moses Williams, Cutter of Profiles"

Silhouettes and African American Identity in the Early Republic

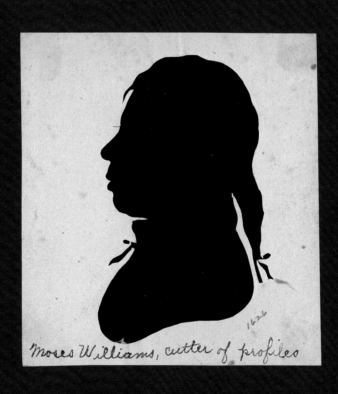

Moses Williams, cutter of profiles

AN EARLY-NINETEENTH-CENTURY silhouette portrait made around 1803 and titled *Moses Williams, Cutter of Profiles*, was attributed in 1990s by the curators of the Library Company of Philadelphia to Raphaelle Peale [fig. 1]. The portrait's existence, its physical characteristics, its inscription, even this recent attribution, raise compelling questions about identity, race, and authorship for the present-day viewer. The small, finely detailed portrait is formed by the layering of two pieces of paper: a white one out of which a profile form has been cut is laid over a black sheet to create a silhouetted profile. The meticulously cut edge defines the high brow of the subject's forehead; the tip of his nose; the lips pressed lightly together; and the high-collared jacket. It forms an undulating hairline, with a long queue at the back. From between the jacket's lapels it becomes a scarf, one end of its bow jutting out into empty space. And while the carved white paper deftly creates physiological characteristics and costume details, the black stock upon which it rests seems to create a veil of darkness rather than to reveal a "truth" about the "identity" of the sitter.

By telling us the subject's name and occupation, the text written across the lower edge of the white paper, "Moses Williams, cutter of profiles," lifts a part of this veil. But at the same time the text adds to the mystery of the image itself. Who was Moses Williams and what significance did his occupation have in relation to his identity? How might we interpret the denotative and connotative meanings found within this image/text combination today? What do they tell us about the silhouette's ability to contain and communicate a sitter's identity? Specifically, how might the artist recreate the subject's race, gender, and class using such a minimal mode? Further still, how might the silhouette's conventions be troped by an artist to assert a self-fashioned identity, one that might stand in opposition to a dominant culture's social prescriptions?

1. Attributed to RAPHAELLE PEALE (American, 1774–1825)
Moses Williams, Cutter of Profiles, AFTER 1802
Hollow-cut profile
3 3/8 x 3 1/4 IN. (8.6 x 8.3 CM)
The Library Company of Philadelphia

For many years Moses Williams (1777–c. 1825) was known only to scholars by a few references that constructed him as the one-time slave of Charles Willson Peale (1741–1827), a foremost painter, naturalist, and museum proprietor of the early republican period.[1] It has long been established through Peale's diary entries, letters, and assorted newspaper clippings that Williams was born and raised within his master's Philadelphia household, and that after his manumission, he worked as a silhouette maker in Peale's Museum. Textually present yet physically invisible until 1996, he existed as a shadowy enigma for historians, what Toni Morrison might term an "Africanist presence" within the well-documented legacy of the Peale family. Recent scholarship, however, has sought to examine Williams's function within the museum and the impact of the silhouettes that he cut upon the visual culture of early-nineteenth-century Philadelphia. Through the foundational research and analysis presented in Ellen Fernandez Sacco's dissertation, "Spectacular Masculinities: The Museums of Peale, Baker, and Bowen in the Early Republic," and in David Brigham's book *Public Culture in the Early Republic: Peale's Museum and Its Audience*, we can now understand much more about Williams's life in the Peale household.[2]

Beginning in the 1760s, Charles Willson Peale fashioned for himself a career in the arts and natural sciences that was unparalleled in his day. In addition to painting portraits of such notables as George Washington, he maintained a museum that featured hundreds of taxidermied New World animals and ethnographic artifacts. He was active in the politics of the time and was a friend and correspondent of Thomas Jefferson, Benjamin Rush, and many other prominent figures. With three different wives, he fathered seventeen children, and while not all of them reached maturity, the ones who did tended to follow their father's example and his teachings by choosing work as visual artists, naturalists, and museologists.

Like other citizens living in the Mid-Atlantic States before and after the War of Independence, Peale owned slaves. While working in his birthplace of Annapolis, Maryland, between 1769 and 1775 he acquired a mixed-race slave couple named Scarborough

and Lucy. It is believed that they came to him as payment for a portrait commissioned by a plantation owner in the area. He later moved his entire household to Philadelphia where, some ten years later, he emancipated the couple in 1786 under provisions outlined in a Pennsylvania law for which he himself had lobbied. The 1780 Act for the Gradual Abolition of Slavery also provided for less restrictive laws on free blacks and allowed Lucy and Scarborough to live as independent, albeit second-class, citizens. Their eleven-year-old son, Moses, however, was still bound by law to remain in their former master's service until the occasion of his twenty-eighth birthday.[3] This situation bound Moses Williams and his family to the Peales, and tightened the stress that the "peculiar institution" of slavery put on life in the busy household.

Growing up apart from his natural parents, Williams was functionally the "eighteenth child" of his master, and prevailing ideological attitudes prescribed that he would be treated as a child throughout his lifetime despite being freed a year early, in 1802, at the age of twenty-seven.[4] Raised alongside the numerous Peale children, who by necessity were trained to be useful members of the museum's staff, Williams was instructed in taxidermy, animal husbandry, object display, and eventually the use of a silhouette-making machine, the physiognotrace.

At the time of its installation he was taught to operate this portrait-making device, but unlike the other junior members of the Peale household, he was not taught the "higher art" of painting. This point is significant, for virtually all of Peale's own children were painters. This was perhaps for no other reason than they had to live up to the names he had given them: Raphaelle, Rembrandt, Angelica Kauffman, and Titian are among the best known. And while these white members of the household were given a full palette of colors with which to express themselves artistically, the slave was relegated to the mechanized blackness of the silhouette, and it effectively removed him from any significant artistic and financial competition with the others.

This situation reveals the complex nature of the elder Peale's control over artistic learning in his household and the role that slavery played within

it. Rembrandt Peale (1778–1860), known for his vivid portraits, later recalled:

> It is a curious fact that until the age of 27, Moses was entirely worthless: but on the invention of the physiognotrace, he took a fancy to amuse himself in cutting out the rejected profiles made by the machine, and soon acquired such dexterity and accuracy, that the machine was confided to his custody with the privilege of retaining the fee for drawing and cutting. This soon became so profitable, that my father insisted upon giving him his freedom one-year in advance. In a few years he amassed a fund sufficient to buy a two story brick house, and actually married my father's white cook, who during his bondage, would not permit him to eat at the same table with her.[5]

Rembrandt's rather unflattering "portrait" of Williams reveals some of the tension between him and his father's former slave, who was six months his senior.

Rembrandt Peale and Moses Williams were unequal cohorts in a peculiar family relationship. As slave and son they were both under the control of their *pater familias*, and the role of the all-powerful head of household was one that the elder Peale, a proponent of the new nation's emulation of republican Rome, relished. Peale's overbearing and capricious paternal demeanor has been a topic of much recent study, including Phoebe Lloyd's provocative argument that he was neglectful of his eldest son Raphaelle's health by knowingly having him work with toxic materials during taxidermy projects.[6]

There is no indication that Williams actually had a desire to paint; he may not have seen it as beyond the possibility of his racial status because of the close proximity of the African American painter Joshua Johnston (active 1789–1825). It has been speculated that Johnston, who worked primarily in nearby Baltimore, received some formal training from several members of the Peale family, including Charles Willson and Rembrandt.[7] However, the extent of Williams's contact with Johnston, or its possible impact upon him, is not known.

Further insight into the peculiar dynamics present in the Peale family, and the role that slavery played in them, may be gleaned from the way that

Williams was mentioned by the elder Peale in letters to family members and close friends. For example, in an 1803 letter to Raphaelle, who was then working in Virginia making silhouettes and painting portraits, Peale praises the work of his former slave: "I have just spoken to a Gentleman who says he was at your Room in Norfolk which was so crouded that he could not get his profiles. Moses has made him a good one, being from Carolina he did not at first relish having it done by a Molatta, however I convinced him that Moses could do it much better than I could."[8] In this anecdote there is a sense that Peale may have secretly enjoyed the discomfort that Moses' race had upon the sitter.

And in an 1808 letter to Rembrandt, then studying in Paris, the patriarch records the birth of Moses' daughter in the same paragraph and sentence as the events of his natural children and grandchildren: "I have the agreable intelligence to communicate of the (safe) recovery of your sisters Angelica's health, and the birth of an other (Daughter) Son, after which she had a severe attack of bilious colick, Raphaelle has also another Son, and Moses a Daughter."[9] In this environment of blurred familial relations, attention to the former slave may have been seen as a slight to the son. I would speculate that Rembrandt's antipathy toward his father may have been redirected toward the easiest possible target, that of the former slave.[10]

The hegemonic language of American white supremacy has created designations for people of color that are not only derisive, but problematic. In a diary entry of 1799 Peale refers to Moses Williams as "my Molatto Man Moses," in a manner quite similar to that found in the 1803 letter to Raphaelle.[11] In the term *Molatto*, estimations of color, blood quantum, and subhuman, equine origins seem to confront each other. The liminal racial identity that these words constructed for Moses Williams, his enslaved status, and his racially mixed heritage caused him to be viewed as profoundly other within the public sphere of Philadelphia that defined American identity as decidedly white. Sacco argues that despite being a vital part of its workings, "Williams's presence in the museum, as silhouette cutter, or, as sent out by Peale dressed as an Indian to pass out handbills for the

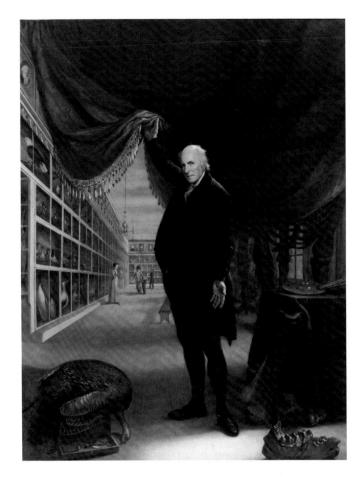

2. Charles Willson Peale (American, 1741–1827)
The Artist in His Museum, 1822
Oil on canvas
103 3/4 x 79 7/8 in. (263.5 x 202.9 cm)
The Pennsylvania Academy of the Fine Arts, Philadelphia,
Gift of Mrs. Sarah Harrison
(The Joseph Harrison, Jr., Collection)

exhibit of the mastodon in 1802, [put] Williams up for the same scrutiny as the displays—because it featured his subordinated status within a practice of visual order."[12]

This "practice of visual order" is well illustrated by Peale's emblematic self-portrait, *The Artist in His Museum*, 1822 [fig. 2]. Here, the elderly proprietor, still virile despite being toward the end of his life, lifts a curtain revealing the contents of the Longroom, the main exhibition space of the museum. On the left side of the composition, near the ceiling, are revealed portraits by him of "great white men." Hierarchically arranged beneath them on the lower levels are various New World ethnographic artifacts and taxidermied animals. To the right is the partially visible skeleton of the mastodon excavated by the artist/naturalist a quarter of a century earlier from a marl pit in New York State. The painting is a visual biography of his life's endeavor to create and control the production of meaning within a circumscribed space.[13]

3. REMBRANDT PEALE (American, 1778–1860)
Man in a Feathered Helmet, c. 1805–13
Oil on canvas
30 1/4 x 25 1/4 IN. (76.8 x 64.1 CM)
Bishop Museum, Honolulu, Hawai'i

This space was the stage upon which Moses Williams played out his role as the other. In this performance of alterity he was not only dressed up as an Indian for advertising purposes, but he may also have been transformed in a painting attributed to Rembrandt Peale, *Man in a Feathered Helmet*, c. 1805–13 [fig. 3]. Sacco suggests that in this painting the "light mulatto" may have been cast as the noble savage and masqueraded against an ethnographic black background as an Hawaiian chief. "A comparison of Williams's profile with that of the young man portrayed in the painting shows the same full mouth and broader jawline." She goes on to argue that through this presentation as a Hawaiian, Williams, in his real-life role as a silhouette cutter, would have been taken out of history and environment and presented like other exhibits in the Longroom, a specimen within a hierarchical order in which the other was at the bottom.[14] Through Sacco's examination of *Man in a Feathered Helmet* it becomes possible to speculate that for Williams a concrete racial selfhood, unlike his professional identity, probably remained liminal throughout his life.

The costumed anonymity of *Man in a Feathered Helmet* would be in direct contrast with the importance of Williams's professional identity as a silhouette maker that the discursive text on the front of the cut-paper portrait asserts. This information is repeated on the back, but here it reads "Moses Williams, the Cutter of Profiles," stating that the sitter's professional identity as a specialist was of paramount importance. Although essentially giving the same information as that found on the front, the action of re-inscription doubles the importance of the subject's "vocation" in the assessment of his identity, for it constitutes a social status on par with those of other artisans, defining him as a skilled worker within his community.

This profound act of naming staged beneath the profile of the artist and on the back of the mount may also be read in terms of the practice of naming Africans in America during the antebellum period. Africans that arrived on slave ships in the eighteenth and nineteenth centuries were given new names as they were sold into slavery. It was not until a slave was freed that he/she was able to name him/her-self. This practice of self-naming may be found in the case of Isabella Dumont, who as a free woman became Sojourner Truth [fig. 4]. Truth is shown here in a carte-de-visite from the 1860s, with the interesting caption "I sell the shadow to support the substance." She is referring to the image produced by photography as the "shadow." It is a statement that signifies upon the "currency of identity" that mechanical reproduction made possible in the nineteenth century. Through systems of multiple image-making, Truth was able to sell a reproduction of her body in order to sustain its source. In this manner the formerly enslaved woman was able to achieve an ironic sort of control over the sale of the representation of her selfhood.[15]

A similar act of naming can also be found in the case of Scarborough Peale, who became John Williams when he and his wife Lucy were freed in 1786.[16] How and why John Williams chose his new name is unknown, but it is important to note that his son also took that last name when he was freed some sixteen years later. The first name of the son is important to consider as well. In the Bible, Moses was separated from his birth-family and raised in the house of the

pharaoh. Eventually, when he was confronted with his difference, his otherness, he was forced to make a critical choice not to ignore this shift in identity. At this point he was reborn when he assumed the life of a Hebrew slave in a newly racialized body. But it was his role as the one chosen by God to lead his people out of Egypt, from bondage to the promised land, that made Moses' name popular among African Americans during slavery.

During the early nineteenth century slaves went more often to another owner than they did into self-possession, and their names changed to suit the new owner's preferences. According to a bill of sale dated 1796 and displayed under an homogenizing mat with the anonymously made silhouette of Flora [fig. 5], "Margaret Dwight of Milford in the County

5. UNKNOWN
Flora, 1796
Silhouette, cut paper and brown ink, mounted with bill of sale
14 x 13 IN. (35.5 x 33 CM)
The Stratford Historical Society, Stratford, Connecticut

of New Haven and State of Connecticut sold Flora, a nineteen-year-old slave, to Asa Benjamin of Stratford in Fairfield County, Connecticut, for the sum of twenty-five pounds Sterling."[17] This extremely rare hand-drawn silhouette was made sometime before this sale, and we can see that Flora's new last name has been appended on the lower right in a different hand. The repeated naming in three different places on the paper: "Floras profile," "Floras profile," "Flora Benjamin," serves to control her identity in both the figural and the discursive fields. Flora's silhouette was part of the documentation that her new owner kept on his purchase for identification purposes in case she ever ran away, and its use in active surveillance is comparable to that of the contemporary police mug shot. This enigmatic profile is distinguished by the soft features of the face abruptly juxtaposed with the spiky, abstract rendering of hair. In its organic regularity it becomes like the petals of a flower, marking the visual and verbal amalgamation of "Flora" and "flower," of woman and object. Her image, like a pressed blossom, is sandwiched into the two dimensions of the paper. And like flowers, one could purchase slaves.

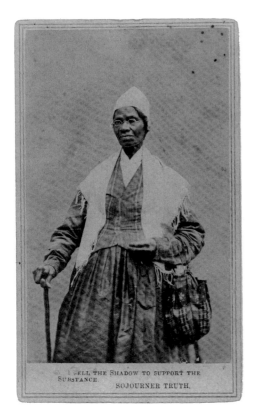

I SELL THE SHADOW TO SUPPORT THE SUBSTANCE.
SOJOURNER TRUTH.

4. UNKNOWN
Sojourner Truth, 1864
Albumen print on card
approximately 4 x 2 1/4 IN. (10.7 x 5.7 CM)
Gladstone collection, Prints and Photographs Division, Library of Congress, Washington, D.C.

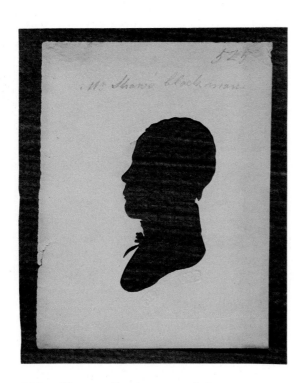

6. Moses Williams (American, 1777–c. 1825)
 Mr. Shaw's Blackman, after 1802
 Hollow-cut profile
 4 15/16 x 3 7/8 in. (12.5 x 9.8 cm)
 The Library Company of Philadelphia

Another rare silhouette of an African American was made at Peale's Museum and inscribed as "Mr. Shaw's blackman"; it is attributed to Moses Williams [fig. 6]. As David Brigham has recognized, the name identifies the subject in relation to his master and his race, locating his existence solely within the institution of slavery and his skin color.[18] Without this title, the viewer might not know he was a slave, or that he was dark-skinned. There is little in the image to indicate race other than the slight fullness of his upper lip or the short wavy hair. As in the silhouette of Williams, the simple rendering of his clothes, an animated bit of necktie peeking out from a high collar jacket, seems to give little indication of his identity, but in this case, his costume must be read as livery, rather than merely contemporary clothing. The silhouette of Mr. Shaw's blackman is interesting to juxtapose with Charles Willson Peale's racializing Williams's identity as "My Molatto Man Moses."

Williams's role in the young nation as a manumitted slave, working within the literal shadow of his former owner at Peale's Museum is key to understanding the complex construction of his identity that *Moses Williams, Cutter of Profiles* presents. Central to this role was his assuming the concession of the physiognotrace device [fig. 7] upon the occasion of his manumission at age twenty-seven, in 1802.[19] This tool for image-making was closely related to the polygraph machine that was owned by Thomas Jefferson, which was designed to make two copies of the same document at once [fig. 8].[20] The polygraph was intended for making multiple documents, and the physiognotrace for making multiple images. And yet both came from the desire that their inventors, Charles Willson Peale and his friend Sir John Isaac Hawkins, had for devising a way to propagate and control the production of textual and visual meaning.

As a mechanically mediated visual presentation, the portrait profiles made by the physiognotrace promised the early nineteenth-century viewer a certain indexical primacy that other forms of image making could not. Like the photographic media that would eventually eclipse it, the physiognotrace produced

7. *left to right:*
 Physiognotrace display
 The Maryland Historical Society, Baltimore

8. John Isaac Hawkins (British, 1772–1845) and
 Charles Willson Peale (American, 1741–1827)
 Polygraph, 1806, mahogany, brass, green baize
 10 x 24 x 17 in. (25.4 x 61 x 43.2 cm)
 Special Collections, University of Virginia Library

something that was viewed by many to be a pure act of mechanical mimesis, an image practically unmediated by human hands. However, after the machine blind-embossed a line on the paper, hand-cutting was a necessary part of the hollow-cut silhouette's creation. In this way physiognotraced profiles also retained what Walter Benjamin would term an aura of individuality.[21] Therefore, the revolution in portraiture that accompanied the physiognotrace device was in its time nearly as significant as the subsequent development of inexpensive photography was during the final third of the nineteenth century. The physiognotrace silhouette retained a great deal of its "aura" because of the physical link between sitter and machine and cutter. All three were linked together via the prosthetic arm of the wooden tracer that was attached to the device.

The physiognotrace that Williams began operating at the museum in 1802 soon became one of the chief attractions for visitors. In its first years, about eighty percent of attendees, as many as eight thousand a year, had their profiles made by Williams, at a cost of eight cents each.[22] In 1805 Peale wrote to his partner Hawkins in England that "the Physiognotrace has done wonders, profiles are seen in nearly every house in the United States of America, never did any invention of making the likeness of men, meet so general approbation as this has done…. It would be too great a task for Mosis to write the Name on each…. However he shall give such names as he may think worthy of being known and remembered."[23]

We can see evidence of the widespread use of these silhouettes in a genre painting by John Lewis Krimmel, an artist working during the period in Philadelphia and the surrounding area. In *Quilting Frolic*, 1813 [fig. 9], portrait profiles are placed above the mantel and just beneath a mezzotint of the "Father of Our Country," George Washington. The silhouettes, whose profiles echo those of faces found on Roman coins, are evidence of the neoclassical style in republican America. In Krimmel's image they function as classicizing icons for the ancestors of the new republicans who cavort in front of them.

Part of the problem with researching nineteenth-century silhouettes is that we often do not know who made them. A handful of other portrait profile

9. John Lewis Krimmel (American, b. Germany, 1789–1821)
Quilting Frolic, 1813
Oil on canvas
17 x 22 1/4 in. (41.2 x 56.5 cm)
The Henry Francis DuPont Winterthur Museum

artists besides Williams and the Peales worked on the eastern seaboard in the 1810s and '20s. Collectively they produced tens of thousands of these small images, which measure about five by four inches. The established method for attributing these images, according to Alice Van Leer Carrick, author of *American Silhouettes: A Collector's Guide*, is that those made at Peale's Museum generally bear the embossment "Museum," while those made by Raphaelle in his independent practice are marked "Peale." While the designation "Museum" must be read as subsuming the output of Williams within it, it would also include profiles by Charles Willson Peale, or even by people who opted to save the eight cent operators' fee by only paying for the paper and making their own. Further, there are certain stylistic details that link the Museum-embossed profiles, such as ink-drawn curls on the head of a female sitter, or the way that a lock of hair falls over the forehead of the man, that, in the absence of an embossment, help to identify them as Peale silhouettes. But whether a silhouette has "Museum" or "Peale" embossed across its lower edge is not a concrete designation of its authorship, just of its origin within the Peale family realm. As a result of such ambiguities, there are a reasonable number of silhouettes attributed to members of the Peale family that bear no embossment, and *Moses Williams, Cutter of Profiles* is one of these. These factors give us reasonable doubt about the "true authorship" of this image. It is not necessarily by Raphaelle Peale; it may have been the product of collaboration on the part of the two men, or it might have been a self-portrait by Moses Williams.

Imagine for a moment, if you will, a possible scene of this image's creation. Moses Williams enters the Longroom of the museum, walks to the end where the physiognotrace is located, takes a piece of paper, folds it twice so that four copies will be made, and inserts into the top of the machine. He sits beneath the device, adjusting his posture to fit his head within the arch at the bottom. Then, using one hand he begins to guide the dowel past the features of his face. It glides easily over chin, nose, eyes, and forehead. The hinges of the machine, which articulate its drawing arm, act to reduce his features onto the small square of paper tacked to the top of the board. The front half of his head now drawn, he stretches to extend the reach of his arm so that it may guide the dowel over his hair and down his back. It is a difficult thing to accomplish, and the line that he achieves in this second half of the image is much choppier and rougher than in the first. The tracing of the profile now complete, Williams removes the paper and begins cutting it out. He doesn't like some of what he sees, so he corrects it to his liking. Then, using a quill and ink, he adds the finishing touch of an arching eyelash, and, perhaps, he writes his name and occupation at the bottom.

In *Moses Williams, Cutter of Profiles*, certain discrepancies reveal both what was ignored and what was embellished during this artistic process. On the white laid paper, embossed pentimenti from the machine's trace-line appear prominently in the areas of the queue and the neck-tie, making a record of what was mechanically "seen" by the device. There is a significant deviation of the cut-line from this path that indicates what was changed by the artist during the cutting process. Here, the remaining trace-lines reveal that the "cutter" altered the length of the hair by extending it nearly one centimeter from the original trace-line, causing it to lie closer to the head. In concert with a stylized lock curling over the forehead, the altered hair follows a smoother, more flowing line.

Although the rounded nose and full lips of Williams's African blood dominate his facial features, the European part of his "Molatto" identity crowns him in the form of long, straight hair. In comparison with the undulations on *Mr. Shaw's blackman*, or the jagged peaks on *Flora*, the hair is decidedly Anglicized.

By deviating from the original form-line, I believe that Moses Williams purposely created an image in which his own features would connote tropes of whiteness rather than blackness. But was it an attempt to deny the African part of his racial heritage? I would argue that it records the anxiety and confusion that he had about his position as a person of mixed race within a white society that despised that heritage. As a newly freed man he needed to create an identity for himself, and he had to do it with the tools that he had been given. In this way *Moses Williams, Cutter of Profiles*, both creates and obscures its subject's identity by signifying and subsuming him beneath the appellation "Moses Williams, cutter of profiles."

Henry Louis Gates, Jr., argues in *The Signifying Monkey* that within the African American literary tradition, "to rename is to revise, and to revise is to signify."[24] In such an act of redrawing, one which I read/propose as kin to that of renaming or revising, we could see Williams signifying on his own profile. Rather than letting the traced image remain as the machine—a machine that it is important to remember was designed by a friend of the man who owned him—had recorded it, he went back and revised it with his scissors. Recall the technical relationship between the physiognotrace and the polygraph devices; in the same manner that Thomas Jefferson insured his archival legacy by producing copies of his writings with the polygraph, so too did Williams provide a visual record of his identity using the physiognotrace. It was a related act of mimetic writing or inscription. However, as his scissors cut into the paper, Williams wrote his own story upon the one produced by the mechanical contraption of his enslaver. Through this act he would achieve agency over a small part of his representation within the public sphere. That this action comes around 1803, at the beginning of his career, shows both his interests in fitting into the artisanal society of Philadelphia and his ability to manipulate and defy its tenets. His marriage to the Peales' white cook, Maria, further indicates this ability, and the fact that their daughter disappeared from history, most probably by passing for white, shows the legacy of the father's own search for identity within a racialized selfhood.

And yet, despite the agency that one might project into this account of Moses Williams's life, apparently the waning of the silhouette business, the basic economic problem of an oversaturated market, may have ended his career. A half-century after Moses Williams began his artistic practice as a cutter of profiles, *Philadelphia Daily News* columnist Frank Colliger wrote in his "Recollections of the Past" that "Moses Williams, a light mulatto man, was brought up in the family of the elder Mr. Peale. He was, as many old folks may recollect, a pleasant, witty, as well as an expert fellow in his vocation; but as his employment gradually declined, even so did Moses, and his finale hastened by too liberal use of the 'social glass'."[25] Peale correspondence from the summer of 1823 confirms that Williams was forced to sell the property that his initial professional success had enabled him to buy.[26] Unlike Rembrandt and Raphaelle, who could paint all manner of portraits, still lifes, or whatever else the market demanded, Williams's artistic flexibility was as limited as the black and white of the paper media with which he worked. At the time of his manumission, Williams had assumed the professional identity that was provided for him by his owner. But when this career failed, he lost the primary thing that had represented his freedom and independence: his ability to signify. Without his professional identity as the "cutter of profiles," Williams's taking of the social glass, his drinking, increased, and he descended into insolvency. Divested of property and without means to support himself, he was simply Mr. Peale's "Molatto Man Moses," a thing that he clearly did not want to be.

The nineteenth-century artistic practice of Moses Williams demonstrates the tradition of signifying as it may have been applied by an African American artist who chose to trope the conventions of the silhouette mode. It becomes clear that Moses Williams had a certain amount of agency and control over his artistic practice, and signifying upon the line of his self-portrait would have been one of the ways that he could show this ability. Regardless of whether his alterations were "good" or "bad," they would have been his.

While works of art by Peale family members proper have been studied in detail over the last two centuries, this silhouette of Williams was "rediscovered" less than ten years ago by the Library Company of Philadelphia, although it has been in their collection since the 1850s. When the curators attributed this image to Raphaelle Peale, regardless of the fact that it does not bear his signature or embossment, they participated in the two hundred years of scholarly obfuscation of Williams's artistic contribution to American art history by denying the possibility that it might be a self-portrait. Is it too much to imagine that Williams's own hand and artistic voice might be found within what at first might seem to be impenetrable blackness? A voice which could have signified upon a specific visual form and through an active and revisionary process made it its own. Why might it not demonstrate the artist's own agency in the visualization of his selfhood, and in so doing stand as his way to subvert the negation of voice that blackness connoted during slavery?[27]

1. This essay began in a graduate seminar led by Roger B. Stein in his capacity as Distinguished Visiting Professor of American Art and Culture at Stanford University during the spring of 1998. I thank Professor Stein for all his help, encouragement, and continuing support. The ideas begun under his guidance were furthered after contact with Ellen Fernandez Sacco at the 1998 American Studies Association meeting in Seattle. I thank Dr. Sacco for her generosity in sharing valuable source material on Williams with me, including the articles by Rembrandt Peale and Frank Colliger cited below. Dr. Sacco's scrupulously thorough research has been key to the illumination of this long forgotten artist. An early version of this paper, titled "In the Shadow of the Peale Family," was given as a presentation as part of the panel "Identity and the Limits of Representation," chaired by David Joselit and Richard Meyer, at the College Art Association Annual Meeting in February 1999. I would like thank Professors Joselit and Meyer for their support and for giving me the opportunity to present. After a reading there in November 2003, this essay was published under the same name in *Proceedings of the American Philosophical Society* 149, no. 1 (March 2005): 22–39. Lastly, I owe a great debt to Alexander Nemerov, my dissertation adviser, who shared with me his insights on art and identity in the early republican period while he was working on his recent book on the still life paintings of Raphaelle Peale.

 For detailed information on Peale and his family, see the large body of scholarship, including the recent museum exhibition catalogue, Lillian B. Miller, ed., *The Peale Family: Creation of a Legacy, 1770–1870* (New York: Abbeville Press in association with the Trust for Museum Exhibitions, and the National Portrait Gallery, Smithsonian Institution, 1997).

2. Ellen Fernandez Sacco, "Spectacular Masculinities: The Museums of Peale, Baker, and Bowen in the Early Republic," Ph.D. diss., UCLA, 1998, pp. 48–74, 110–12; David R. Brigham, *Public Culture in the Early Republic: Peale's Museum and Its Audience* (Washington, D.C.: Smithsonian Institution Press, 1994).

3. The text of the 1780 Act for the Gradual Abolition of Slavery governing Moses Peale's condition reads thusly: "IV. *Provided always, and be it further enacted*, That every Negro and Mulatto child, born within this State after the passing of this act as aforesaid (who would, in case this act had not been made, have been born a servant for years, or life, or a slave) shall be deemed to be, and shall be, by virtue of this act, the servant of such person, or his or her assigns, who would in such case have been entitled to the service of such child, until such child shall attain the age of twenty-eight years, in the manner, and on the conditions, whereon servants bound, by indenture for four years are or may be retained and holden; and shall be liable to like corrections and punishment, and entitled to like relief, in case he or she be evilly treated by his or her master or mistress, and to like freedom dues and other privileges, as servants bound by indenture for four years are or may be entitled, unless the person, to whom the service of any such child shall belong, shall abandon his or her claim to the same; in which case the Overseers of the Poor of the city, township, or district, respectively, where such child shall be abandoned, shall, by indenture, bind out every child so abandoned, as an apprentice, for a time not exceeding the age herein before limited for the service of such children"

(from *Pennsylvania Law Book*, vol. I, p. 339, as recorded in William Henry Egle, *History of the Counties of Dauphin and Lebanon, in the Commonwealth of Pennsylvania: Biographical and Genealogical* (Philadelphia: Everts & Peck, 1883), p. 50. For a discussion of the complexities of the legislation and its practical realities, see Gary B. Nash and Jean R. Soderlund, *Freedom by Degrees: Emancipation in Pennsylvania and its Aftermath* (New York: Oxford University Press, 1991).

4. Sacco, "Spectacular Masculinities," pp. 50–52, 60.

5. Rembrandt Peale, "The Physiognotrace", *The Crayon* 4 (1857): 307–8.

6. Phoebe Lloyd, "Philadelphia Story," *Art in America* 76 (November 1988): 154–71.

7. Carolyn J. Weekley et al., *Joshua Johnson, Freeman and Early American Portrait Painter* (Williamsburg, Va., The Abby Aldrich Rockefeller Folk Art Center, The Colonial Williamsburg Foundation; Baltimore: The Maryland Historical Society, 1987) provides the most thorough and complete research on Johnson's life and presents a convincing argument for his connection to the Peales.

8. Charles Willson Peale to Raphaelle Peale, 18 July 1803, in *The Selected Papers of Charles Willson Peale and His Family*, ed. Lillian B. Miller (New Haven, Conn.: Yale University Press for the National Portrait Gallery, Smithsonian Institution, 1983), p. 542.

9. Charles Willson Peale to Rembrandt Peale, 11, 18 September 1808, in ibid., p. 1138.

10. Other Peale children expressed whatever anxiety and anger they had regarding their father through different means. Raphaelle rejected the portraiture practice that his father would have had him do in favor of constructing highly personalized still-life paintings. And Titian Ramsay Peale II, the youngest son, made a curious and imaginative drawing of his father's severed head on the last page of a sketchbook (Decapitation, c. 1822, Sketchbook 15c, 29r, American Philosophical Society, Philadelphia). This image, which Kenneth Haltman claims to be an Oedipal projection in which the adult child fantasizes about his father's gruesome death, is eerily similar to a silhouette in its profile orientation and dark cast shadow (Kenneth Haltman, "Titian Ramsey Peale's Specimen Portraiture; or Natural History as Family History," in Miller, *The Peale Family*, p. 191).

 Sacco gives great attention to the role that Williams played in the museum, functioning both as a concessionaire and a racialized display (Sacco, "Spectacular Masculinities," pp. 71–72).

11. Charles Willson Peale, Diary 17, Cape May, N.J., 30 May–12 June 1799, in Miller, *Selected Papers*, p. 241.

12. Ellen Fernandez Sacco, "Racial Theory, Museum Practice: The Colored World of Charles Willson Peale," *Museum Anthropology* 20, no. 2 (1997): 28.

13. Roger B. Stein, "Charles Willson Peale's Expressive Design: The Artist in His Museum," *Prospects: The Annual of American Cultural Studies* 6 (1981), pp. 138–85. This piece is an exhaustive study of Peale's process of creating an emblematic painting with specifically American sources. It offers a detailed look at the methodology behind the creation of the painting and the museum that is represented within its imaginary space.

14. Sacco, "Spectacular Masculinities," pp. 110–12. Adrienne Kaeppler, in "Rembrandt Peale's Hawaiian Ethnographic Still Life," *The Hawaiian Journal of History* 27 (1993): 227–38, noted that the painting "obviously did not depict a Hawaiian." Sacco has deduced that because Williams was the approximate age of the sitter at the time of the painting and since he was already exoticized within the museum he was the most likely candidate.

15. Nell Irvin Painter's *Sojourner Truth: A Life, A Symbol* (New York: W. W. Norton, 1996) contains an excellent discussion of Truth's use of the carte-de-visite as both a source of self-definition and economic self-support; see the chapter "Truth in Photographs."

16. Gary B. Nash, *Forging Freedom: The Formation of Philadelphia's Black Community, 1720–1840* (Cambridge, Mass.: Harvard University Press, 1988), chapter 2.

17. Transcribed in text by Janet Levine in Guy C. McElroy et al., *Facing History: The Black Image in American Art 1710–1940* (San Francisco: Bedford Arts; Washington, D.C.: Corcoran Gallery of Art, 1990), p. 10.

18. Brigham, *Public Culture in the Early Republic*, p. 71.

19. This physiognotrace machine was created in the late 1790s by the English inventor John Isaac Hawkins. They were expensive to make and only a few of them were used in the United States between 1802 and 1840. However the operators of such devices, including Charles Balthazar Julien Févret de Saint-Mémin, who used an earlier version by a French inventor, produced a huge number of images during this time. The Peale family of Philadelphia owned several machines. The one that was operated by Moses Williams under their auspices at the museum was maintained in the Longroom of Independence Hall and was responsible for tracing as many as eight thousand profiles in one year (Charles H. Elam, *The Peale Family: Three Generations of American Artists* [Detroit: Detroit Institute of Arts and Wayne State University Press, 1967], p. 110).

20. A demonstration of this machine at work may been seen during the opening credits of the 1995 film *Jefferson in Paris*.

21. This shift from an individual image to an infinitely reproducible generalization raises many issues about the silhouette's nature as sign. These issues are addressed by Walter Benjamin's seminal essay, "The Work of Art in the Age of Mechanical Reproduction," in his *Illuminations*, ed. Hannah Arendt, trans. Harry Zohn (New York: Schocken Books, 1985).

22. Brigham, *Public Culture in the Early Republic*, p. 70.

23. Charles Willson Peale to John Isaac Hawkins, 17, 22, 25 December 1805, in Miller, *Selected Papers*, p. 916.

24. Henry Louis Gates, Jr., *The Signifying Monkey: A Theory of African American Literary Criticism* (Oxford: Oxford University Press, 1988), p. XXIII.

25. Frank Colliger, "Peale's Philadelphia Museum, & c." *Philadelphia Daily News*, undated clipping in Poulson's Scrapbook of Philadelphia History, 8:18–24. Collection of the Library Company of Philadelphia.

26. Sacco, "Spectacular Masculinities," p. 51.

27. Henry Louis Gates, Jr., *The Slave's Narrative* (Oxford: Oxford University Press, 1985), xxvi–xxxi.

Portraits of a People
Gwendolyn DuBois Shaw and Emily K. Shubert

Attributed to SCIPIO MOORHEAD
(LIVED IN BOSTON C. 1750)

Phillis Wheatley, Negro Servant to
Mr. John Wheatley, of Boston,
frontispiece to *Poems on Various Subjects,*
Religious and Moral, PUBLISHED 1773

Engraving
5 1/16 x 4 IN. (12.9 x 10.2 CM)
Special Collections, Margaret Clapp Library,
Wellesley College

These three images of the African-born Phillis Wheatley on pages 59–61 demonstrate various media in which the celebrated enslaved poet was shown during and after her lifetime. An original painting or drawing, on which the frontispiece portrait was based, would have been made sometime in the spring of 1773 by an artist in either Boston or London. The portrait was engraved and added to the first edition of the publication of Wheatley's book *Poems on Various Subjects, Religious and Moral* (see the essay "On deathless glories fix thine ardent view"). It shows Wheatley deep in thought, her gaze directed upward and inward, as if she is searching for the next words to complete the poem that stands in progress on the writing table before her. While it has often been attributed to another enslaved African American living in Boston, Scipio Moorhead, there is little concrete evidence to support this attribution.

The black-and-white, cut-paper silhouette of Wheatley that is now in the collection of the American Antiquarian Society is a curious object for, if it indeed represents Wheatley and is also by William King, it could not have been taken from the sitter during her lifetime. King is known to have been active between 1804 and 1806, some twenty years after Wheatley's death in 1784. A newspaper clipping advertising the skills of William King is affixed to the album page alongside the silhouette of Wheatley and three other sitters; one is identified simply as "N.E. Phinch" and the other two are unknown. The silhouette itself, with its contrasting use of a hollow-cut facial profile against a black backing accented by white clothing and accessories, is of a style that was popular in the 1820s, making it unlikely that the image was made

by King. It is interesting to note, however, that the original owners of the silhouette were keen to identify it as Wheatley. Other than the costume of the white sash and bonnet that resemble those worn by Wheatley in her book's frontispiece portrait, there is little in the image itself that would make one think that it represented the African American author. That this desire to connect the image to Wheatley was present in the middle of the nineteenth century, nearly a half century after she first rose to prominence in the public sphere of New England, speaks to her enduring fame and may be related to the republication of her book of poems in 1834, 1835, and 1838.

The final image here of Wheatley, a lithograph published by the French firm of Lemercier, is an imaginary rendering of the poet, whose strict religious upbringing and puritanical owners would never have allowed her to be depicted without her head and bust covered. Rather, the image is of a dark-skinned woman with close-cropped hair and round breasts that echo the puffed sleeves of her fashionably low-cut dress. She is shown gazing directly into the eyes of the viewer, her ears pierced and with dangling earrings, and a rope of pearls around her neck. She is an elegant, worldly woman, but in her cosmopolitan presentation she reveals herself to be a French fantasy of her real-life counterpart.

GDS

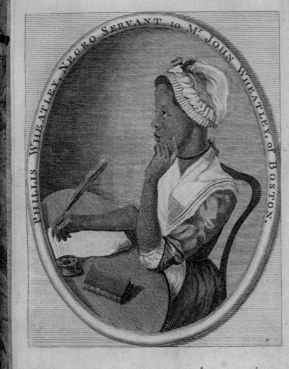

PHILLIS WHEATLEY, NEGRO SERVANT to M.ʳ JOHN WHEATLEY, of BOSTON.

Published according to Act of Parliament, Sept.ʳ 1, 1773 by Arch.ᵈ Bell,
Bookseller N.º 8 near the Saracens Head Aldgate.

POEMS

ON

VARIOUS SUBJECTS,

RELIGIOUS AND MORAL.

BY

PHILLIS WHEATLEY,

NEGRO SERVANT to Mr. JOHN WHEATLEY,
of BOSTON, in NEW ENGLAND.

LONDON:

Printed for A. BELL, Bookseller, Aldgate; and sold by
Meſsrs. COX and BERRY, King-Street, *BOSTON.*

M DCC LXXIII.

WILLIAM KING
(ACTIVE C. 1792–1804)

BERNARD LEMERCIER Impremerie
Lithographs and Co., Paris

*Tentatively identified as a depiction of
Phillis Wheatley*, C. 1820
Silhouette, cut paper
5 X 4 IN. (12.7 X 10.2 CM)
American Antiquarian Society, Worcester,
Massachusetts

Phyllis Wheatley from *Revue des Colonies*,
BETWEEN 1834 AND 1842
Lithograph
9 1/8 x 5 3/4 IN. (23.2 X 14.6 CM)
Photographs and Prints Division, Schomburg Center
for Research in Black Culture, New York York
Public Library, Astor, Lenox, and Tilden Foundation

Benjamin Banneker
(1731–1806)

Benjamin Banneker, frontispiece to
Benjamin Bannaker's Pennsylvania,
Delaware, Maryland, and Virginia Almanac,
for the Year of Our Lord 1795;
Being the Third after Leap-Year,
PUBLISHED 1795

Book
6 7/8 x 4 5/16 IN. (17.5 X 11 CM)
The Maryland Historical Society, Baltimore

In the face of oppressive and stereotyping imagery designed to curtail any freedoms that African Americans might attempt to take for themselves, book frontispieces of the late eighteenth and early nineteenth centuries often reveal the struggle of literate African Americans to find a place in a public culture that only saw them as nameless chattel unworthy of individualized representation. The frontispiece of *Benjamin Bannaker's Pennsylvania, Delaware, Maryland, and Virginia Almanac, for the Year of Our Lord 1795...* is graced with a portrait of the author that shows him as a serious, inward-looking young man. His image is created by a collection of competing linear textures: the tight curlicues of his hair, the dark cross-hatching on his face, and the parallel striping of his simple Quaker waistcoat and jacket create different forms out of myriad black lines. He is framed within a roundel that is placed just beneath the title on the first page of the book, and with a scroll across the bottom that reads "BANNAKER," resolving any possible question about who might be the author of the volume.

A surveyor and a mathematician, Banneker published six annual almanacs between 1792 and 1797. The first edition from 1792 did not include a frontispiece, and it would seem that the decision to include an image of the author was due to his increasing fame. Little used today, almanacs were found in many colonial households and contained important scientific information about the cycles of the moon and other celestial bodies, tide tables, and the optimum dates for planting and harvesting crops. Unlike many other producers of almanacs, Banneker added a variety of other, nonscientific materials in his volumes, including literature and commentaries. In the 1793 edition he included poetry by the African-born Phillis Wheatley and his own correspondence with Thomas Jefferson in which he challenged the future president's negative statements on the intelligence and creative capabilities of Africans and African Americans.

GDS

Benjamin Bannaker's
PENNSYLVANIA, DELAWARE, MARY-
LAND, AND VIRGINIA
ALMANAC,
FOR THE
YEAR of our LORD 1795;
Being the Third after Leap-Year.

BANNAKER.

—PRINTED FOR—
And Sold by JOHN FISHER, *Stationer.*
BALTIMORE.

John Blennerhassett Martin
(1797–1857)

Engraving of the Marquis de Lafayette's original certificate of November 21, 1784, commending James Armistead Lafayette for his service during the Revolutionary War, with portrait, c. 1824

Engraving
8 3/4 x 6 3/4 in. (22.2 x 17.2 cm)
Virginia Historical Society, Richmond

James Armistead Lafayette, c. 1824

Oil on canvas
28 7/16 x 23 in. (72.2 x 58.4 cm)
The Valentine History Center, Richmond, Virginia

James Armistead (c. 1759–1830), an enslaved African American from Virginia, enlisted in the Continental Army in 1781, perhaps at the behest of and certainly with the permission of his owner, William Armistead. Rather than joining a black regiment such as those organized in Rhode Island or Boston, Armistead became an orderly attached to the Marquis de Lafayette. Following the war, Armistead was lauded for having been a faithful servant and excellent spy; he was instrumental in deceiving Lord Cornwallis, a ploy leading directly to the British general's surrender at Yorktown. Lafayette wrote a testimonial for his servant:

> This is to testify that the bearer by the name of James has done essential services to me while I had the honour to command in this state. His intelligence from the enemy's camp were industriously collected and more faithfully delivered. He perfectly acquitted himself with some important commissions I gave him and appears to me entitled to every reward his situation can admit of. Done under my hand, Richmond November 21st, 1781. Lafayette[1]

Moved by this statement, the General Assembly of Virginia bought James from his owner and emancipated him. From that time on, James Armistead would go by the name James Armistead Lafayette out of respect for his former commander. In 1818, free but unable to support himself, James petitioned the state for relief and was granted a veteran's pension for his service during the Revolutionary War.

On the occasion of Lafayette's visit to Richmond in 1824, James met the marquis once again and under his auspices had his formal portrait painted by John B. Martin. Wearing a white neck-cloth and blue military coat, James Armistead Lafayette appears without decoration save his bright buttons embossed with an American eagle. Depicted late in life, with graying hair and a wrinkled face, his forehead and cheeks marked by deep creases, the ex-slave and former spy appears still proud and dignified in his defining role as a soldier.

The engraved portrait of James Armistead Lafayette is accompanied by a facsimile transcription of the Marquis de Lafayette's original commendation. In comparison to the oil painting, greater attention is given to the details and folds of his neck-cloth, and the furrows about his cheeks and forehead seem even further exaggerated; as the engraving is black and white, the blue of his army coat is lost. Rather than a picture of a man, we are presented with a narrative portrait of Armistead Lafayette that is more documentation than work of art.

The purpose of reproducing the portrait and certificate seems to have been didactic in nature. Engravings of James Armistead Lafayette's image and story could be widely and cheaply distributed, thereby providing an educational tool, an example of the potential for African American accomplishment that was steeped in both patriotic loyalty and honor.

EKS

1. Lisa W. Strick, *The Black Presence in the Era of the American Revolution, 1770–1800* (Washington, D.C.: Education Department, National Portrait Gallery, Smithsonian Institution, 1973), p. 25.

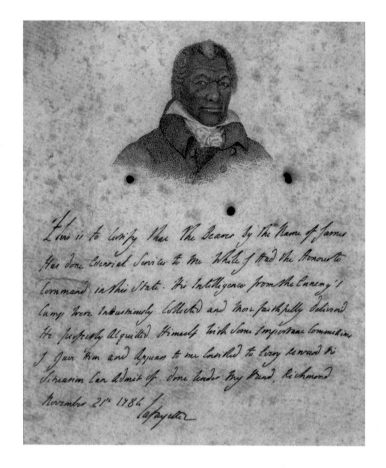

This is to certify that the Bearer by the Name of James Has done Essential Service to Me While I Had the Honour to Command in this State. His Intelligence from the Enemy's Camp were Industriously Collected and more faithfully Delivered. He perfectly Acquitted Himself with Some Important Commissions I gave him and Appears to me Entitled to Every Reward his Situation Can Admit of. Done Under My Hand, Richmond November 21st 1784.

Lafayette

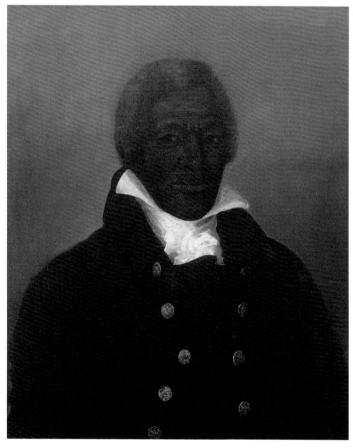

CHARLES WILLSON PEALE
(1741–1827)

Silhouette of Paul Cuffee, 1811

Paper
3 3/4 x 3 1/16 IN. (9.5 x 7.8 CM)
The Historical Society of Pennsylvania

Paul Cuffee (c. 1759–1817), the son of a Native American woman and a free African American man, grew up in his native Massachusetts. He was raised in the Quaker faith and soon developed a love for the sea. At the age of sixteen, he began a distinguished career as a marine merchant, with his first whaling voyage to the Gulf of Mexico. Eventually he would become captain of a fleet and employ countless crews of free African American men on his ships. In 1780, Cuffee along with six other freemen wrote a protest to the legislature in Boston complaining of taxation without representation. Even as freed men they were unable to vote or "enjoy the profits of their labors"[1] though they paid taxes and had fought for their country in the Revolutionary War.

A driving force behind the first black-led back-to-Africa movement, Cuffee would command several trips to Sierra Leone, during which he scouted possibilities for colonization, met with local leaders, and distributed religious literature. Although it would be several years before the American Colonization Society would help to establish Liberia, Cuffee strongly believed that the future for African Americans lay in a return to Africa, and because of this he passionately fought popular public opinion against it. He sought support for the African colonization cause, speaking with Quakers and others in the Philadelphia community, where he spent much of his career as a merchant.

It may have been during one of these visits to Philadelphia that the prominent captain had his silhouette made. This simple cut-paper profile of Cuffee shows a heavy-set man with a prominent, hooked nose. The artist included the detail of an eyelash in the profile, and the subtle wave in the form line of his hair alludes to the sitter's race. On the verso of this image are handwritten notes identifying the sitter as Paul Cuffee with an annotation of "1811 Received from London." The silhouette is in the style of Charles Willson Peale and it may have been made by him in his Philadelphia museum, or by the freedman Moses Williams, who worked for nearly twenty years in Peale's Museum cutting profile silhouettes. That the note on the back indicates that a former owner received the silhouette from London suggests that this it was a valued token that traveled abroad with Cuffee, or someone else who knew him, and that it returned to United States later as some sort of token of affection and remembrance. Because cut-paper profile silhouettes were cheap to make, costing less than ten cents in most cases, they were frequently exchanged and often traveled with their owners as reminders of relatives left behind.

EKS and GDS

1. Herb Boyd, ed., *Autobiography of a People: Three Centuries of African American History Told by Those Who Lived It* (New York: Doubleday, 2000), pp. 34–35.

Attributed to RAPHAELLE PEALE
(1774–1825)

Moses Williams, Cutter of Profiles, AFTER 1802

Hollow-cut profile
3 3/8 x 3 1/4 IN. (8.57 x 8.26 CM)
The Library Company of Philadelphia

See discussion in the essay "Moses Williams, Cutter
of Profiles," pp. 44–56.

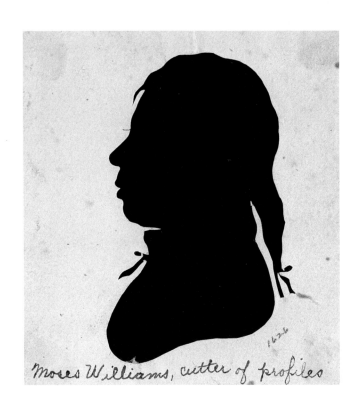

Moses Williams, cutter of profiles

Moses Williams
(1777–c. 1825)

Mr. Shaw's Blackman, AFTER 1802

Hollow-cut profile
4 15/16 x 3 7/8 IN. (12.5 x 9.8 CM)
The Library Company of Philadelphia

See discussion in the essay "Moses Williams, Cutter of Profiles," pp. 44–56.

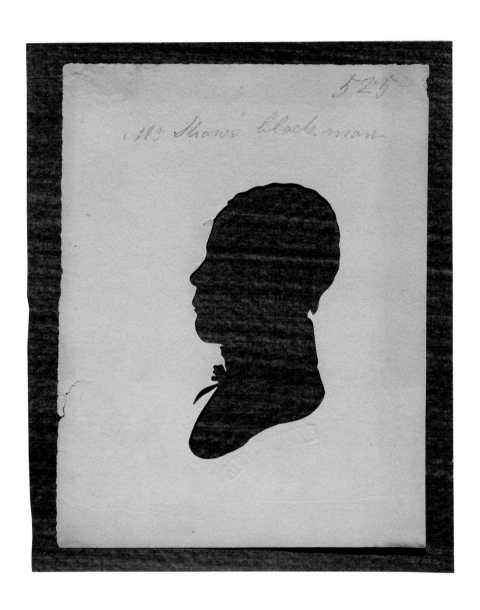

Gilbert Charles Stuart
(1755–1828)

Presumed Portrait of George Washington's Cook, N.D.

Oil on linen
29 15/16 x 25 in. (76 x 63.5 cm)
Museo Thyssen-Bornemisza, Madrid

The painting that has long been believed to be a portrait of George Washington's cook, Hercules, is of a sitter whose actual identity remains uncertain among scholars. It has traditionally been attributed to Gilbert Stuart, who was working in Philadelphia between 1794 and 1803, when Washington was in residence there and when an enslaved man named Hercules was serving as his cook. In 1795, 1796, and 1797, Washington sat for Stuart several times (including for the famed "Atheneum" and "Landsdowne" portraits), so it is likely that the painter would have encountered the enslaved members of the Washington household. The uniform that the man wears, a chef's coat and hat, indicate his role in the household. The bright white of the uniform sets him off against the black background from which his warm, brown face emerges. Yet, the uniform and the connection to Washington serve to obscure his personal identity beneath an appellation that creates an identity for him through the name of his owner and the duty for which he was trained. Despite this, the slight smile that raises the corners of his mouth, coupled with his direct gaze, hint at the individual within.

Hercules was one of a small group of African Americans that were enslaved by George Washington. The majority of those who lived at Washington's plantation on the Potomac River in northern Virginia, Mount Vernon, were owned by his wife, Martha Dandridge Custis Washington, who had inherited them from her first husband, John Parke Custis. Hercules served at Mount Vernon during the 1780s, when he was noted by Tobias Lear, Washington's chief presidential secretary, as being a proud and intelligent man whose skills as a cook could aid his

self-sufficiency if he were to ever leave slavery of his own accord. Lear's observations about his abilities and his probable desire for freedom were tested in 1790 when Hercules, who had been serving as cook at the presidential house in Philadelphia, was summoned to Mount Vernon. At the time, Pennsylvania law declared free any slave who resided in the state for more than six months, which Hercules had done. Because Hercules was now legally free in Pennsylvania it may seem odd that he decided to follow Washington's orders and voluntarily return to the slave-holding state. However, Hercules was biding his time, correctly anticipating that the return to Mount Vernon was temporary and that he would soon be sent back to Philadelphia. In 1797, at the end of Washington's eighth and final year as president and before he returned to private life and retired permanently to Virginia, Hercules disappeared from the President's Philadelphia house and was never seen again.

The picture today simply called *The Flutist* (see p. 75) was once attributed to the Rhode Island–born painter Gilbert Stuart. The sitter, identified by some scholars as Barillai Law, a veteran of the American Revolution, is shown holding a flute in his right hand and clutching a folio of sheet music in his left. His body fills the right side of the canvas, his brown face with its softly curling black hair atop a white cravat and red-collared coat. He stares out at the viewer with a serious, arresting gaze that bespeaks his musical skill and personal intensity.

continues on page 74

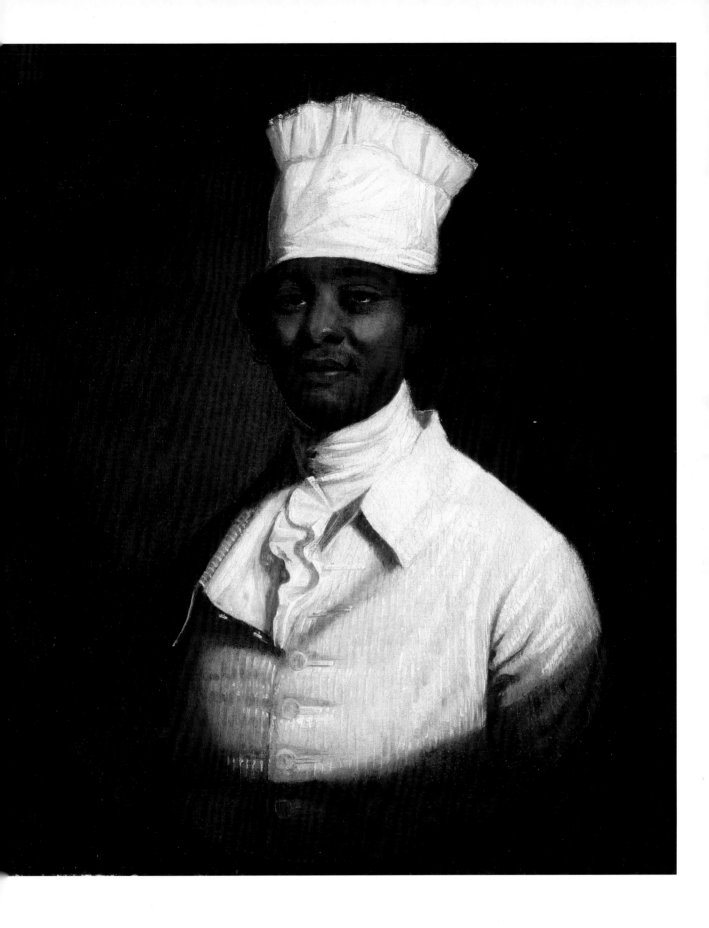

UNKNOWN

The Flutist, 1810

Oil on canvas
35 x 28 in. (88.9 x 71.1 cm)
Diplomatic Reception Rooms,
U.S. Department of State, Washington, D.C.

That both paintings were at one time attributed to Stuart is probably the result of his fame as a portrait painter during the late eighteenth and early nineteenth centuries. And while there are no firmly attributed portraits of African American sitters by Stuart with which to compare the coloring of the skin or the treatment of the physiognomy, an interesting story from Reverend Edward Peterson's *History of Rhode Island* (1853) asserts that Gilbert Stuart "derived his first impression of drawing from witnessing Neptune Thurston, a slave who was employed in his master's cooper shop, sketch likenesses on the heads of casks," indicating the painter's childhood interest in the observation of African Americans and their creative abilities.

GDS

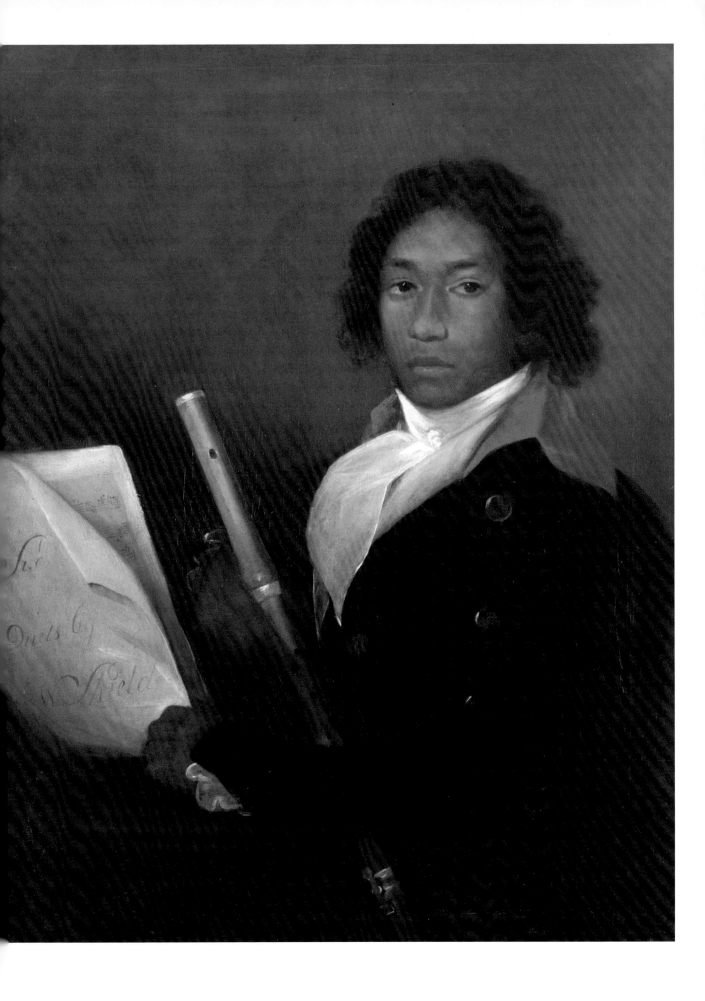

Rembrandt Peale
(1778–1860)

Man in a Feathered Helmet, c. 1805–13

Oil on canvas
30 1/4 x 25 1/4 in. (76.8 x 64.1 cm)
Bishop Museum, Honolulu, Hawai'i

See discussion in the essay "Moses Williams, Cutter of Profiles," pp. 44–56.

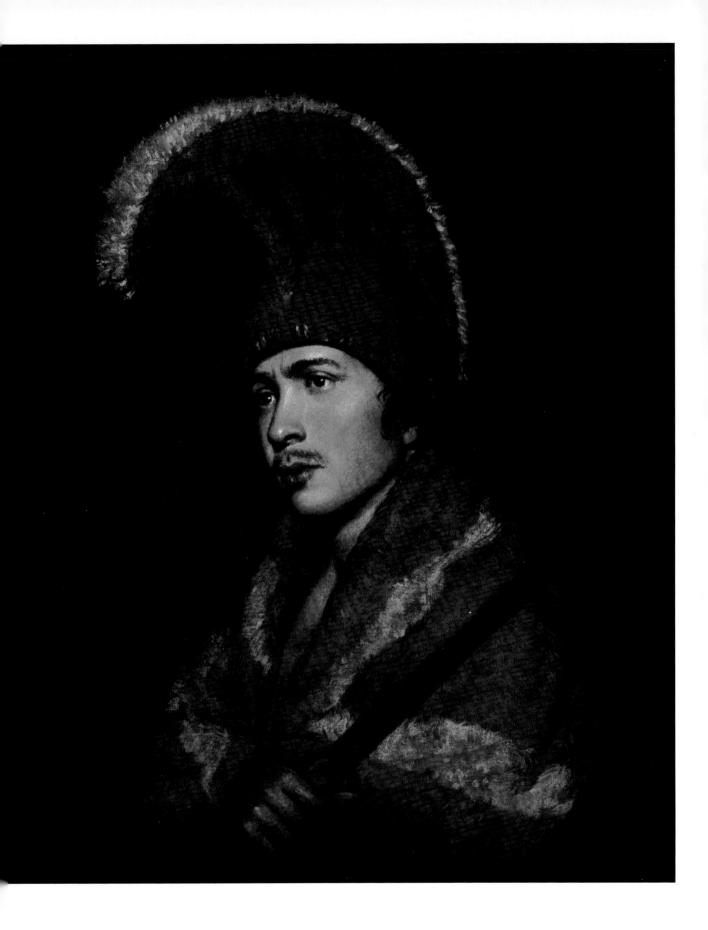

CHARLES WILLSON PEALE
(1741–1827)

Yarrow Mamout, 1819

Oil on canvas
24 x 20 IN. (61 x 50.8 CM)
Atwater Kent Museum of Philadelphia,
The Historical Society of Pennsylvania Collection,
Gift of Charles S. Ogden

I heard of a Negro who is living in Georgetown said to be 140 years of age.... He is comfortable in his Situation having Bank stock and lives in his own house.... I propose to make a portrait of him should I have the opportunity.
 —Charles Willson Peale[1]

Charles Willson Peale's portrait of Yarrow Mamout was painted over the course of two days in 1818 while Peale was visiting the nation's new capital in Washington, D.C., to record the likenesses of various prominent politicians. At that time Mamout was a local character living in Georgetown who was best known for his exceptional longevity—he told Peale that he was 133 years-old—and for being a practicing Muslim. Placed against a dark background, the elderly Mamout wears a striped knit cap, a blue jacket—disconcertingly one wing of its collar juts up and the other one down—and a heavy, ill-fitting brown coat. A white shirt collar and a bit of red cloth that suggests a scarf or vest peek out from beneath his slightly pointed chin. The cap is pushed back on his forehead, which in turn catches the light to reveal a receding hairline bordered by two tufts of white hair. Mamout's ears are large and his cheeks a bit sunken, both marks of his longevity, while his steady gaze attests to a full command of his faculties. The plethora of clothing possibly alludes to Mamout's exceptional ability as a manumitted person to sustain himself—not all formerly enslaved people were able to feed and clothe themselves or to obtain shelter, let alone own land, as he had done.

Mamout, probably an Anglicized version of one of the Muslim names Mahmoud or Mohammed, was probably born in Guinea in the early 1700s. Enslaved while still a teenager, he was transported across the Atlantic and sold in Montgomery County, Maryland, to Samuel Beall in 1728. Beall later willed Mamout to his son, Brooke, who retained him until his own death. In 1792, a few years prior to his demise, Brooke Beall promised to grant Mamout his freedom upon the completion of a house that he was constructing. Unfortunately, Beall died before the construction was concluded, but his widow, Margaret, eventually made good on her late husband's promise and freed Mamout in 1797. Despite the seeming magnanimity of this gesture, it is important to note that Mamout was at least in his eighties when he was freed and, having no other resources, was compelled to continue to work as a hauler for his livelihood. Providentially, his business succeeded and, after two failed ventures entrusting his savings to local businessmen, he was able to purchase property and became one of the first stockholders in Columbia Bank, the second chartered bank in the United States.

The image of Mamout probably was placed in Peale's Museum in Philadelphia along with the other portraits made during his 1818 visit to Washington, D.C. If the painting was installed in the galleries, it may have been used to illustrate extreme longevity—fifteen years later P.T. Barnum would continue this effort to tap the popular fascination with black centenarians when he exhibited an elderly African American woman, Joice Heth, and advertised her as the 161-year-old nurse of George Washington. It may have also been used to represent racial difference; art historian David Steinberg has noted that the awry collar of Mamout's blue jacket serves to mark him as unable to control his personal appearance, thereby "marginalizing him relative to social conventions, and by extension, to full participation in the social order."[2] In addition, Mamout's uncommon adherence to Islam surely made him an interesting subject for Peale to exhibit. At that time there were only a small number of enslaved and formerly enslaved African Americans who practiced the Muslim faith; among them Omar Ibn Said, who in 1831 published an autobiography chronicling his years of enslavement in Charleston, South Carolina. All of these factors combined to make Mamout an interesting subject to Peale, whose curiosity extended from the arts, to the natural sciences, to politics.

GDS

1. Lillian B. Miller et al., eds., *The Selected Papers of Charles Willson Peale and his Family*, Vol. 3, *The Belfield Farm Years, 1810–1820* (New Haven, Conn.: Yale University Press, 1991), p. 650.

2. David Steinberg, "Charles Willson Peale Portrays the Body Politic," in *The Peale Family: Creation of a Legacy, 1770–1870*, ed. Lillian B. Miller (New York: Abbeville Press in association with the Trust for Museum Exhibitions, and the National Portrait Gallery, Smithsonian Institution, 1996), p. 132.

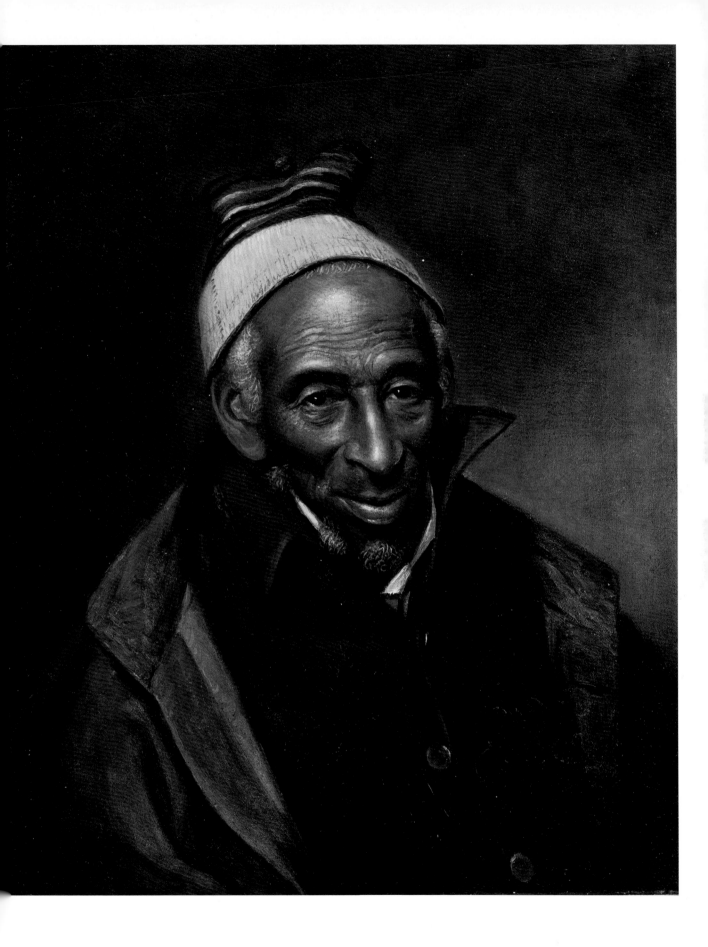

JEREMIAH PEARSON HARDY
(1800–1887)

Abraham Hanson, c. 1828

Oil on canvas
24 1/2 x 21 9/16 in. (62.2 x 54.8 cm)
Addison Gallery of American Art, Phillips Academy,
museum purchase

There is a casual, almost unfinished quality to this portrait of Abraham Hanson, a barber working in Bangor, Maine, during the 1820s and '30s.[1] Loose brushwork dominates, virtually no background is depicted, and the subject is relaxed both in posture and facial expression. Hanson cocks his head, his gaze meeting that of the viewer and creating an intimate connection. The background, a purplish mass of clouds, hints at a sunset; but beyond a suggestion of a horizon line, there is not a defined scene or context for the subject.

The warmth of Hanson's expression conveys a personality supported by accounts from the *Annals of Bangor* of 1882, where Judge John E. Godfrey recollects that Hanson "possessed much humor...and, as he afforded amusement to his customers, he was well patronized, and deemed worthy to have his portrait painted by Hardy."[2] The smile and informal nature of the portrait echo the "humor" for which Hanson apparently was known by his predominantly white clientele. Furthermore, they speak to an easy relationship between artist and subject, an assumption supported by Hanson's profession as a barber and his role as a well-regarded member of Bangor's African American community.

Jeremiah Pearson Hardy, originally from New Hampshire, spent the majority of his life painting in central Maine. An accomplished draftsman from a young age, Hardy studied with Samuel F.B. Morse in New York, and briefly operated a studio in Boston before returning to Bangor in 1825. In addition to painting miniatures and full portraits for private clients, Hardy was commissioned by local public and professional figures as well as several members of the Penobscot Nation, Native Americans still present in and around Bangor.[3]

EKS

1. William B. Miller, *Maine and its Artists, 1710–1963: An Exhibition in Celebration of the Sesquicentennial of Colby College, 1813–1963* (Waterville, Maine: Colby College Art Museum, 1963), p. 14.

2. Elizabeth F. Wilder, ed., *Maine and Its Role in American Art* (New York: Viking Press, 1963), p. 74; and John Edwards Godfrey, "Annals of Bangor," in *History of Penobscot County* (Cleveland, Ohio: Williams, Chase, 1882), p. 622.

3. Bangor Historical Society, *Jeremiah Pearson Hardy: Portrait of a Community* (Bangor, Maine: Bangor Historical Society, 1999).

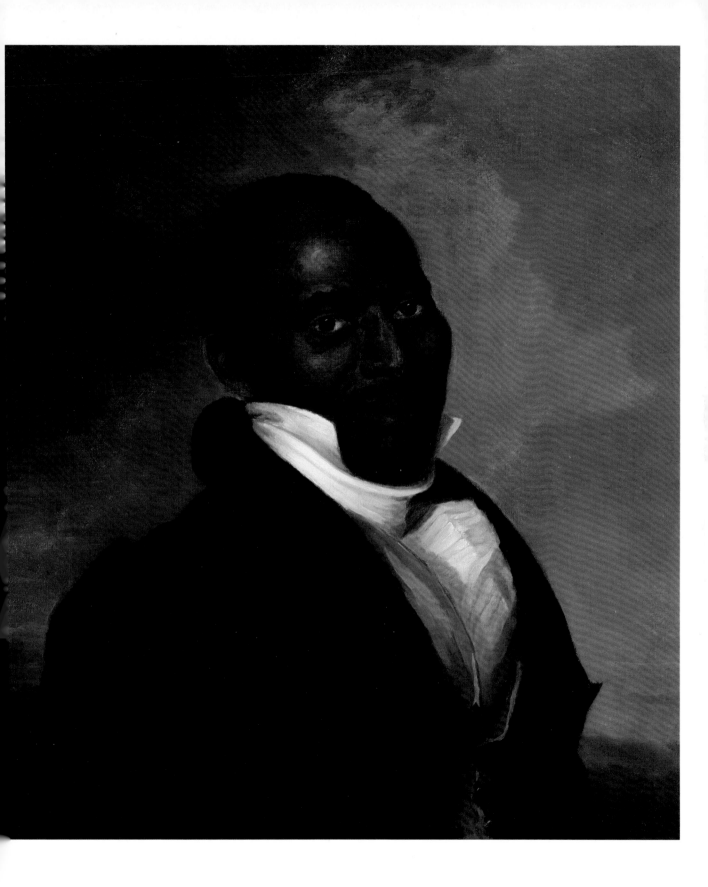

WILLIAM P. CODMAN
(1798–1831)

Portrait of John Moore, Jr., 1826

Oil on canvas
26 x 21 3/4 IN. (66 x 55.3 CM)
American Antiquarian Society, Gift of
Martha Jane Brown, Bernice Brown Goldsberry,
John J. Goldsberry, Jr., 1974

John Moore, Jr., was born in 1799 to free African American parents in Boston. In 1827, Moore listed his occupation in the "People of Color" section of the Boston City Directory as a "barber," a popular career choice for members of the free black community. This image of John Moore, Jr., depicts him as a young, relatively affluent man who is comfortable in his status. Seated on an ornate painted chair, Moore turns slightly, his left arm draped casually over the back of the chair. He is elegantly dressed, and his crisp white shirt is accented with a jeweled stickpin, contrasting his dark coat and gold buttons. With stylish, long sideburns, fashionable clothing, and an overall air of prosperity, Moore is portrayed as a respectable member of society. Although there is no visible indicator of Moore's profession, he appears successful and self-confident in this portrait. Barbers and hairdressers were classified as skilled laborers, and the work provided a unique opportunity for crossing the color line well into the twentieth century. Freemen such as Moore, Abraham Hanson, and Edward Mitchell Bannister worked intimately with customers from diverse racial and economic backgrounds, many times in their clients' homes. Although in the early nineteenth century less than one-third of Boston's two thousand African Americans were skilled, entrepreneurial, or professional workers, a category that included barbers,[1] those who were constituted an influential black bourgeoisie. Barbering was one of a small number of available yet respectable careers that provided a high level of autonomy and helped to build a middle class of skilled businessman and admired community leaders.

William Codman is listed in the directories as an artist active from 1820 to 1831.[2] Codman advertised himself in various newspapers around New England as a portrait and landscape painter available for hire.[3] While no records of this portrait's commission have been located, it is reasonable to assume that as a successful barber Moore may have hired Codman to paint his portrait. That the painting was a valuable possession for the Moore family is demonstrated by the fact that it remained in the possession of his descendents for a century and a half, until it was given to the American Antiquarian Society in 1975.[4]

EKS

1. "Black Occupations and Social Stratification in Nineteenth Century Boston," on Boston African American National Historic Site, National Park Service, 2003, <www.nps.gov/boaf/occupations.htm> (7 February 2005).

2. Karen M. Jones, "Museum Accessions," *Antiques* 108 (September 1975): 342.

3. Codman's advertisements for "portrait, landscapes and fancy paintings" appear in several newspapers in Maine, Massachusetts, and New Hampshire from 1819–31, including *New Hampshire Patriot*, 4 October 1819; and *Portland (Maine) Advertiser*, 26 May 1824.

4. Genealogical Record, Brown Family Papers 1762–1965, American Antiquarian Society Manuscript Collection.

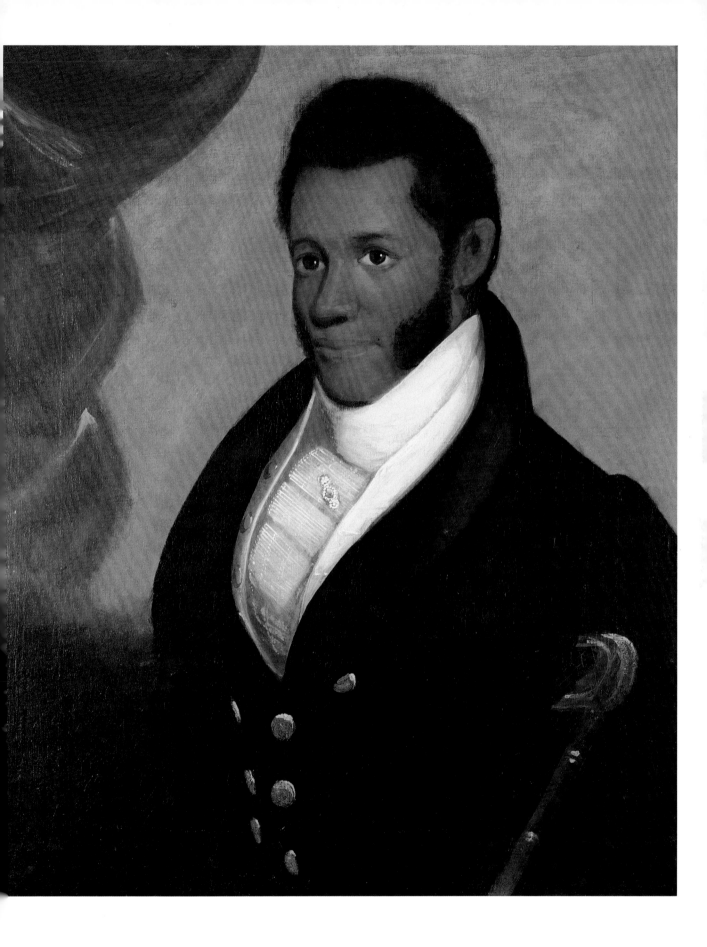

Jules Lion
(1816–1866)

Ashur Moses Nathan and Son, 1845

Pastel on paper
36 x 26 in. (91.4 x 66 cm)
Ann and Jack Brittain and children

The double portrait of Ashur Moses Nathan and his son by Jules Lion and the self-portrait of Julien Hudson (see page 87) are images which speak to the complexities of family relationships and racial identification in Louisiana of the 1830s and '40s. Both Hudson and Lion were *gens du couleur*, or free people of color, living in New Orleans. Hudson's mother was mixed-race of African and French descent, and his father was an English merchant. Little is known about his life, but it is believed that he received some training in portrait painting from the Italian-born miniaturist Anthony Meucci, who worked in New Orleans during the 1820s. Slightly more is known about Lion, who was born in France and moved to New Orleans in 1837. Lion began his career as a lithographer and a portrait painter, and he is credited with being the first artist to exhibit daguerreotypes in New Orleans, in 1840; he eventually taught art through an academy that he organized himself with another colleague at the College of New Orleans.

Jules Lion's double portrait made around 1845 of the wealthy Jewish merchant Ashur Moses Nathan and his mixed-race son, who has been tentatively identified as Lion's own stepson, Achile Lion, highlights the intricacy of paternity under a legal system that did not allow legal marriages between whites and blacks. As art historian Judith Wilson has noted, Nathan willed the bulk of his estate to Achile Lion, whom he had adopted in 1859.[1] From this record and others, it would appear that Jules Lion had married Achile's mother and raised a child she had with Nathan as his own until Nathan chose to legally adopt the youth in order to make him his legal heir. In the portrait the taller, darker-skinned son is placed just behind his biological father, his right arm wrapping around the older man's shoulders while their left hands are clasped in front, forming a bond across generations and a racial designation. The two figures echo each other in their dress, hair, and expression, further asserting their familial relationship. Wilson suggests that it is possible that, through the tender act of commemorating the relationship between Nathan and Achile, in this portrait Lion alludes to his own mixed-race heritage and at the same he helps validate his stepson's true paternity and record the affectionate relationship between the white father and his brown son.

A racially complicated heritage is also at the root of Julien Hudson's self-portrait made in 1839. Here the artist presents himself as a handsome young man; he would have been twenty-eight or twenty-nine at the time. He wears a dark coat over a white shirt and a delicately patterned vest. A black scarf is tied at his neck, above which rise thick sideburns. His face is dominated by a prominent nose and small yet full lips whose rosy color is echoed in his cheeks. Hudson's piercing eyes, which connect directly with the viewer, are a bluish grey color that is picked up in the subtly gradated background, and yet he remains remote, retaining the dignity of a gentleman who is seen on his own terms. As Hudson's image contains no overt physiognomic characteristics that may be read as stereotypically African, for many viewers the image is hard to read as representing a mixed-race person. However, this was how the artist was publicly known in his community. In antebellum New Orleans

continues on page 86

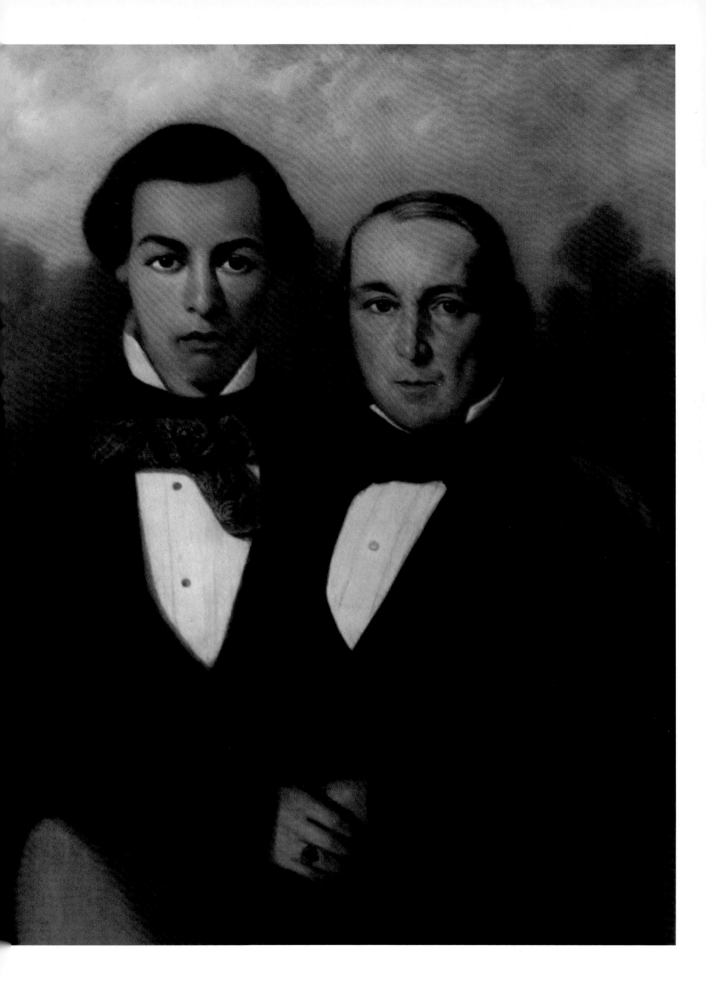

Julien Hudson
(1811–1844)

Self-Portrait, 1839

Oil on canvas
8 3/4 x 7 IN. (22.2 x 17.8 CM)
Louisiana State Museum, New Orleans

laws designated individuals with as little as one-sixteenth African ancestry as *gens du coleur*. However, the artist may have chosen to underscore his white heritage in the almost grotesque over-pronouncement of an exceedingly narrow nose and reduction of the lips to a full yet childish pout. In these exaggerated features there is perhaps an unconscious indication of the artist's own anxiety over the physical markers in his face of an ambiguous racial designation.

GDS

1. Judith Wilson, "Optical Illusions: Images of Miscegenation in Nineteenth- and Twentieth- Century American Art," *American Art* 5, no. 3 (Summer 1991): 91.

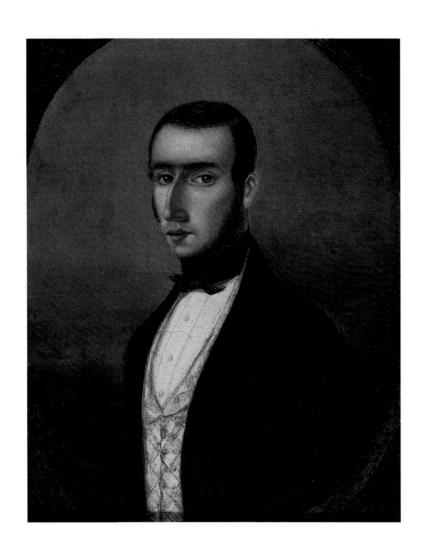

Published by JOHN DAINTY
(ACTIVE PHILADELPHIA, EARLY 19TH CENTURY)

*Rev. Richard Allen. Founder of
the African Methodist Episcopal Church,
in the United States of America 1779, 1813*

Stipple engraving (leaf from book)
11 3/8 x 8 1/4 IN. (28.9 x 21 CM)
The Library Company of Philadelphia

This engraving shows the Reverend Richard Allen, the founding bishop of the African Methodist Episcopal Church. As a well-respected man of the cloth, Allen was an important role model, and as one of the founders of the African Methodist Episcopal Church, his image was reproduced a number of times by a variety of artists. Here, he is pictured in a standard portrait with a simple background, complete with a half-drawn curtain.

Seated with a pillow on his lap, Allen stares out at the viewer. There is a sense of concern in the rendering of Allen's face that speaks to his role in the community and his responsibility as a church elder. Holding a book, most probably the Bible, he points to one page while his other hand grasps the binding. With this gesture and serious gaze, Allen visibly communicates the importance of what he reads; stern and pleading, he demands our attention and entreats the viewer to respond.

At the top of the sheet, handwritten notes, perhaps added by a previous owner, elaborate on Allen's story:

> The curiosity of the Portrait below is, that it was made for the *First Black Bishop* in the U. States & perhaps in the world! He is indeed a self created Bishop; nevertheless, as such he has now, in his 65 years, in 1824, probably created 100 ministers, by *his* ordination! He was born & bred in Philad[a]. He was originally a slave of Benj[n] Chew's Esq[re] & learn[d] the trade of a Shoemaker; & like St. Paul, 'labored with his own hands,' while he ordained–

As an illustration in John Fanning Watson's *Extra-illustrated autograph manuscript of Annals of Philadelphia* (p. 276), this image would have served as an introduction and a visual reference for the entry that followed. Yet the anonymous writer did not find that to be sufficient and chose to extol Allen's influences and good work, adding a written narrative to complement the visual and to precede the text.

EKS

"The curiosity of the Portrait below is, that it was made for the first Black Bishop in the UStates, & perhaps in the world! He is indeed a self created Bishop; nevertheless, as such he has now, in his 65 year, in 1824, probably created 100 ministers, by his ordination! He was born & bred in Philad? He was originally a Slave of Benjn Chew's Esqr & learnt the trade of a Shoemaker; & like St Paul, "laboured with his own hands" while he ordained—

Rev. Richard Allen,

FOUNDER of the AFRICAN METHODIST EPISCOPAL CHURCH,

in the UNITED STATES of AMERICA, 1779.

Phila.Pub. by J.Dainty 1813.

P.S. Duval & Co.
Lithographers, Philadelphia

Rev. Richard Allen, Bishop of the First African Methodist Episcopal Church, c. 1820s–1830s

Lithograph
11 1/2 x 8 1/4 in. (29.2 x 21 cm)
Photographs and Prints Division, Schomburg Center
for Research in Black Culture, The New York
Public Library, Astor, Lenox, and Tilden Foundation

In this lithograph portrait the Reverend Richard Allen (1760–1830) is depicted simply against a blank background. Though the creases in his forehead are clear and communicate a sense of responsibility or worry, Allen's eyes and face are soft and relaxed. Dark shadows beneath his eyes are echoed in the shading around his shoulders and chest. His neckpiece and vest are carefully detailed, each fold marked with soft light and shadow.

A prominent leader among the African American population of Philadelphia and in the larger religious community of the early United States, the esteemed Reverend Allen was representative of the important subjects Peter S. Duval chose to illustrate. A French émigré running a studio in Philadelphia during the mid-nineteenth century, Duval was one of America's earliest and foremost lithographers. Working with a steam rotary press, he was able to print a large volume of images quickly.[1] Moreover, for Duval and others, lithography served as an artistic medium as well as a means of reproducing images for widespread publication and circulation.

Because of Allen's role in founding the African Methodist Episcopal Church, the first black denomination in America, his likeness would have been highly desirable to the working- and middle-class African American parishioners whom he served, and untold numbers of these lithographs would have found their way into such homes. Through his preaching of the word, his writings, and through the distribution of his image, Allen was able to effect a profound change in the religious life of the pious and striving black folk who sought both solace and hope from the Christian doctrine of salvation that he advocated.

EKS and GDS

1. Harold Cramer, "An Overview of Pennsylvania Mapping Circa 1850 to 1900," on *Historical Maps of Pennsylvania*, 2004, <www.mapsofpa.com/article4.htm> (4 January 2005).

RAPHAELLE PEALE
(1774–1825)

Absalom Jones, 1810

Oil on paper mounted on board
30 x 25 IN. (76.2 x 63.5 CM)
Delaware Art Museum,
Gift of Absalom Jones School, Wilmington, 1971

Born into slavery in Delaware in 1746, Absalom Jones taught himself to read from the Bible as a child, beginning his religious dedication at an early age. After being sold to a store owner in Philadelphia, Jones attended a night school founded by Quakers and completed his education. By working late each night, Jones was able to buy the freedom of his wife, ensuring their children would be freeborn, and years later, procured his own freedom. In 1787, Jones and Richard Allen organized the Free African Society (FAS), a religiously-oriented mutual aid society, "to support one another in sickness, and for the benefit of their widows and fatherless children."[1] Seven years later, when they were refused the opportunity to worship equally in a predominantly white church, Jones and Allen went on to form the St. Thomas African Episcopal Church and the African Methodist Episcopal Church, respectively. The first black Episcopal priest in the United States, Jones had a large following, and by the end of his first year as pastor had attracted more than five hundred parishioners to his church.

Pictured here in a formal half-length portrait by Raphaelle Peale, Jones is marked as a man of the cloth through his dress and his bearing. Wearing ecclesiastical robes and gripping a Bible with his right hand, he sits in front of a deep red curtain with carefully defined folds that attest to Peale's sensitive use of color, light, and shadow. The rich, sensuous quality of the reds combined with the formal composition and decorous depiction of the sitter creates an arresting image. Jones, popularly known as the Black Bishop of the African Methodist Episcopal Church, is depicted as religious aristocracy. The elaborately detailed religious robes and rather large, prominent Bible communicate the significance of his place in society.

Raphaelle Peale was the eldest son of Charles Willson Peale, a sometime politician, a museum entrepreneur, and the foremost painter working in Philadelphia both before and after the Revolutionary War. Unlike his father, who primarily painted portraits of notables, including Thomas Jefferson and George Washington, Raphaelle is best known for his highly illusionistic, trompe l'oeil still lifes, a painting genre that he pursued against his father's wishes. This image of Jones is one of a handful of portraits that Raphaelle Peale made, and because of this and its African American subject, it occupies a curious place in his body of work. That Peale, a white artist, chose (or was commissioned) to paint the African American minister, indicates that he was at ease with members of the often marginalized African American community in Philadelphia.

EKS and GDS

1. William Douglass, in *Annals of the First African Church in the United States of America...* (1862), excerpt transcribed as "A Discourse... African Church," on WGBH/PBS, *Africans in America*, Resource Bank, 1998, <www.pbs.org/wgbh/aia/part3/3h471t.html> (15 January 2005).

Ethan Allen Greenwood
(1779–1856)

Portrait of Charles Jones, 1815

Oil on panel
26 x 18 3/4 in. (66 x 47.6 cm)
Addison Gallery of American Art, Phillips Academy,
gift of William Vareika

Five years after Raphaelle Peale completed his portrait
of Absalom Jones, the Boston-based artist Ethan Allen
Greenwood painted, signed, and dated a portrait
that is purported to be of Absalom's son, Charles Lee
Jones. Little information is available about the
younger man's life; however, it is likely that as a son
of the minister he too would have been active in the
African Methodist Episcopal Church. Compared
with the richness of color and painterly sensitivity
evident in Peale's rendering, the Greenwood portrait
has a stiff and naïve directness that indicates less
artistic training. Although the sitter is depicted as a
neatly coiffed and well-dressed young man, Greenwood
obviously struggled with capturing the skin tone of
his subject, and there is an overall awkwardness
in contrast to the polish and sophistication of his other
portraits of prominent New Englanders.

EKS

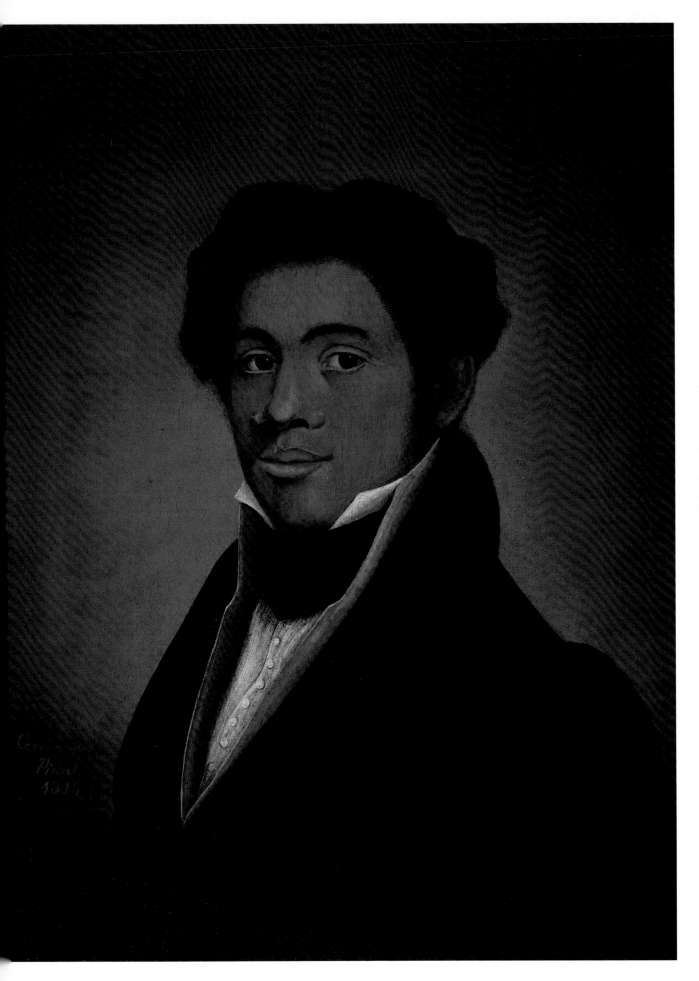

UNKNOWN

Lemuel Haynes, frontispiece to *Sketches of the life and character of the Rev. Lemuel Haynes, A.M., for many years pastor of a church in Rutland, Vt., and late in Granville, New-York. By Timothy Mather Cooley...,* PUBLISHED 1837

Engraving
7 X 4 1/2 IN. (17.78 X 11.43 CM)
Rare Books/Special Collections, Library of Congress, Washington, D.C.

The Reverend Lemuel Haynes (1753–1833) began his life as an indentured servant on a deacon's farm in Massachusetts, where he was said to have been abandoned by his African American father and white middle-class mother. From an early age, he dedicated himself to his own education, especially where it applied to theology. He was a talented writer and orator from an early age, and as an adolescent he frequently conducted services at his local parish. In 1774, at the age of twenty-one and with his servitude completed, he enlisted as a minuteman in the Continental Army. While fighting against the British, Haynes was inspired to write a ballad-sermon that became famous for its subtle protest of the irony of fighting for the liberty of a country that enslaved thousands of people on the basis of skin color. Ordained as the first black minister of the Congregational Church in America after his return from the war, Haynes would go on to preach and serve as pastor at a number of parishes around New England. The Reverend Haynes gained prominence for his wisdom, piety, and eloquence, overcoming racism from the pulpit with his passionate religious and political sermons.

Timothy Mather Cooley, a white colleague of his in the Congregational Church, published a full memoir on Haynes four years after his death, in 1837. This engraving that served as the frontispiece for the biography depicts the Reverend in a standard half-length portrait and presumably was based on another image created before his death. Haynes's intense stare is softened by a partial smile on his lips and a slight tilt of his head. A bright light hits the side of his face and neck, highlighting the white of his collar against his dark coat and emphasizing the religious life it symbolizes. As a frontispiece the image would have served to foreground the identity of the book's subject. The piety of Haynes and his mixed race, denoted by his clerical dress and the subtle shading of his face, could be conveyed to the reader through the visual as well as the textual.

EKS

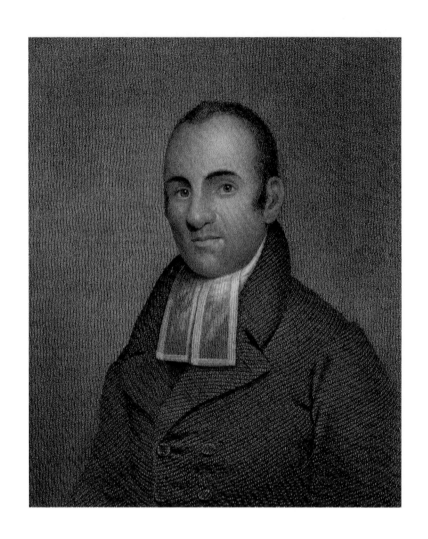

UNKOWN

Jarena Lee, frontispiece to
The Life and Religious Experience of
Mrs. Jarena Lee, FIRST PUBLISHED IN 1836

Engraving
3 3/8 x 3 1/4 IN. (8.8 x 8.3 CM)
The Library Company of Philadelphia

See discussion in the essay "On Deathless Glories Fix
Thine Ardent View" pp. 26–43.

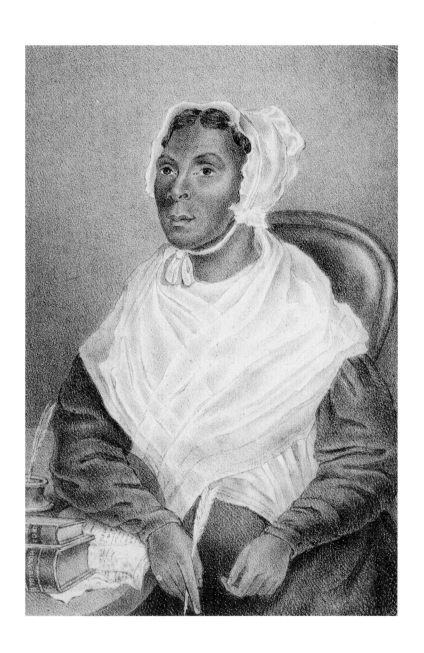

Joshua Johnston
(active 1796–1824)

Portrait of a Man
[possibly Abner Coker], c. 1805–10

Oil on canvas
27 7/8 x 22 in. (70.8 x 55.9 cm)
Bowdoin College Museum of Art, Brunswick, Maine,
Museum Purchase, George Otis Hamlin Fund

Now recognized as America's first known African American painter, the details of Joshua Johnston's life remain uncertain despite the fact that a large body of work has been attributed to him. Johnston was active in Baltimore, Maryland, from 1796 to 1824. And although there has been speculation as to whether Johnston received any formal artistic training (several sources connect him to various members of the Peale family), his paintings are highly stylized and rigid in their technique, revealing a formulaic and often charming approach to the portrayal of his middle-class subjects.

Only two of Johnston's eighty documented paintings are of African American sitters. Generally known today by the purely descriptive titles *Portrait of a Man* and *Portrait of a Gentleman*, both paintings appear to be of clerics based on the white cravats they wear.

While it is difficult to definitively establish identities for the men in this pair of portraits—there are no markings on the backs of the canvases and the paintings have traveled great distances in the nearly two hundred years since their creation, one ending up in Maine and the other in Bath, England—their physical appearance and the similarities in color, composition, and overall depiction are enough to imply that the two are related. Johnston has placed both of his subjects against a plain background set within painted spandrels. In a style similar to other portraits of the period, Johnston elongated the figure's necks and exaggerated the sloping of the shoulders.

The subjects are most likely the Coker brothers, Abner and Daniel, who were ordained ministers and founding members of the African Methodist Episcopal Church in Baltimore. Along with their Philadelphia counterparts Richard Allen and Absalom Jones, the two were popular leaders in the formation of a new class of free African Americans in the Mid-Atlantic States. In *Portrait of a Man*, whose sitter has been tentatively identified as Abner Coker, the face has been heavily modeled through the use of dark shadows about the eyes and cheeks that contrast with the bright white of his shirt and collar. Rather than being personalized through the use of an emblematic pictorial device, he is portrayed rather simply, through subdued colors and spare presentation, as well as in conservative dress that has often been identified as clerical. Daniel Coker, believed to be the sitter for *Portrait of a Gentleman* (see p. 103) was also a respected member of the Baltimore community; he eventually immigrated to Liberia in order to contribute to the foundation of a free African state politically and socially dominated by transplanted African Americans, some of them formerly enslaved and others freeborn. Coker stood as an example of the potential and success of the growing population of freed slaves, a role model whose piety offered both and blacks and whites hope for racial harmony.

EKS and GDS

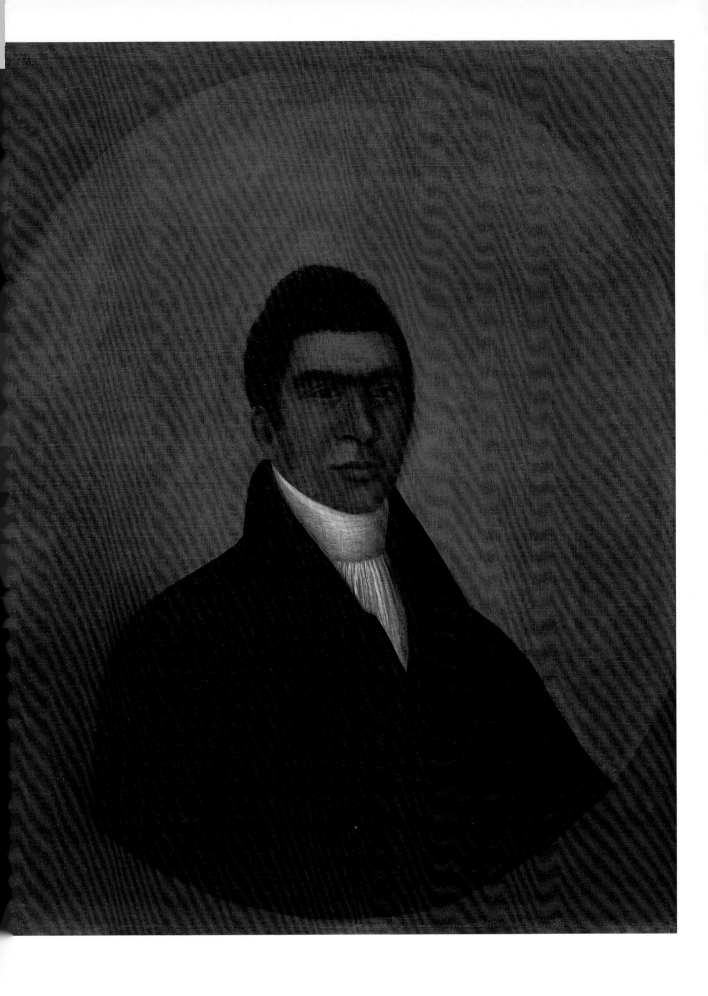

JOSHUA JOHNSTON
(ACTIVE 1796–1824)

Portrait of a Gentleman
[Portrait of Daniel Coker], c. 1805–10

Oil on canvas
29 x 25 IN. (73.6 x 63.5 CM)
The American Museum in Britain, Bath, England

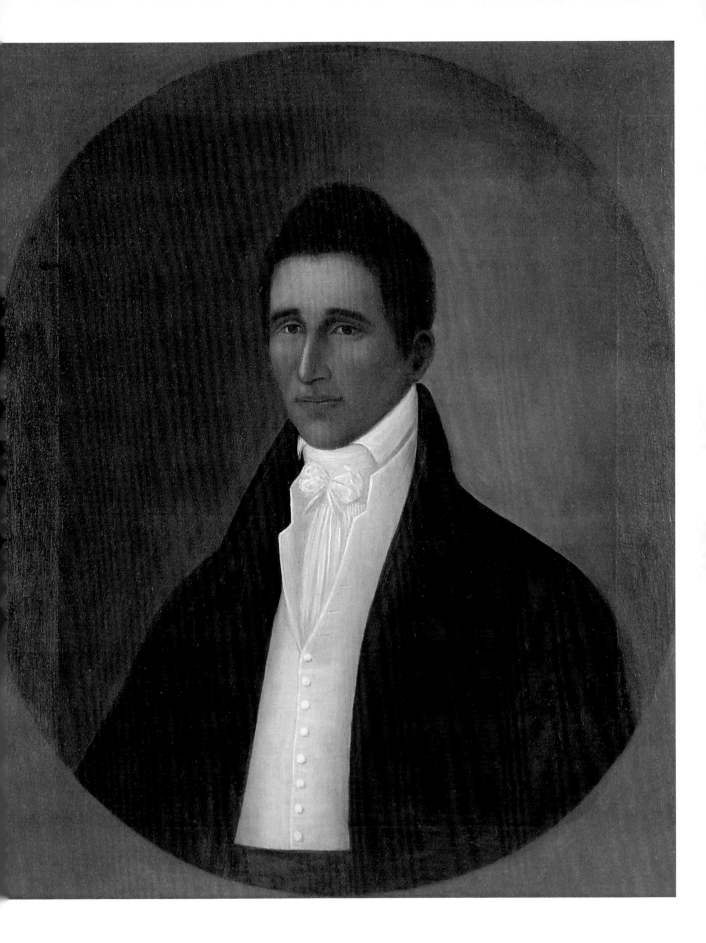

Unknown

James Forten, 1800–10

Tempera or gouache on paper
6 1/2 x 4 3/8 in. (16.5 x 11.1 cm)
The Historical Society of Pennsylvania

James Forten was born in Philadelphia in 1766 to free African American parents. A powder boy for the Continental Army during the Revolutionary War, Forten became a successful businessman operating a sail-making enterprise. A staunch abolitionist, he spoke passionately against the concept and practice of colonization, believing that it would aid the South by ridding the country of the strongest opponents to slavery: free African Americans. Forten left a legacy of social and political activism. As an innovator in the Philadelphia community, he collaborated with a number of African American leaders, while his family continued his tradition of activism for generations to come: from his daughter Harriet who married fellow abolitionist Robert Purvis to his grand-niece, suffragette Charlotte Forten Grimké.[1]

In this portrait, Forten is shown in profile against a plain background, staring straight ahead, his jaw set beneath a prominent nose. He is dressed conservatively in somber colors and an elegant coat and knotted neckpiece, reinforcing his position as a highly regarded man in Philadelphia society. There is a hint of pink to his lips and his face has a barely noticeable flush. The portrait, with its classicizing profile orientation, is made in the style of the French emigrant Charles Balthazar Julien Févret de Saint-Mémin, who worked in Philadelphia from 1798 to 1803. Working in a hybrid mode similar to that of silhouette cutters such as Moses Williams, Saint-Mémin popularized physiognotrace drawings which he made using a machine that transferred the outline of a sitter onto a piece of paper. Rather than cutting out the silhouette and leaving its interior blank, he would then embellish the image with chalk or watercolor,

essentially fleshing out the features of the sitter.[2] It is possible that this portrait was made by him or perhaps by a member of the Peale family, most likely Raphaelle, who were also well acquainted with the possibilities of the physiognotrace machine. Regardless of the actual identity of the artist, Forten's desire to have a profile portrait made of himself probably signals his interest in contemporary modes of portraiture that were linked to early American ideas of republican virtue through their emulation of the historical democracies of ancient Greece and the republic of Rome, whose coinage they mimicked.

EKS and GDS

1. "The Forten Women 1805–1883," on WGBH/PBS, *Africans in America*, Resource Bank, 1998, <www.pbs.org/wgbh/aia/part3/3p477.html> (11 November 2004).

2. Ellen G. Miles, *Saint-Mémin and the Neoclassical Profile Portrait in America*, ed. Dru Dowdy (Washington, D.C.: National Portrait Gallery and the Smithsonian Institution Press, 1994), pp. 66–113.

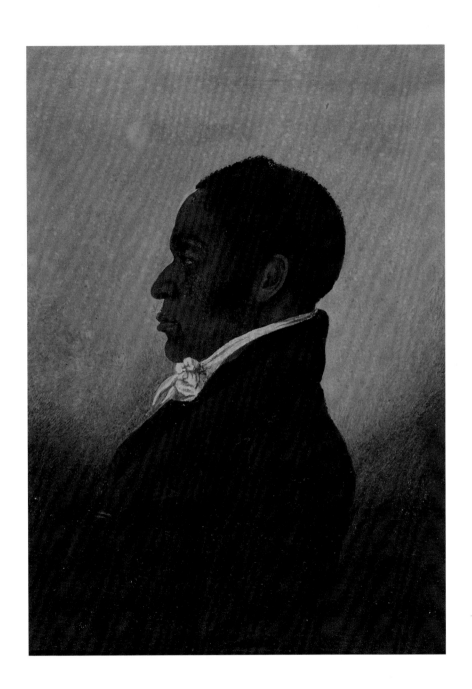

WILLIAM MATTHEW PRIOR
(1806–1873)

William Whipper, c. 1835

Oil on canvas
27 x 22 1/2 IN. (68.6 x 57.2 CM)
Fenimore Art Museum,
The New York State Historical Association,
Cooperstown

Sometime around 1835 the European American portrait painter William Matthew Prior painted a subject who would remain among his most famous sitters, the abolitionist and activist member of the Underground Railroad William Whipper. Along with his business partner and fellow abolitionist Steven Smith, Whipper was destined to become one of the wealthiest African Americans of his generation through shrewd real estate, rail, and lumber investments. Born in Lancaster, Pennsylvania, in 1804, Whipper grew up in Philadelphia before settling in Columbia, Pennsylvania, home to a large and prosperous African American middle class. While initially holding the belief that hard work on the part of free African Americans and the attainment of economic parity would eventually curb anti-black racism among whites, by the end of the 1830s Whipper had come to believe that it was "not a lack of elevation, but complexion that deprived the man of color equal treatment."

This portrait of a young Whipper displays the hallmarks of his middle-class station. In it he is presented as a well-dressed gentleman; the owner of not only a gold watch, hinted at by the presence of its chain arcing across his broad chest from left to right, but also a monocle and two gold rings glittering on his long, tubular fingers. His high-necked shirt collar and ebony cravat pin are framed by the curving lapels of a delicately embroidered jacket. In his right hand he holds a book that bears his initials, W.W., his thumb stuck in-between the pages, perhaps to mark an entry in what might be a personal journal or a daily appointment diary. The image crystallizes a belief that personal social equality could be both asserted and possibly even attained through the presentation of the self as successful and educated.

GDS

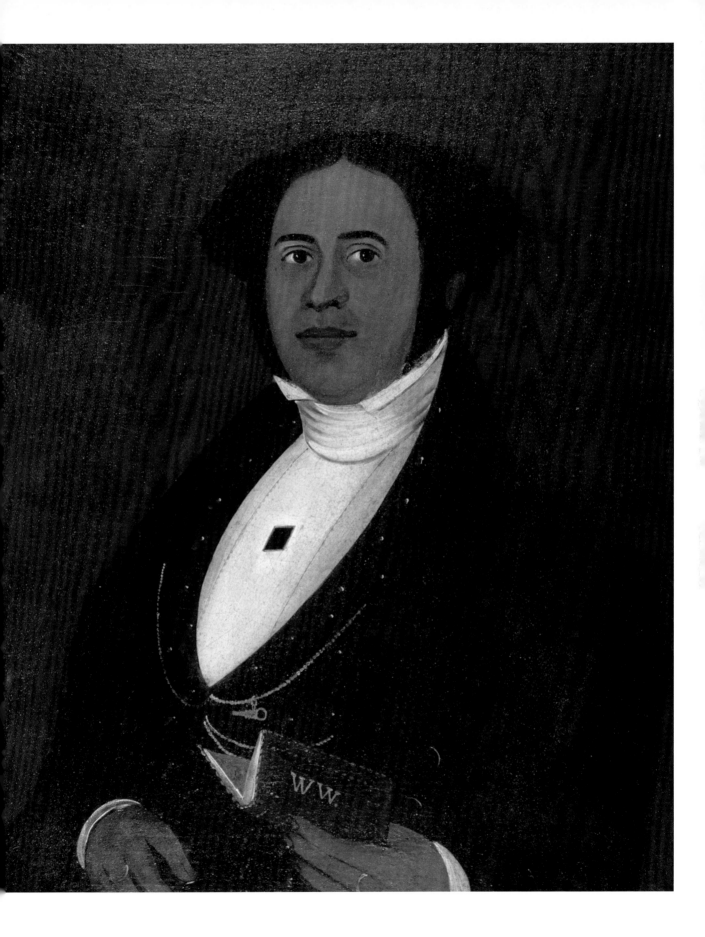

Thomas Wilcox Sully
(1811–1847)

Portrait of Joseph Jenkins Roberts, c. 1844

Oil on canvas
24 x 20 in. (61 x 50.8 cm)
Atwater Kent Museum of Philadelphia,
The Historical Society of Pennsylvania Collection,
Gift of the Pennsylvania Colonization Society

Joseph Jenkins Roberts (1809–1876) immigrated to the African colony of Liberia at the age of twenty with his mother and younger brothers after the death of his father. Born and raised in Virginia the son of a prosperous African American businessman, Roberts was caught up in the missionary zeal of spreading Christianity as well as the social, political, and economic prospects of leading freemen in a return to Africa. At the time of his arrival in Liberia, the colony remained the legal property of the American Colonization Society (ACS), an organization of both whites and blacks formed in 1817 to send free African Americans to Africa as an alternative to remaining in the US after emancipation. Proponents of colonization came from two perspectives: one group consisted of philanthropists and abolitionists who wanted to free enslaved Africans and their descendants and provide them with the opportunity to return to Africa, while the other group was slave owners who feared free African Americans and wanted to expel them from America. Eventually, the ACS, based in Philadelphia and then Washington, D.C., would send more than 13,000 immigrants to Liberia. Roberts was integral in guiding the new republic to its independence, and during the expansion and transition of the settlement, he served as sheriff, chief justice, lieutenant governor, and the first black governor before being elected as the first president in 1847. Nearly thirty years later, during a long political and financial crisis following the disastrous presidency of Edward Roye, Roberts once again served as president.

Commissioned by the ACS in Philadelphia, this portrait by Thomas Wilcox Sully, the son and pupil of Thomas Sully, predates the father's portraits of fellow Liberian presidents Edward Roye and Daniel Warner (see next entries). Roberts is dressed in a formal dark brown coat with a black satin vest, a starched white shirt, and a thin gold watch chain that hints at his status and prosperity. The work currently has an overall yellow cast, and Roberts's skin tone is light beige, the color exaggerated by his graying light brown hair. However, this depiction corresponds to Roberts's racial heritage of more than seven-eighths white, a fact that was common knowledge and frequently publicized.

The formal portraits of Liberian presidents painted by the Sullys were most likely intended for prominent display in the meeting spaces of the ACS. Depicting models of success for the colonization movement, the works publicly commemorate these men's achievements and by example encourage potential Liberian immigrants. Roberts and his family had immigrated to Liberia with the full support of the Society. Given his economic and political success in the new republic, no doubt he stood as a perfect role model for the colonization movement.

EKS

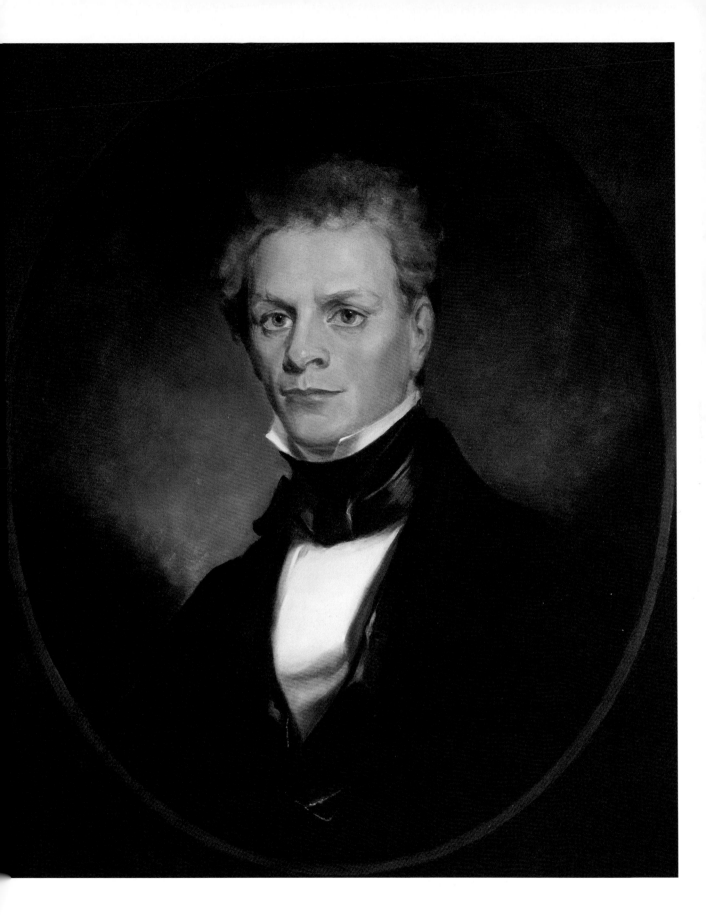

AUGUSTUS WASHINGTON
(c. 1820–1875)

Philip Coker, c. 1856–60

Daguerreotype
4 x 3 in. (10.2 x 7.6 cm)
Prints and Photographs Division, Library of Congress,
Washington, D.C.

One of the most successful African American daguerreotypists of his time, Augustus Washington was well known as an entrepreneur with a studio in Hartford, Connecticut, during the late 1840s. The son of a former slave and politically engaged as an abolitionist, Washington was one of several artists who used their photographic skills to promote anti-slavery activities. Despite his own success, Washington was pessimistic about the prospects for African Americans in American society and supported the American Colonization Society's efforts to create a free black republic in Africa. This movement simultaneously offered a new start and a return to his ancestors' roots, and Washington immigrated to Liberia in 1853.

A famous Liberian subject of Washington's, the Reverend Philip Coker was a missionary in the service of the African Methodist Episcopal Church. While there is some evidence to suggest that Philip was related to the brothers and fellow A.M.E. clergymen Daniel and Abner Coker (see pp. 100–103) the exact relationship remains unclear. Chaplain of the Liberian Senate at the time of this portrait, Philip Coker stares squarely back at the camera with a stern expression. With his head tilted slightly down-ward, Coker gazes over the small glasses perched on his nose. Under his left arm is a book, presumably a Bible, a reference to his profession as a man of the church and possibly to emphasize his literacy. Coker communicates a quiet strength and sense of formality, speaking to Washington's skills as a daguerreotypist and his delicate handling of light.

As shown by this plate, Washington worked primarily in a small format, perhaps owing to the scarcity of photographic supplies in Liberia. Washington produced this portrait of Coker, in addition to that of Edward James Roye, as part of a larger group of portraits sent to the American Colonization Society. In an effort to lend support to the African coloniza-tion cause, he depicted the successful members of the state in their roles as leaders of the new nation.

EKS

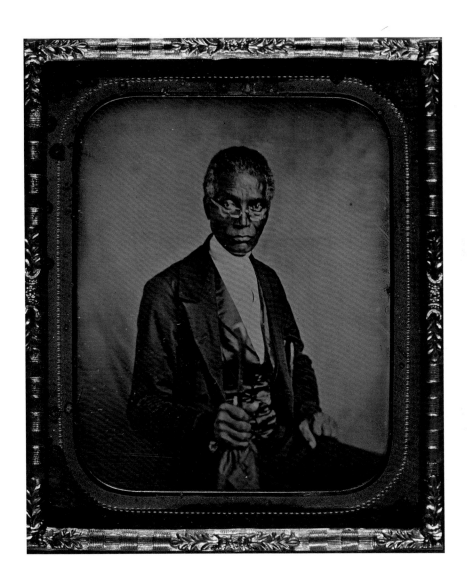

Augustus Washington
(c. 1820–1875)

Edward James Roye, c. 1856–60

Daguerreotype
4 x 3 in. (10.2 x 7.6 cm)
Prints and Photographs Division, Library of Congress,
Washington, D.C.

Edward James Roye (1815–1872), the son of a former
slave, moved to Liberia from Ohio in 1846 as a part
of the popular cause supported by the American
Colonization Society. A successful businessman, Roye
rose through the ranks of the government and
became a controversial figure in the political history
of Liberia. He served as president of the country for
two years, but was forcibly removed from office after
being accused of corruption and fraud. Imprisoned,
tried, and convicted, he suffered a mysterious death
after escaping from prison. Photographed in better
days, Roye stands dressed in formal attire with a
serious expression on his face, his right arm raised as if
he were taking an oath. In the context of Washington's
other daguerreotypes sent to the American Coloniza-
tion Society, this piece would appear to re-enact Roye's
swearing in to the Liberian Senate.

EKS

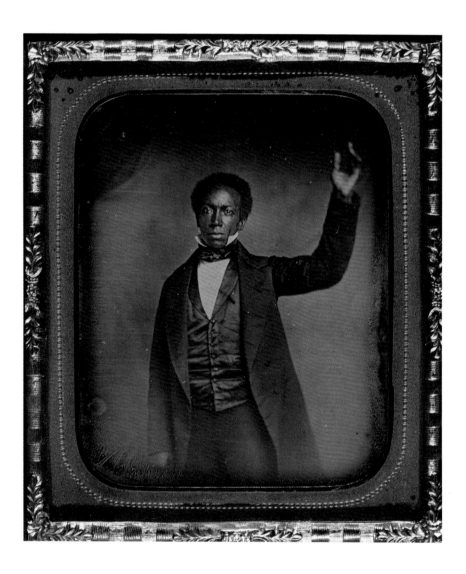

Thomas Sully
(1783–1872)

Edward James Roye, 1864

Oil on canvas
24 x 20 in. (61 x 50.8 cm)
Atwater Kent Museum of Philadelphia,
The Historical Society of Pennsylvania Collection,
Gift of the Pennsylvania Colonization Society

The Anglo-American painter Thomas Sully enjoyed wide popularity and a distinguished career spanning three-quarters of the nineteenth century that left a legacy of countless works of art. Based in Philadelphia, Sully was well known for his portraits, and although he painted more than two thousand different subjects, few were of African Americans. These several images were all commissioned by the American Colonization Society and depicted the first political leaders of Liberia, who had been installed through the society's efforts to relocate free African Americans on African soil.

This portrait of Edward James Roye was painted when he was chief justice of Liberia's Supreme Court, before he was elected president in 1869. Roye's portrait reflects his elevated stature in the new country's social structure as a very successful businessman and rising politician. Dressed in a black coat, vest, and bowtie, Roye stares intently from the canvas, serious but sympathetic in appearance. Because Roye and the other subjects of Sully's Liberian portraits were physically on the other side of the Atlantic Ocean, the artist was forced to rely on daguerreotypes to obtain accurate likeness. However, he only noted in his register that he painted these portraits for the Colonization Society, and failed to mention that he used daguerreotypes as their basis, a fact which is clear from letters between the subjects and the society.[1]

Stylistically, Sully tended to idealize his subjects even as he created fairly accurate likenesses. This work demonstrates Sully's typically fluid brushwork, smooth textures, and soft coloring, which create an effect of intimacy in the portrayal; his skill with light and shadow is evident in the refined quality of Roye's face. As a commission for the society promoting the colonization of Liberia, this portrait appropriately portrays a distinguished gentleman, confident and secure. And while this body of work may have been his only foray into the portrayal of African Americans, there is also evidence that Sully served as an instructor for several African American artists. When Robert Douglass, Jr., a Philadelphia-born African American artist, expressed interest in traveling to Europe to further his artistic studies, Sully wrote him several letters of introduction, giving the young artist his highest commendation.[2]

EKS

1. Monroe H. Fabian, *Mr. Sully, Portrait Painter: The Works of Thomas Sully, 1783–1872* (Washington, D.C.: Smithsonian Institution Press for the National Portrait Gallery, 1983), p. 119.

2. James A. Porter, *Modern Negro Art* (1943; Washington, D.C.: Howard University Press, 1992), p. 21.

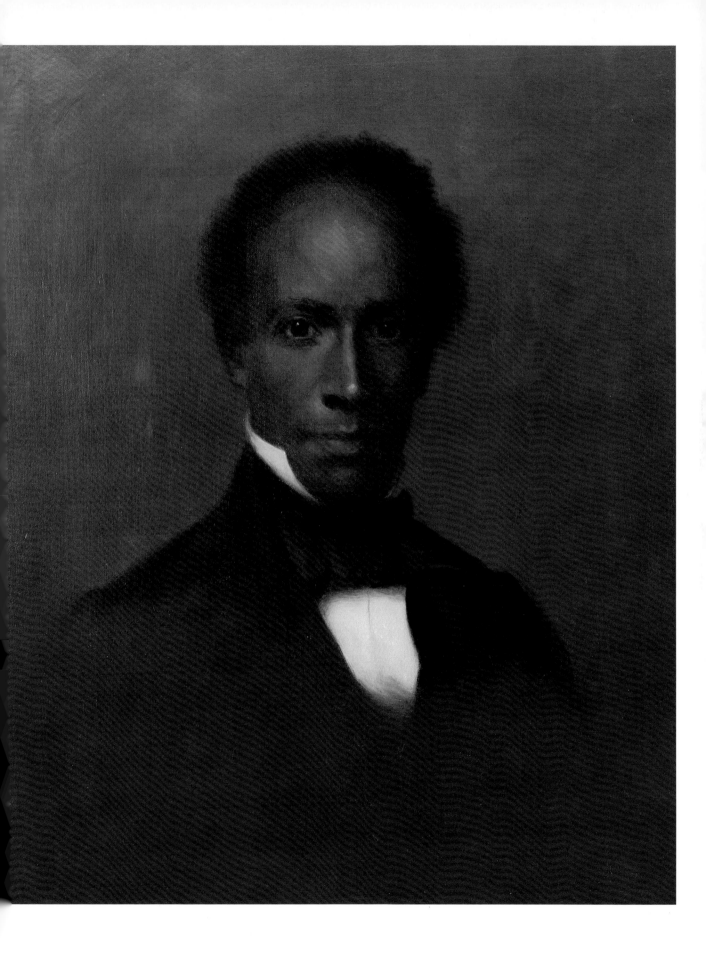

Thomas Sully
(1783–1872)

Daniel Dashiel Warner, 1864

Oil on canvas
24 x 20 IN. (61 x 50.8 CM)
Atwater Kent Museum of Philadelphia,
The Historical Society of Pennyslvania Collection,
Gift of the Pennsylvania Colonization Society

One of a group of portraits of African Americans commissioned from Thomas Sully by the American Colonization Society, this work depicts Daniel Dashiel Warner. Among the first African Americans to arrive in Liberia, at the young age of seven, Warner emigrated from Maryland with his family in 1823. Before entering politics in Liberia, he planned and built a shipyard, and became a successful and influential businessman. President of the country from 1864 to 1868, Warner is best known for writing the country's national anthem. At the time of this portrait, he was beginning his four-year presidential term, during which his main concern was integrating the indigenous people of Liberia with the American immigrants to form a unified society. Warner was involved in the government for almost forty years, and served as vice president for four terms.

There is no documentation that Sully met Warner while painting the image. As with the portrait of Edward James Roye (see p. 115), this canvas was painted from a daguerreotype provided by the subject with the help of the Colonization Society.[1] A bust-length rendering, it is similar to the image of Roye, although Warner is not portrayed as elegantly. Sully painted Warner with a grayish-brown skin tone that signals awkwardness in the artist's handling of black skin and gives Warner a somber, almost stern appearance. Wearing a brown coat with a black velvet collar and black bowtie, Warner is formally attired, yet the portrait appears almost unfinished, with the lower half of the image fading into an empty canvas.

The portraits of Roye and Warner were probably intended for display in the meeting hall of the American Colonization Society to be used to promote the society's efforts to relocate free African Americans to Africa. By picturing these men as well dressed and successful within American middle-class norms, the society could visually champion a program predicated on the idea that the transportation of blacks out of the country was the best way to solve the problems of racism, inequality, and competition with free whites in increasingly tight job markets. While immigration to Liberia offered some African Americans an opportunity to establish economic enterprises that would have been difficult or impossible to achieve in most parts of the United States during the antebellum period, ultimately it would not prove to be a viable or a desirable option for resolving the country's race problems, as would be made manifest by the Civil War.

EKS and GDS

1. Monroe H. Fabian, *Mr. Sully, Portrait Painter: The Works of Thomas Sully, 1783–1872* (Washington, D.C.: Smithsonian Institution Press for the National Portrait Gallery, 1983), p. 119.

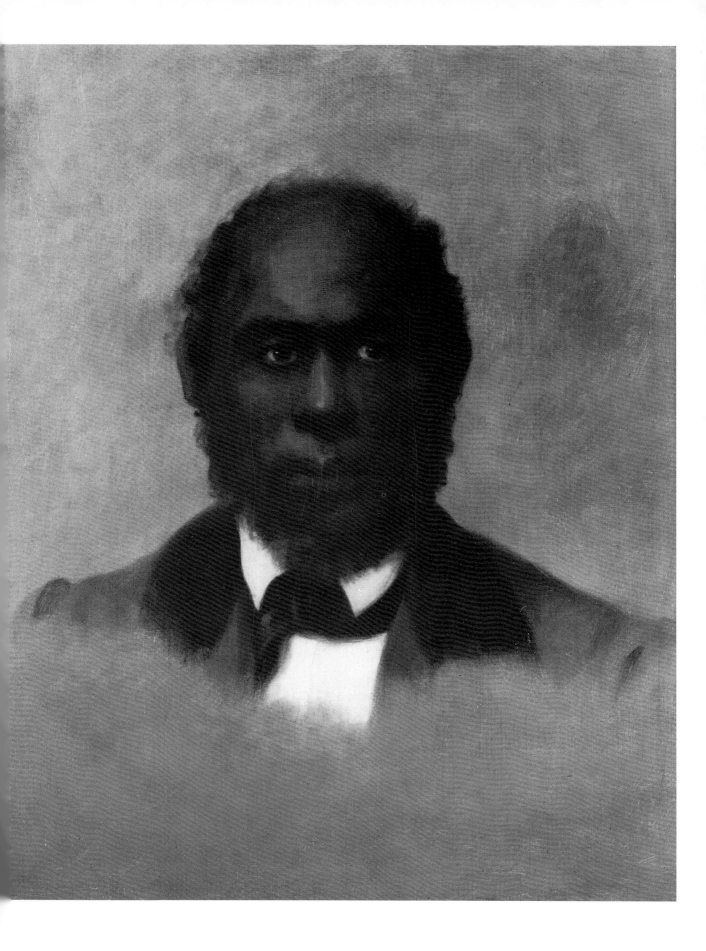

Unknown

Seven Members of the Philadelphia Vigilance Committee: Charles Wise, N. W. Depee, J. M. McKim, Robert Purvis, William Still, Passmore Williamson, Jacob White; also of Thomas Garrett, 1840s

Ambrotypes
Overall, 5 1/2 x 4 1/2 IN. (14 X 11.4 CM)
Boston Public Library / Rare Book Department

Composed of individual portraits of the members of the Philadelphia Vigilance Committee and their colleague Thomas Garrett, a prominent "conductor" on the Underground Railroad, this set of ambrotypes is small enough to be held in the palm of the hand. A private-scale image, it was probably displayed in an abolitionist home in Boston whose owners sought to affiliate themselves with fellow crusaders against the "peculiar institution" of slavery. Gathered within the frame, the three rows of portraits present a group of men brought together by a common cause. All neatly and similarly dressed, the men look to be peers, and have stern or solemn expressions.

After the gradual abolition of slavery in Pennsylvania was legislated in 1780, Philadelphia became home to a significant and increasingly affluent population of free African Americans. In the nineteenth century it became a mecca for fugitives from the neighboring slave-states of Maryland and Virginia. Before the Civil War, vigilance committees were developed in most Northern cities by both European American and African American abolitionists to help prevent the kidnapping and enslavement of free African Americans and the re-enslavement of successful runaways. The majority of vigilance committees were composed of concerned citizens who supplied fugitives with lodging, clothing, and money. They assisted runaways in establishing homes, finding work, and reconnecting with family members.

The center images, of Thomas Garrett (left), a Quaker and devoted member of the Underground Railroad, and of the Philadelphia Vigilance Committee's president, Robert Purvis (right), who had become well known through his efforts on behalf of Sengbeh Pieh and the other Mendi captives involved in the *Amistad* revolt, are of a larger size, thereby emphasizing their importance and creating a subtle hierarchy within the group. One of many modes Purvis adopted to advance the cause of abolition was distributing likenesses of himself and other people involved in anti-slavery activities, and this photograph serves as an important record of the leaders of one of the most active anti-slavery groups during the 1830s and '40s.

EKS

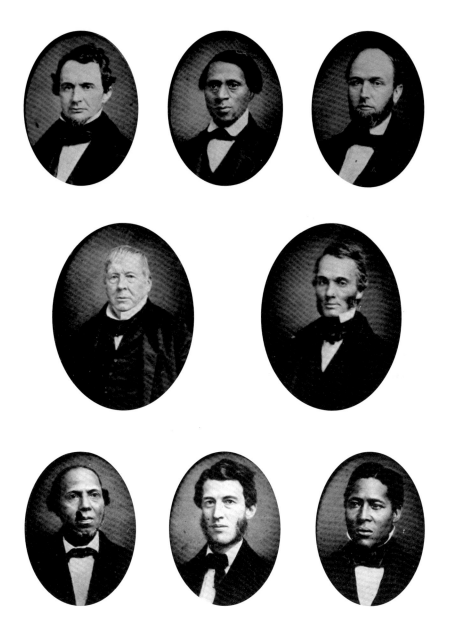

UNKNOWN

Robert Purvis, c. 1840

Daguerreotype
4 3/8 x 3 3/8 in. (11.1 x 8.6 cm)
Boston Public Library / Rare Book Department

Pictured here in a half-length portrait, Robert Purvis (1810–1898), the son of a white Englishman and a free, mixed-race African American woman, projects an air of elegance and propriety. His patterned waistcoat and refined neckband reinforce his high standing in Philadelphia society. A prominent crusader against slavery nationally and locally, Purvis turns his head to the right, gazing into the distance, as if deep in thought. His lips and cheeks are carefully hand-tinted and bring life to a face that would have been seared into the memories of the hundreds of slaves that he helped to escape North through the Underground Railroad station that he operated out of his own home. While the daguerreotype's small size, combined with its gilded frame, make it seem today like an intimate object, more like a personal keepsake rather than a formal portrait, it is important to note that it was one of many portraits of Purvis in a variety of media that were distributed by and amongst opponents of slavery during the nineteenth century. This image is truly extraordinary considering it was made in the United States only a short time after the invention of the daguerreotype by Louis Jacques Mandé Daguerre in France in 1839.

Purvis lived in Philadelphia for most of his life and was well known and highly respected for his work in the Abolitionist movement. He served as president of the Vigilance Committee of Philadelphia for its six years of existence, 1839–44, as president of the Pennsylvania Anti-Slavery Society, 1845–50, and for many years was the only African American member of the Pennsylvania Society for Promoting the Abolition of Slavery. Residing in the city that was home to the most developed artistic community in the country, Purvis was well aware of the power of images and the ways in which the cult of personality could be invoked to further political aims. Because of this he often used his own image, with its predominantly European physiognomic characteristics, to promote a deeper understanding of the racist contradictions involved in the practice of slavery in the United States.

EKS and GDS

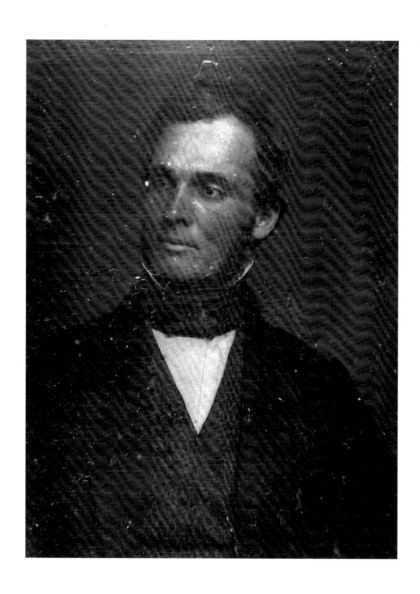

Frederick Gutekunst
(1831–1917)

Robert Purvis, 1890

Albumen print on card
6 1/2 x 4 1/4 in. (16.5 x 10.8 cm)
American Antiquarian Society, Worcester,
Massachusetts

Photographed on August 4, 1890, on the occasion of his eightieth birthday, Robert Purvis appears as a stately older man in this large-format cabinet card. This is a fashionable portrait made by Frederick Gutekunst, a Philadelphia native from the German-town neighborhood, who worked for more than fifty years and photographed hundreds of notables, including three U.S. presidents, writers such as Henry Wadsworth Longfellow and Walt Whitman, actors, men of the cloth, and Civil War soldiers. The wrinkles in his face and his bright white hair attest to Purvis's age, and Gutekunst has captured his inner strength and resolve. Well-dressed and with his hair neatly combed, he is shown as a gentleman, self-confident yet unassuming. His eyes gaze to his left while his face expresses his benevolent nature.

This half-length portrait, with its blank back-drop and formal sitting arrangement, was completed fifty years after the previous daguerreotype portrait of Purvis, and the changes in the subject's face convey something of his work as a lifelong activist. In spite of dedication to the abolitionist cause, Purvis was criticized in the 1870s for his position on the Fifteenth Amendment giving African Americans the right to vote. A strong supporter of women's rights, Purvis argued that African American men should not be enfranchised unless all women received the vote as well. After proudly presiding over the fiftieth anniversary meeting of American Anti-Slavery Society in 1883, Purvis retired from political and social reform activities.

EKS

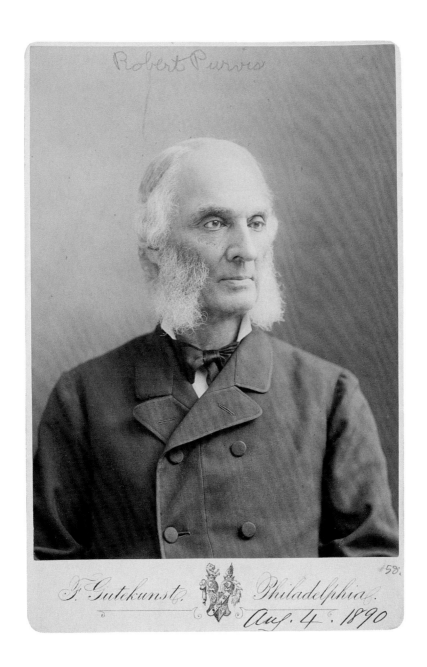

Robert Purvis

F. Gutekunst. Philadelphia. Aug. 4, 1890

Nathan Jocelyn
(1796–1881)

Portrait of Cinque, Joseph Cinque (Sengbe Pieh), SEPTEMBER 1839

Oil on canvas
30 1/4 x 25 1/2 IN. (76.8 x 64.8 CM)
The New Haven Colony Historical Society,
Gift of Dr. Charles B. Purvis, 1898

In 1839, the man popularly known as Cinque emerged as the courageous leader of a rebellion on the slave-ship *Amistad*. Born Sengbeh Pieh of the Mendi people, he was captured in his native Sierra Leone, sold into slavery, and taken to Cuba aboard the Portuguese cargo ship *Tecora* with hundreds of other prisoners. As it was illegal to import slaves to Cuba, these prisoners were given Spanish Christian names loosely based on the phonetic translation of their given names; Sengbeh became Joseph Cinque. Sold at market, Cinque was placed on board the *Amistad* with 53 men, women, and children, most of them also Mendi. The degrading conditions and blatant disregard for their lives moved Cinque to break free from his chains midjourney and overthrow the small crew. Unable to navigate the ship, the Mendi ordered the captain to steer towards Africa. However, for six weeks the crew slyly kept the *Amistad* in American waters. Finally, the ship was captured by the U.S. Navy off New London, Connecticut, and the enslaved Africans were taken ashore and imprisoned for the murder of several crewmembers. With the support of sympathetic abolitionists, and after three highly publicized trials, the case went to the U.S. Supreme Court. Represented by former president John Adams, the Mendi were acquitted of any wrongdoing and in 1841 returned to Sierra Leone. During their time in America, the Mendi attained a celebrity status, while Cinque, as leader of the group, was perceived as either a courageous hero or a murderer.

In this portrait, Nathaniel Jocelyn portrayed Cinque as a quietly heroic icon. He is shown from the waist up, with his head slightly turned and gaze averted. Portrayed in a single-shouldered robe that resembles a toga and holding a wooden staff in his left hand, purportedly the weapon he used against his captors, Cinque is bathed in a warm intense light that reflects the romantic overtones of the dramatic landscape behind him. Cinque's arms, neck, and chest are defined by musculature that echoes the lines of the rugged cliffs behind him. And while the toga alludes to classical motifs, it also references contemporaneous Mendi dress, blending the image of classical Western mythology with that of Cinque's own traditions.

Commissioned by abolitionist Robert Purvis while Cinque was incarcerated, this portrait functioned as a tool in the ongoing campaign for resistance by redefining the face of freedom for enslaved Africans and as a means to further the publicity battle for the Mendi. Jocelyn invested his subject with a moral and spiritual air, marking Cinque as a symbol of abolitionism. During the Mendis' trial, Jocelyn's portrait was adapted as a steel engraving by John Sartain, mass-produced, and sold to the public. Purvis submitted Jocelyn's portrait for exhibition at the Artists' Fund Society in Philadelphia, but it was rejected as it was "contrary to usage to display works of that character, believing that under the excitement of the times, it might prove injurious both to the proprietors and the institution."[1] This rejection speaks to the era's charged atmosphere and to the revolutionary nature of the portrait itself, illustrating an enslaved African as a humanized and moral icon.

EKS and GDS

1. J. Neagle, "The 'Hanging Committee' of the 'Artists' Fund Society' Doing Homage to Slavery," *The Pennsylvania Freeman*, 21 April 1841, p. 2.

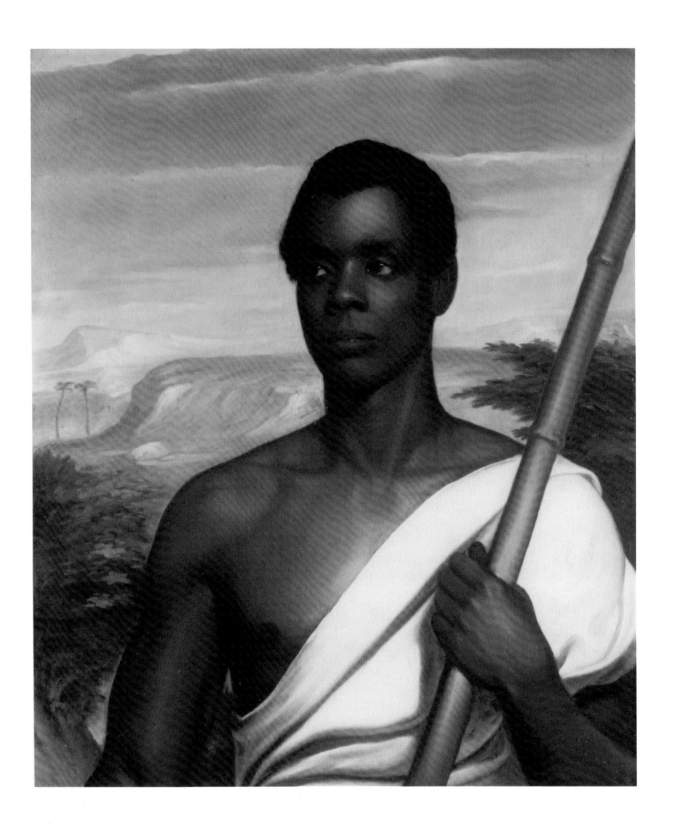

WILLIAM H. TOWNSEND
(1822–1851)

TOP
Grabo, 1839

Graphite on paper
6 1/4 x 4 1/2 IN. (15 x 11.4 CM)
Beinecke Rare Book and Manuscript Library,
Yale University

BOTTOM
Fuli, 1839

Graphite on paper
6 3/4 x 5 1/2 IN. (17.2 x 14 CM)
Beinecke Rare Book and Manuscript Library,
Yale University

Connecticut artist William H. Townsend drew twenty-two pencil sketches of the imprisoned Mendi of the *Amistad* as they awaited trial in New Haven. Quickly reaching a celebrity-like status, the group received crowds of visitors, as locals and tourists alike paid the jailer to view the captured Africans. Each of Townsend's intimate drawings presents an individualized portrait, and many of the subjects are identified with their phonetically spelled Mendi names, further humanizing them.

The young man Grabo is pictured with his head turned to his left and eyes averted to the right. There is a hint of a nervous smile, and he conveys a humble, almost shy nature. His creased forehead and peculiar gaze communicate a sense of worry or the possibility that he is uncomfortable sitting for his portrait. Drawn in a precise manner, the shadows of Grabo's face are realistically crafted, while his clean-cut facial hair and neatly pressed collar support the modest air of this man. At the time the portrait was completed, Grabo was identified as the second in command to Cinque on the *Amistad*, and as such he was one of the most important witnesses during the group's trial.

Fuli appears to be slightly older. With elongated, slightly slanted eyes and a wide flat nose, he faces to his right and stares resolutely ahead to meet the gaze of the viewer, communicating a determination and confidence absent in the image of Grabo. Visible in Fuli's portrait are preliminary markings suggesting that this was a hurried sketch, but also reinforcing the artist's intention to complete an accurate likeness.

Marqu (see p. 129) appears to be the only female drawn by Townsend and one of only two children he depicted. The fact that the majority of these portraits are of men speaks to the practice of importing slaves of higher commercial value: males over females and children. Typical orders by slave-traders, such as those given by Timothy Fitch in 1761 to slave ship Captain Peter Gwinn, demonstrated this profit-driven preference: "You are not to take any Children & Especilly Girls, if you can avoid it by any means & as fiew Woman as PoSsible, & them Likely but as many Prime Young Men Boys as you Can get from 14 to 20 Years of Age Take no Slave on Board that has the Least defect or Sickly."[1] There were four children in the group of Mendi imprisoned in New Haven, three of whom were girls.

When the Mendi captives returned to Sierra Leone in 1841 they were accompanied by several African American and European American missionaries. Among them was William Raymond, who had studied in the theological department at Oberlin Collegiate Institute (later Oberlin College) in Ohio, and who established a mission at Komende in the Sherbo region of Sierra Leone. Although most of the mature members of the *Amistad* group of Africans sought to return to their previous homes, this was not possible for the children, whose knowledge of their own familial origins had been compromised by the traumatic experience of the Middle Passage. As a result, Reverend Raymond's mission became a foster

continues on page 128

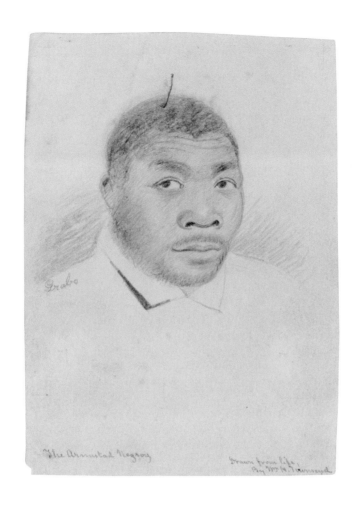

Grabo

The Amistad Negroy

Drawn from life,
By Wm H Townsend

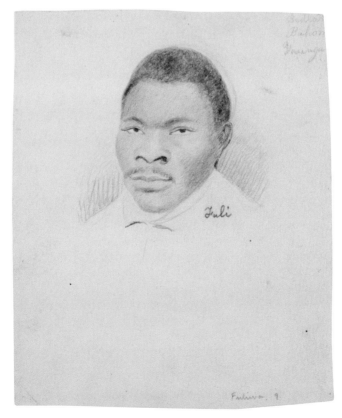

Fuli

William H. Townsend
(1822–1851)

Marqu, 1839

Graphite on paper
6 1/2 x 5 1/2 IN. (16.5 x 14 CM)
Beinecke Rare Book and Manuscript Library,
Yale University

home to them where they were raised as Christians
while serving his family by keeping house and cook-
ing. In 1848 Marqu, who had been given the name
Sarah Margru Kinson by the abolitionist Lewis
Tappan, was sent by Raymond to the United States
to study at Oberlin. She returned the following year
to Sierra Leone, where she lived out her life as a
missionary. She is shown here as a young girl with a
penetrating gaze and a sweet, innocent face. Townsend
has presented her as if she were a girl like any other,
and without considering the historical context, it is
easy to forget the terrible circumstances surrounding
the image's creation.

EKS and GDS

1. William H. Robinson, *Phillis Wheatley and Her Writings*
 (New York: Garland Publishing, 1984), p. 4.

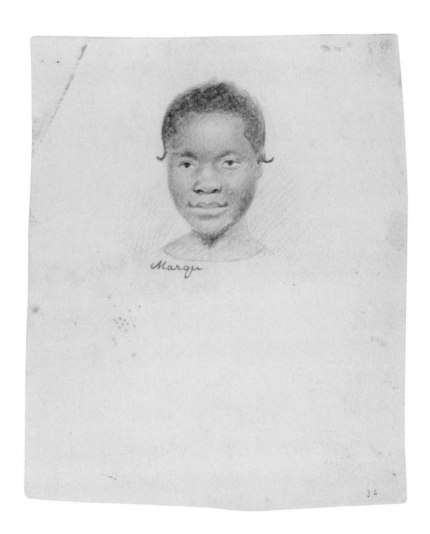

UNKNOWN

Joseph Cinquez: Leader of the gang of Negroes who killed Captain Ramon Ferrers and the cook on board the Spanish Schooner Amistad *Captured by Lieutenant Gedney of the US. Brig* Washington *at Culloden Point Long Island, August 24th, 1839, October 1, 1839*, 1839

Hand-colored lithograph
9 5/8 x 7 1/4 IN. (24.5 x 18.4 CM)
Stanley-Whitman House, Farmington, Connecticut

This hand-colored lithograph depicts Sengbeh Pieh, or Joseph Cinquez (Cinque) as he was popularly known, on the deck of the slave ship *Amistad* with his right hand resting on the handle of a machete and his left fist on his hip. Barefoot and dressed in the unlikely garb of white sailor's trousers, he wears a bright red shirt that is open to his chest. Pieh resolutely gazes into the distance and seems to tower above his surroundings. Well-groomed and with a flush in his cheeks, he stands in a pose reminiscent of a classical Roman warrior. The stance, contrived props, and unrealistic clothing present a romanticized image of Pieh rather than an accurate depiction as the leader of captives who staged a successful revolt aboard the Spanish ship after it had left Cuba. The figure pictured here is hard to reconcile with the imprisoned man who fought for his life and those of the other Africans sold into slavery. It promotes a stylized image of Pieh as a calm warrior in control of the situation, at home on the deck of a ship with a weapon he handles with ease. The visual images of Pieh and the other Mendi prevalent around the time of the very public murder trial and debate that surrounded them were not always positive; however, this representation is of a heroic man who justly overthrew his captors.

EKS

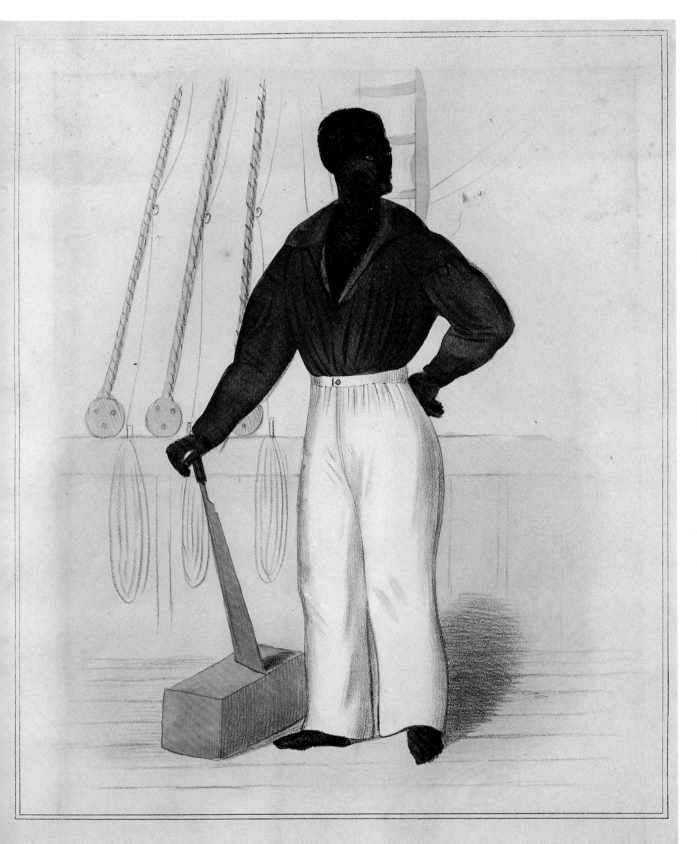

JOSEPH CINQUEZ,

*Leader, of the gang of Negroes, who killed Captain Ramon Ferrers and the Cook, on board
of the Spanish Schooner Amistad. Captured by Lieutenant Gedney, of the U.S. Brig Washington,
at Culloden Point, Long Island, August 24th 1839.*

Unknown

Sergeant Henry Stewart, Company E,
54th Massachusetts Regiment, 1863

Ambrotype
7 1/16 x 5 1/8 in. (18 x 13 cm)
Massachusetts Historical Society, Boston

These three photographs of members of Company E belong to a group of 108 portraits collected by Captain Luis F. Emilio of the 54th Massachusetts Volunteer Infantry Regiment, the first black regiment organized in the North during the Civil War. The regiment was formed in 1863, following the Emancipation Proclamation, from volunteers from around the North and South (not solely Massachusetts residents) who wanted to join the Union Army in the hopes of winning the war and effecting the abolition of slavery in the Southern states that had seceded.

The hand-tinted ambrotype of Sergeant Henry Stewart shows him standing at attention, holding a sword, posed next to a prop classical column. Stewart had enlisted in the 54th in March 1863 at the age of nineteen, and excelled in military service, for which he received rapid promotion from private to sergeant; he died in battle only six months later.

A painted landscape of a military encampment serves as the imaginary setting for Private Charles H. Arnum's tintype. A native of Massachusetts, Arnum was a former teamster who enlisted in the 54th Regiment in November 1863 at the age of twenty-one. A notation on the verso states that this is a copy of a picture taken at Morris Island, South Carolina, the first location that the regiment was stationed after its organization. Arnum stands with his hand placed on an American flag that has been draped over a small table. The flag serves as an emblem of freedom and the Union and is a reminder of Arnum's purpose in joining the 54th Regiment.

John Goosberry, a private in Company E and a member of its band, was a young sailor who came from Canada to fight with the Union Army in July 1863. As in the image of Private Arnum, this tintype was also carefully tinted to accentuate the ornate uniform with an intricate belt buckle and gold buttons. Goosberry stands holding his piccolo, his hands in the ready position as if he is about to play. His gaze meets the viewer's with an intensity of expression that conveys his seriousness and resolve. Posed in an empty room, there are no compositional devices beyond his instrument to individualize him.

In the years immediately preceding the Civil War, numerous photographic processes were developed that were both cheap and relatively easy to execute. In the 1850s tintypes, ambrotypes, and methods that utilized paper and other inexpensive materials such as albumen prints and small albumen prints mounted on cards, known as carte-de-visites, began to supplant the more unwieldy practice of daguerreotypy, which required more delicate and less portable equipment. Because of these advances and the desire of both Union and Confederate soldiers to leave their likenesses behind with loved ones before departing for the front, there are numerous images of the everyday soldiers who fought and died during the Civil War. The overwhelming majority of these images depict men much like these members of the Massachusetts 54th, dressed in uniform, standing at attention or as if ready for action. Often they are the first and only photographs that would have been made of the sitter. They record soldiers, frozen in time, poised on the threshold of a war that was for many of them the defining moment of their lives.

EKS and GDS

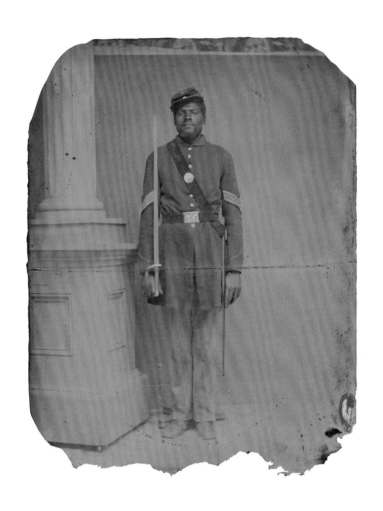

Unknown

LEFT

Private Charles H. Arnum, Company E,
54th Massachusetts Regiment, 1864

Tintype taken at Morris Island, South Carolina
7 1/16 x 5 1/8 in. (18 x 13 cm)
Massachusetts Historical Society, Boston

RIGHT

Private John Goosberry, Company E,
54th Massachusetts Regiment, 1865

Tintype
7 1/16 x 5 1/8 in. (18 x 13 cm)
Massachusetts Historical Society, Boston

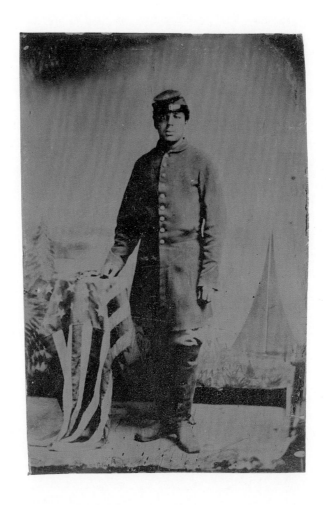

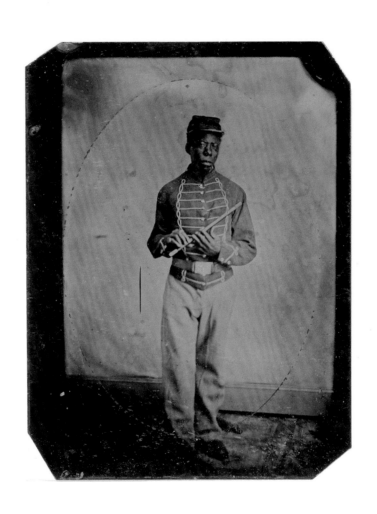

Theodor Kaufmann
(1814–1900)

Portrait of Hiram Rhodes Revels, c. 1870

Oil on mill-board
12 x 10 in. (30.5 x 25.4 cm)
Courtesy of the Herbert F. Johnson Museum of Art,
Cornell University, Transferred from Olin Library

Born to a free family in North Carolina in 1827, Hiram Revels was first apprenticed to his brother as a barber before moving to the free state of Indiana to further his education at a seminary. As a young minister at the outbreak of the Civil War, he urged African American men to fight for the Union Army and helped to form two regiments in Maryland, while he served as chaplain. After settling in Mississippi after the war, Revels became pastor of the local African Methodist Episcopal Church and was nominated to run for the State Senate. He won a seat from his district and worked to abolish the Black Codes, repressive laws aimed at curtailing African American social and political freedom, and to ratify the Thirteenth, Fourteenth, and Fifteenth Amendments, which allowed the state to re-enter the Union. In 1870, Revels was elected as the first African American member of the United States Senate, filling the seat vacated by Jefferson Davis nearly ten years earlier. When he finished his fourteen-month term, he became President of Alcorn University, the state's first college for African American students, and continued to be active both in the political and religious spheres.

This portrait by Theodor Kaufmann clearly communicates the prominence of a highly respected man who became publicly admired for his diplomacy and his political and religious work. Dignified in the face of racism during his time in the Senate and as a leader in the black community, Revel's strength of character seems to permeate his serious yet kind appearance. Pictured in a bust-length portrait, he turns slightly and stares intently out from the canvas. White lines in the skin surrounding his eyes add a sense of intensity to Revels, while the echoing bright white of his shirt flashes from underneath the black of his coat. Even as Revels looks very lifelike, the stark color contrasts throughout the painting, and those especially evident in his face lend a melodramatic air to the work.

Kaufmann, a German emigrant who fled his native country when he was implicated in an anti-government uprising, fought for the Union army during the Civil War. As an artist, he was known to be politically engaged, painting charged images of fugitive slaves and Civil War scenes that highlighted racial, social, and political issues. His portrait of Revels was commissioned by the Boston firm of Louis Prang and Company, prominent dealers of chromolithography, who reproduced the image for public distribution and sold it widely throughout the North during Reconstruction.[1] Its popularity was due to Revels's own celebrity and the scarcity of such portraits that lionized African American men. As Frederick Douglass observed about the work:

> It strikes me as a faithful representation of the man. Whatever may be the prejudices of those who may look upon it, they will be compelled to admit that the Mississippi Senator is a man, and one who will easily pass for a man among men. We colored men so often see ourselves described and painted as monkeys, that we think it a great piece of good fortune to find an exception to this general rule.[2]

EKS

1. Joshua Brown, "Toward a Meeting of the Minds: Historians and Art Historians," *American Art* 17, no. 2 (Summer 2003): 4–9.

2. Frederick Douglass, "Pictures and Progress," *The Frederick Douglass Papers*, Series 1, Vol. 3, ed. John W. Blassingame (New Haven, Conn.: Yale University Press, 1985), pp. 452–73.

William Matthew Prior
(1806–1873)

Three Sisters of the Copeland Family, 1854

Oil on canvas
26 7/8 x 36 1/2 in. (68.3 x 92.7 cm)
Museum of Fine Arts, Boston,
Bequest of Martha C. Karolik for the
M. and M. Karolik Collection of American Paintings,
1815–1865

William Matthew Prior, a painter of European descent, was responsible for creating a large number of portraits of African American sitters from all along the eastern seaboard during the middle of the nineteenth century. Keeping a studio that he dubbed The Painting Garret in the semi-integrated neighborhood of East Boston during the 1840s and '50s, Prior painted various members of the petit bourgeoisie in a predictable and often exceedingly flat manner.

The construction of this charming image of Eliza, Nellie, and Margaret, the three young daughters of a pawnbroker and used clothing dealer from Boston's North End neighborhood, shares strong affinities with group portraits of white children, particularly girls, from midcentury. Each of the girls holds a small emblem of her youth and ripening femininity: a book, a spring of cherries, or a bouquet of flowers.

While all three little faces of the Copeland sisters are serene and pleasant, with gently upturned mouths and warm brown eyes that address the viewer, their bodies remain stiff and doll-like, betraying the rote manner in which Prior approached his treatment of the body in general. In their linear placement we see Prior's near total disregard for, or disinterest in, issues of illusionistic space. Rather than trying to ground the smallest of the three girls, he allows her to float miraculously in-between her sisters. Likewise, the petticoats that extend out of the two older girls' skirts appear empty, as though they have no legs. Working primarily as a facial portraitist, Prior may have viewed limbs and digits as peripheral elements (the fingers, while present, do seem to be an afterthought), deeming anything tangential to the sitter's face a secondary accessory to the creation of an accurate and satisfactory depiction. And although he has chosen to concentrate on the individuation of the faces of each of the sitters, as art historian Guy McElroy pointed out, they remain "broad and mask-like" guises in which modulations of light and dark struggle to convey dimensionality.[1] This lack of attention to naturalistic physique is indicative of both Prior's late style and his more common mode of portraiture that focused solely on the face of the sitter, as in his portrait of Absalom Boston (see p.141).

The linear, flat style that characterizes Prior's work is often called "folk" or "vernacular," however, material culture historian John Michael Vlach has better described it as "plain," a term which alludes to not only its stripped-down nature but also its affinity to the flat "plane" of the canvas.

GDS

1. Guy C. McElroy, *Facing History: The Black Image in American Art 1710–1940* (San Francisco: Bedford Arts Publishers in association with the Corcoran Gallery of Art, 1990), p. 32.

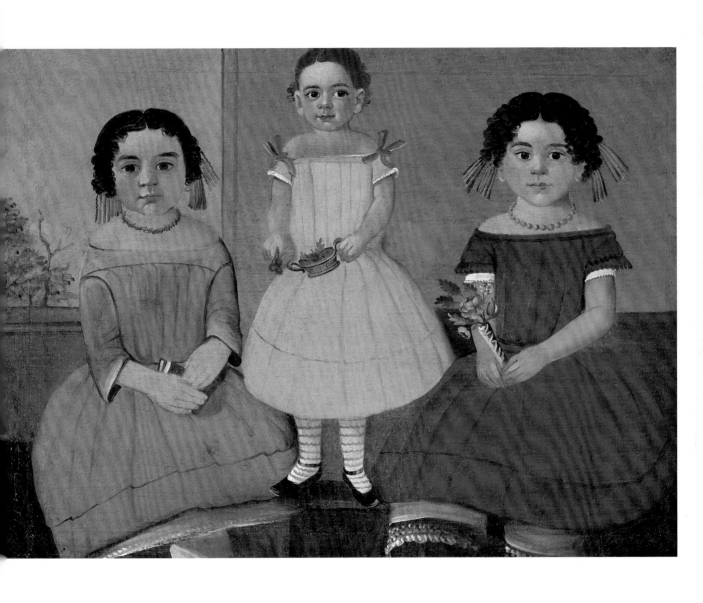

William Matthew Prior

(1806–1873)

Absalom Boston, 1830

Oil on canvas
14 1/2 x 10 5/8 in. (36.8 x 26.9 cm)
Courtesy of the Nantucket Historical Association,
gift of Sampson Pompey

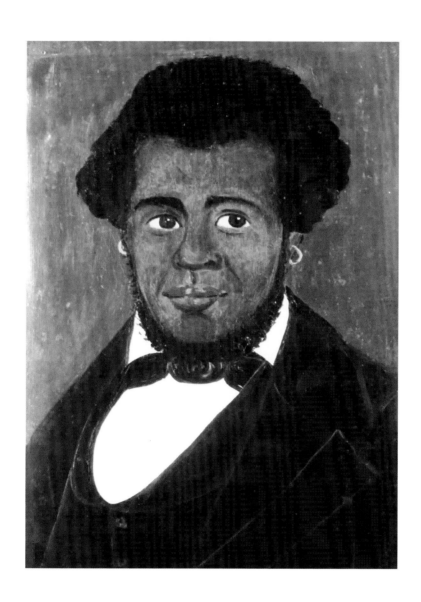

William Matthew Prior
(1806–1873)

TOP

Mrs. Nancy Lawson, c. 1843

Oil on canvas
30 x 25 in. (76.2 x 63.5 cm)
Shelburne Museum, Shelburne, Vermont

BOTTOM

Mr. William Lawson, c. 1843

Oil on canvas
30 x 25 in. (76.2 x 63.5 cm)
Shelburne Museum, Shelburne, Vermont

See discussion in the essay "Negro Portraits" pp. 12–25.

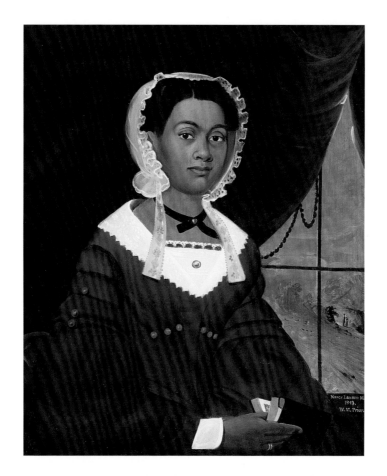

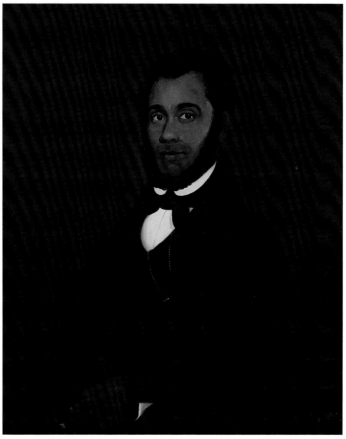

EDWARD MITCHELL BANNISTER
(1828–1901)

TOP

Dr. John Van Surley DeGrasse, C. 1848

Oil on canvas
Oval, 23 x 19 IN. (58.4 x 48.3 CM)
Courtesy of Kenkeleba Gallery, New York

PATRICK HENRY REASON
(1817–1856)

BOTTOM

Isaiah DeGrasse, N.D.

Oil on canvas
29 1/2 x 24 3/8 IN. (74.9 x 61.9 CM)
Courtesy of Kenkeleba Gallery, New York

Edward Mitchell Bannister is today remembered as a painter of landscapes in the Barbizon tradition. However, like many American landscape painters of the period, including Robert Scott Duncanson (1821–1872), Bannister began his career as a portraitist and a photographer. After emigrating from New Brunswick, Canada, to Boston in his early twenties, he began to paint portraits of middle-class African Americans and other sitters in the 1850s. Because work was scarce and his skills were still developing, he worked as a barber, a common occupation for African American men in the nineteenth century.

One of Bannister's earliest known painted portraits is of Dr. John Van Surly DeGrasse (1825–1868), the son of George DeGrasse and Marie Van Surly DeGrasse, and the grandson of Count François Joseph Paul DeGrasse, who served in the French Navy and commanded a fleet of ships in the Caribbean against Britain during the American Revolutionary War. John Van Surly DeGrasse was a noted physician who studied in France and took his medical degree at Bowdoin College in Maine. During the late 1840s he became active in Boston in the abolitionist movement and later served as the first black surgeon in the Civil War, with the 35th Regiment of U.S. Colored Infantry from North Carolina. Bannister's portrait presents the doctor as a well-dressed, middle-class professional. The tones are dark and the modeling rather flat, and yet the gravitas of the sitter radiates from the eyes, and his benevolence is indicated from the slight smile that is barely readable through the great bush of beard whose outer margins disappear into the dark background.

Other portraits from the DeGrasse family collection include one of Isaiah DeGrasse, the doctor's brother, by the African American painter and print-maker Patrick Henry Reason. Reason is best known as the American engraver of the popular image of the kneeling slave with the inscription "Am I not a man and a brother?" that was first conceived at the end of the eighteenth century by the British abolitionist and ceramist Josiah Wedgwood. One of the few paintings known to be by Reason, the portrait of Isaiah DeGrasse was probably executed in the 1840s, when the conservative costume shown, a black cravat worn over a white shirt with a black jacket, was prevalent. Isaiah DeGrasse is shown, from the waist up, in what appears to be a very well-appointed library. He seems to have been interrupted by the viewer while reading, and holds a book with a green morocco binding in his left hand, his thumb inserted into the pages to hold his place. Behind him is a case full of other colorfully bound volumes, many of which rest at slight angles one against the other, as though they had been recently browsed. The fluted column that anchors the right side of the composition, balancing the jumble of books on the left, implies the sitter's interest in a classical education, one that could veritably be found in the books that he is shown to clearly value.

About 1852 Bannister completed a pastel portrait of Cordelia Lucretia Howard, who would later become Mrs. John Van Surly DeGrasse, that presents her as a beautiful yet introspective young woman.

continues on page 146

Edward Mitchell Bannister
(1828–1901)

TOP

Lucretia Cordelia DeGrasse, AFTER 1852

Pastel on paper
15 1/4 x 12 1/4 IN. (38.7 x 31.1 CM)
Courtesy of Kenkeleba Gallery, New York

William Matthew Prior
(1806–1873)

BOTTOM

Margaret Gardner Howard, N.D.

Oil on canvas
25 3/4 x 21 3/8 IN. (65.4 x 54.3 CM)
Courtesy of Kenkeleba Gallery, New York

Cordelia was the daughter of Margaret Gardner and Peter Howard, who were married on May 16, 1808, by the Reverend Joseph Eckley, D.D., in Boston. Sometime in the second quarter of the nineteenth century a highly detailed portrait of Margaret Gardner Howard was made by the European American painter William Matthew Prior. That the DeGrasse and Howard families were able to afford multiple painted portraits of family members, and that these works remained in the family through the late twentieth century, speaks to the solidity and dynamism of the African American social system that had developed in Boston during the nineteenth century.

In addition to collecting painted portraits of family members, John Van Surly DeGrasse and Cordelia Howard DeGrasse also had photographic portraits made of themselves (see p. 149). That of Cordelia by John A. Heard included here is undated, but it was probably made in the 1860s when the carte-de-visite format was ascendant. Bannister produced the carte-de-visite of her husband in 1862. Another was made by James Wallace Black, who was well-known at the time for the iconic photograph of the anti-slavery radical John Brown (National Portrait Gallery, Washington, D.C.) that was taken in 1859, just months before his failed raid on the arsenal at Harper's Ferry, Virginia, and his subsequent execution. Bannister's painted and photographic portraits of Dr. DeGrasse, who was both an anti-slavery activist and a pillar of the African American community, are a visual testament to the artist's involvement in the abolitionist work in Boston and to his status as a midlevel, but well established, artist who was versatile and technologically innovative.

In addition to the support that he received from portrait commissions through the DeGrasse family and others, one of Bannister's greatest patrons and supporters was his wife, Christiana Carteaux (see page 151), whom he met in the 1850s. Carteaux, who had roots in the Native American communities around Providence, Rhode Island, was a hairdresser who owned her own business. She was also active in the anti-slavery movement (during the war she served in the Colored Women's Auxiliary), and when they married in 1858, her financial acumen enabled Bannister to devote nearly all his time to art. During this period he received some formal art training at the Lowell Institute in Boston under the painter William Rimmer (1816–1879) and began to expand his repertoire from portraits to religious subjects, genre, and still life, and, later, to landscape painting.

Unfortunately, much of the progress that Bannister made in the 1860s was challenged in the 1870s and 1880s as the dominant culture of the United States became increasingly hostile to black creativity. This general hostility retarded the spread of African American artistic culture during the Gilded Age. Following the Civil War the climate for African Americans living in Boston changed dramatically. Many displaced former slaves had begun making their way north in search of work and opportunity. Within a few years the community of free black professionals to which the Bannisters belonged, many of whom had been in the area long before the war, began to see their social status slip. They were no longer readily identifiable within an increasingly large black population,

continues on page 148

LEFT

John Van Surley DeGrasse, c. 1861–1865

Albumen print on card
Approximately 4 x 2 1/4 IN. (10.2 x 5.7 CM)
Massachusetts Historical Society,
DeGrasse-Howard Papers, 1776–1976

CENTER

Cordelia Howard DeGrasse, 1863

Albumen print on card
Approximately 4 x 2 1/4 IN. (10.2 x 5.7 CM)
Massachusetts Historical Society,
DeGrasse-Howard Papers, 1776–1976

and they faced racist slights on the streets and elsewhere. As freedmen skilled only in farm work and artisanal trades flooded the increasingly industrialized labor markets of northern cities, working-class whites (who were themselves mostly emigrants from Ireland and other impoverished European countries) adopted racist attitudes about the right to work. Furthermore, the white community that had supported the abolitionist cause was now far less interested in the changed situation for African Americans, having been more enamored by the idea of freedom than by the reality of the free blacks who now filled their city. This tense climate led in some cases to race riots and generally made the environment of the city unbearable for many middle-class black families, who increasingly found that their presumption of social privilege was not a protection against racially motivated violence.

In 1869 Bannister and Carteaux, possibly threatened by the continued erosion of race relations and their own social status, removed themselves to the significantly smaller city of Providence. At the time, it was home to a small community of artists, and its environs were characterized by the remnants of a once-large system of plantations and shipping businesses that had been linked to the slave trade. Some members of the African American population of Rhode Island, exemplified by Carteaux's own family, had mixed with Native Americans from the area, creating a dynamic ethnic community.

Although he began his artistic practice painting many black Bostonians, the landscapes that became Bannister's specialty rarely included any African

American characters. This significant absence of black bodies may be read as part of a survival mode by which the artist submerged his own blackness beneath a generic landscape aesthetic that called for a benign white presence in the composition, an assumed white producer of the object, and an ideal white spectator standing before it.

This sublimation into whiteness that is present in much of Bannister's painting, with obvious notable exceptions, was also apparent in the covert ways by which he submitted his work to exhibitions, often keeping his racial identity a secret. For example, in 1876 he entered an already much lauded work, *Under the Oaks* (location unknown), in the competition at the Philadelphia Centennial Exposition. There it won first prize for painting and gave rise to one of the most frequently recounted stories of nineteenth-century African American art history, one that reflects the racism and difficulties with which black artists of this generation had to contend:

> I learned from the newspapers that "54" had received a first prize medal, so I hurried to the Committee Rooms to make sure the report was true. There was a great crowd there ahead of me. As I jostled among them many resented my presence, some actually commenting within my hearing in a most petulant manner what is that colored person in here for? Finally when I succeeded in reaching the desk where inquiries were made, I endeavored to gain the attention of the official in charge. He was very insolent. Without raising his eyes, he demanded in the most exasperating tone of voice, "Well what do you want here any way? Speak lively." "I want

continues on page 150

Edward Mitchell Bannister
(1828–1901)

RIGHT

John Van Surley DeGrasse, 1862

Albumen print on card
3 x 2 in. (7.6 x 5.1 cm)
The Museum of Afro-American History,
Boston and Nantucket

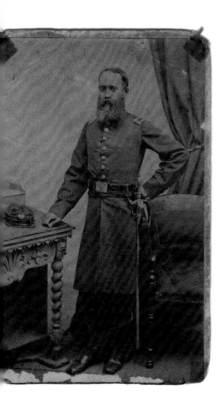
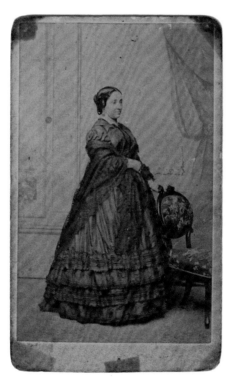

Edward Mitchell Bannister
(1828–1901)

Portrait of Christiana Carteaux Bannister, N.D.

Oil on canvas
35 x 26 7/8 IN. (88.9 x 68.3 CM)
Collection of the Newport Art Museum by extended
loan of the Rhode Island Black Heritage Society
in trust of Bannister House

to enquire concerning 54. Is it a prize winner?"
"What's that to you," said he? In an instant my blood
was up: the looks that passed between him and
others in the room were unmistakable. I was not an
artist to them, simply an inquisitive colored man;
controlling myself, I said deliberately, "I am inter-
ested in the report that *Under the Oaks* has received
a prize; I painted the picture." An explosion could
not have made a more marked impression. Without
hesitation he apologized, and soon everyone in the
room was bowing and scraping to me.[1]

This type of national success must have been
bittersweet for Bannister because, while it garnered him
recognition from the black and white communities
outside of New England, it also exposed him to the
tide of racism that had continued to rise in the United
States. And it was just this type of reception that
probably caused him to shy away from black charac-
ters and from overtly racialized subject matter. To
the white officials and attendees of the Philadelphia
Centennial Exposition, like the Bostonians he had
left behind, he would never be distinguishable from
the black bodies that labored in the hay fields that he
had begun to paint. Nevertheless, he continued to
exhibit nationally, in 1879 at the National Academy
of Design and in 1880 at the New Orleans Cotton
Centennial Exposition.

GDS

1. As recorded in George Whitaker, "Edward Mitchell Bannister,"
undated typescript, pp. 4–5, Edward Mitchell Bannister
Papers, Archives of American Art, Smithsonian Institution,
Washington, D.C.

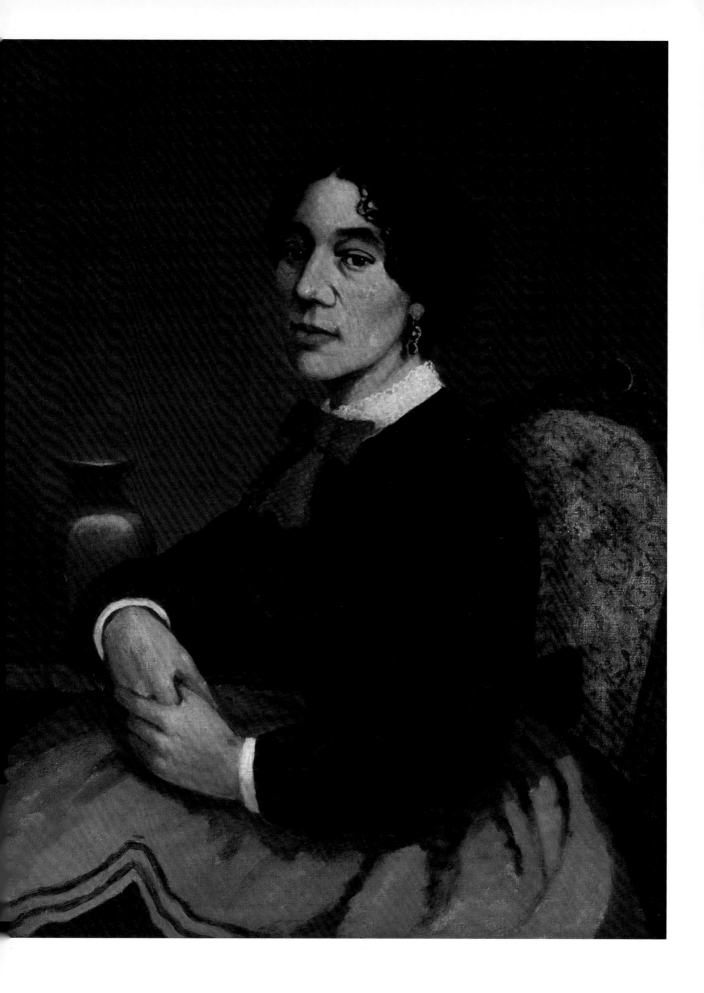

Eastman Johnson
(1824–1906)

The Freedom Ring, 1860

Oil on paperboard
18 x 22 IN. (45.7 x 55.9 CM)
Hallmark Fine Art Collection, Hallmark Cards, Inc.,
Kansas City, Missouri

Two groups of carte-de-visite photographs of formerly enslaved children by various photographers and the small painting titled *The Freedom Ring* by Eastman Johnson illustrate a peculiar phenomenon that arose on the eve of the Civil War. Between 1860 and 1864, European American abolitionists, foremost among them Reverend Henry Ward Beecher, the brother of Harriet Beecher Stowe, sought to cultivate the feelings of anti-slavery whites around the hereditary nature of slavery in the Southern states. Using live showings and inexpensive photographic reproductions in the form of small, collectible carte-de-visites that were sold to raise funds and awareness, Beecher and others employed the bodies and images of mixed-race slave children as illustrations of the assumed sexual depravity associated with their existence. Historian Mary Niall Mitchell has argued that the visible racial ambiguity of children such as Fannie Virginia Casseopia Lawrence, Rebecca Huger, and Rosina (Rosa) Downs, highlighted the seemingly arbitrary nature of a system of enslavement that included persons who were white-looking, yet not really white.[1]

Rose Ward, the subject of Eastman Johnson's painting *The Freedom Ring*, was among the first of several children who were "redeemed," or purchased out of slavery, through funds raised by parishioners of Beecher's Plymouth Church in Brooklyn, New York. In the painting, Johnson has depicted her as a girl of about seven or eight wearing a traveling coat and sitting on the bare planks of a wooden floor. A small chest stands open behind her on the left, while a scarf has been draped haphazardly over a chair to the right. Her wavy brown hair is neatly parted down the middle and has been swept back from her

face to reveal a rosy cheek and a contemplative gaze that is fixed on the ring of the painting's title. It is perched between the two lower knuckles of her right index finger, revealing its over-large size and signaling its newness and peculiar novelty to the girl.

As art historian Patricia Hills has noted, *The Freedom Ring* was inspired by the successful efforts of Beecher and his congregation to ransom young, nearly white girls from slavery.[2] Money was raised for the purchase of Rose by passing a collection basket into which congregation members were urged to place cash. One of the parishioners was so moved by the girl's circumstance that she took a ring from her finger and added it to the funds in the basket. Because the amount raised exceeded the girl's purchase price, the child was allowed to keep the ring. It became known as her "freedom ring," an interesting appellation for a decorative accoutrement in an era that saw the fitting of various metal collars around the necks of enslaved people, as well as the wearing of leather "slave bands" by middle-class women as signs of sexual subjugation to their lovers.[3]

A potential for redemption was present in the act of awarding the ring to young Rose, whose body was of interest to viewers because it visually represented the socially transgressive act of interracial sexual activity, for just as a ring symbolizes commitment in the context of marriage, it also indicates the social legitimization of a relationship, through religious and/or legal means. This sort of legitimacy was exactly the social currency that such mixed-race children lacked due to the circumstances of their births, almost

continues on page 154

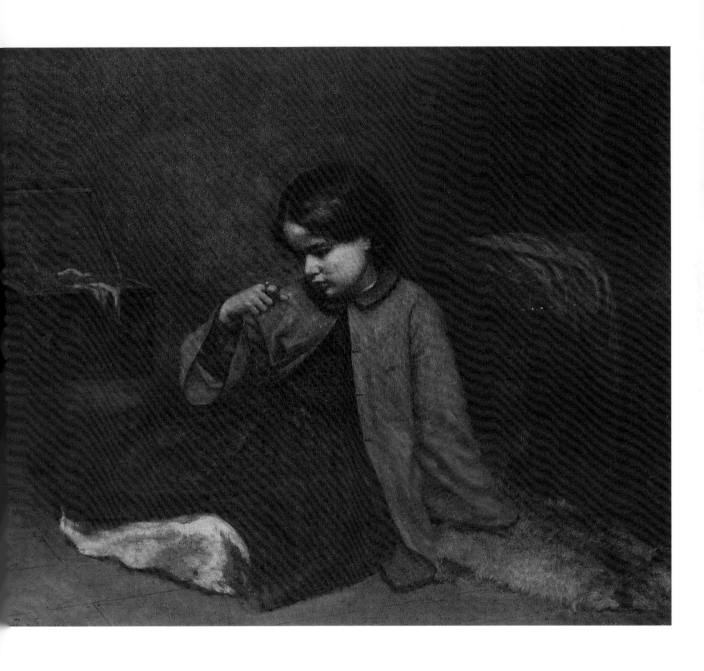

James Wallace Black
(1825–1896)

Fannie Virginia Casseopia Lawrence.
A Redeemed Slave Child, 5 years of age.
Redeemed in Virginia by Catherine S. Lawrence;
baptized in Brooklyn at Plymouth Church,
by Henry Ward Beecher, MAY 1863

Albumen print on card
4 X 2 1/4 IN. (10.2 X 5.7 CM)
American Antiquarian Society, Worcester,
Massachusetts

exclusively out of wedlock to light-skinned, enslaved African American women and the white men who owned and sexually exploited them.

The problematic nature of such light-but-not-white children is also seen in the photographs of Fannie Lawrence. In the first of several images here of young Fannie, she stands alone in a photography studio that is bereft of props with the exception of a drape that intrudes on the composition from the upper left corner and disappears beneath the back hem of her full skirt. She holds her arms akimbo, her head cocked to the viewer's right as if looking toward someone standing out of the frame. From underneath a pillbox hat, delicate blonde ringlets frame a face that looks slightly older than the five years she is supposed to have been. Below the photograph is the caption:

> FANNIE VIRGINIA CASSEOPIA LAWRENCE.
> A Redeemed SLAVE CHILD, 5 years of age.
> Redeemed in Virginia by Catherine S. Lawrence.
> Baptized in Brooklyn at Plymouth Church by
> Henry Ward Beecher, May 1863. Entered
> according to Act of Congress in the year 1863 by
> C.S. Lawrence, in the clerk's Office of the District
> Court of the United States for the Southern
> District of New York.

The text is of special interest in part because it alerts the viewer as to how to read the identity of the racially ambiguous body in the photograph, i.e., "she may look white, but is not really white; she was formerly enslaved." The text also reveals that Fannie's body, despite having been bought out of slavery by Catherine Lawrence, was essentially still a commodity. That Lawrence sought to protect her legal claim to the right to reproduce her stepchild's likeness photographically indicates that she was actively seeking remuneration from its sale and distribution.

Unlike Fannie Lawrence and Rose Ward, whose freedom was purchased under the auspices of Reverend Beecher and the congregation of Plymouth Church (of which Catherine Lawrence was a member), the "slave children of New Orleans," Charley, Rebecca, and Rosa (see p.161), were freed by General Nathaniel Prentice Banks directly following the Emancipation Proclamation's effective date of January 1, 1863, nearly a year after the fall of New Orleans to Union Army forces. General Banks—who had been a U.S. Congressman (he was the first Republican Speaker of the House, in 1856) and governor of Massachusetts 1858 to 1861, when he received his army commission—was acutely aware of the power of racial propaganda. Between August and October of 1863, the all-black enlisted men and white officers of the Massachusetts 54th Regiment were under Bank's command in North Carolina. Soon after the beginning of hostilities, the 54th had been organized by the Massachusetts Brahmin elite who sought to prove not only the merit of African Americans as soldiers but also their co-investment in the war effort. Images of the soldiers in battle were highlighted in popular magazines such as *Harper's Weekly*, and accounts of their exploits were glowingly recounted in the anti-slavery press. In a similar vein as the promotion of the 54th, the bodies and images of the emancipated slave children of New Orleans were provided by the U.S. Army to the American Missionary Association and the National Freedman's Relief Association to highlight efforts to fund schools and religious education for newly freed people in Louisiana.[4] The patriotic and educational intent of this endeavor can be seen in the

continues on page 160

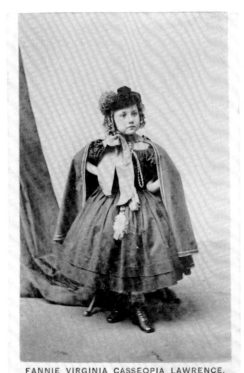

FANNIE VIRGINIA CASSEOPIA LAWRENCE,

A Redeemed **SLAVE CHILD**, 5 years of age. Redeemed
in Virginia, by Catharine S. Lawrence; baptized in Brooklyn,
at Plymouth Church, by Henry Ward Beecher, May, 1863.

Entered according to Act of Congress, in the year 1863, by C. S.
Lawrence, in the Clerk's Office of the District Court of the United States,
for the Southern District of New York.

Charles Paxson
(ACTIVE 1860s)

A Slave Girl from New Orleans,
c. 1864

Albumen print on card
3 1/8 x 1 15/16 IN. (7.9 x 5 CM)
Fogg Art Museum, Harvard University Art Museums,
Kate, Maurice R. and Melvin R. Seiden
Purchase Fund for Photographs

Renowden Studio

Fannie Virginia Casseopia Lawrence, 1863

Albumen print on card
Approximately 4 x 2 1/4 IN. (10.2 x 5.7 CM)
Prints and Photographs Division, Library of Congress,
Washington, D.C.

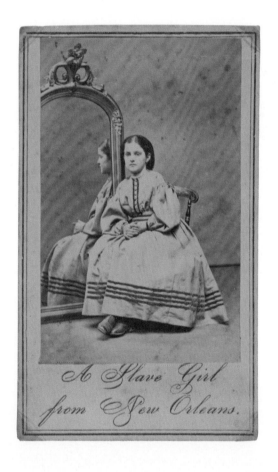

KELLOGG BROTHERS PHOTOGRAPHERS
(ACTIVE 1860S)

Fannie Virginia Casseopia Lawrence.
A Redeemed Slave Child, 5 years of age.
Redeemed in Virginia by Catherine S. Lawrence;
baptized in Brooklyn at Plymouth Church,
by Henry Ward Beecher, MAY 1863

Albumen print on card
4 X 2 1/4 IN. (10.2 X 5.7 CM)
American Antiquarian Society, Worcester,
Massachusetts

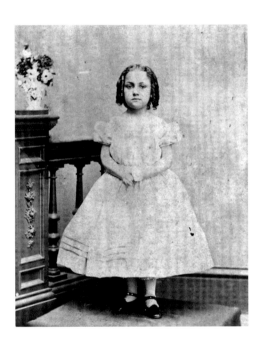

M.H. KIMBALL

(ACTIVE 1860S AND AFTER)

Rebecca, an Emancipated Slave,
from New Orleans, 1863

Albumen print on card
3 1/4 IN. X 2 1/8 IN. (8.3 CM X 5.4 CM)
Fogg Art Museum, Harvard University Art Museums,
Kate, Maurice R. and Melvin R. Seiden
Purchase Fund for Photographs

M.H. KIMBALL

(ACTIVE 1860S AND AFTER)

Rebecca, Augusta and Rosa,
Emancipated Slaves, from New Orleans, 1863

Albumen print on card
3 3/8 IN. X 2 1/8 IN. (8.63 CM X 5.4 CM)
Fogg Art Museum, Harvard University Art Museums,
Anonymous Gift in honor of Michelle Lamunière

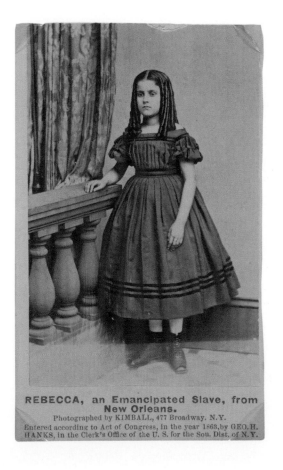

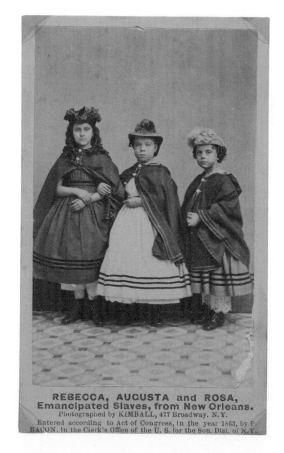

CHARLES PAXSON
(ACTIVE 1860s)

Oh! How I Love the Old Flag.
Rebecca, A Slave Girl from New Orleans, 1864

Albumen print on card
4 x 2 1/4 in. (10.2 x 5.7 cm)
American Antiquarian Society, Worcester,
Massachusetts

CHARLES PAXSON
(ACTIVE 1860s)

Freedom's Banner. Charley, A Slave Boy
from New Orleans, c. 1864

Albumen print on card
3 5/16 x 2 1/16 in. (8.4 x 5.2 cm)
Fogg Art Museum, Harvard University Art Museums,
On loan from the Historical Photographs and
Special Visual Collections Department,
Fine Arts Library, Harvard College Library,
Bequest of Evert Jansen Wendell

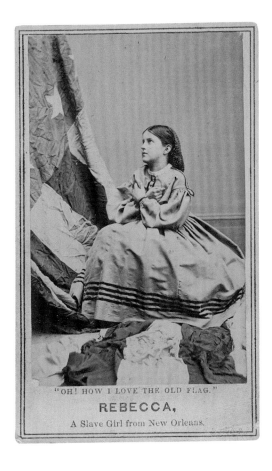

"OH! HOW I LOVE THE OLD FLAG."
REBECCA,
A Slave Girl from New Orleans.

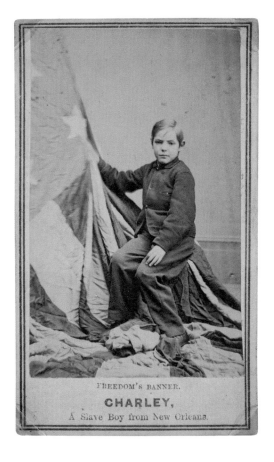

FREEDOM'S BANNER.
CHARLEY,
A Slave Boy from New Orleans.

Charles Paxson
(ACTIVE 1860s)

Learning is Wealth. Wilson, Charley, Rebecca,
and Rosa. Slaves from New Orleans, 1864

Albumen print on card
4 X 2 1/4 IN. (10.2 X 5.7 CM)
American Antiquarian Society, Worcester,
Massachusetts

placement of specific props, such as books, in the
photograph titled "Learning is Wealth," which includes
an older, darker-skinned man named Wilson, or
the reverence for the "Old Flag" that Rebecca is posed
to demonstrate in another image. The implication
of the dark-skinned Wilson studying with a group of
children implies a not-so-subtle racial hierarchy at work
regarding ideas of race and in-born abilities to learn.
In the photograph, which formally places Wilson on
the same line as young Charley, he is presented as being
at the same intellectual level as his lighter-skinned
companions.

As the images of these "redeemed" or "eman-
cipated" children reveal, there were complex ideas
at play during early years of the Civil War about
slavery, race, and an individual's innate and potential
worth. If these photographs continue to pose questions
about who was worth saving and why, then the
painting of Rose Ward and her "freedom ring" offers
a mode of redemption through which those whose
sin was written on their very bodies could be brought
back within the fold of a tenuous social order during
an uncertain period of change.

GDS

1. Mary Niall Mitchell, "'Rosebloom and Pure White,' Or So It
 Seemed," *American Quarterly* 54, no. 3 (September 2002): 369–410.

2. Patricia Hills, "Painting Race: Eastman Johnson's Pictures of
 Slaves, Ex-Slaves, and Freedmen," in *Eastman Johnson, Painting
 America,* ed. Teresa A. Carbone (New York: Brooklyn Museum
 of Art in association with Rizzoli, 1999), p. 133.

3. For a discussion of "slave bands," see Anne McClintock's study
 of the use of such devices in the power and sexual relationship
 between Hannah Cullwick and Arthur Munby in London
 of the 1850s and '60s in her *Imperial Leather: Race, Gender, and
 Sexuality in the Imperial Contest* (London: Routledge, 1995),
 pp. 132–80.

4. Mitchell, "Rosebloom," 369–70.

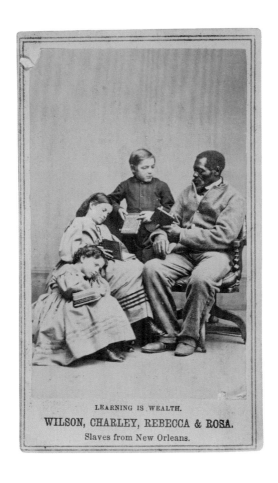

LEARNING IS WEALTH.

WILSON, CHARLEY, REBECCA & ROSA.

Slaves from New Orleans.

UNKNOWN

TOP

Frederick Douglas, frontispiece to
*Narrative of the life of Frederick Douglass,
an American slave, Written by Himself,*
PUBLISHED 1845

Engraving
6 3/4 x 4 1/2 IN. (17.2 x 11.4 CM)
Manuscripts, Archives, and Rare Books Division,
Schomburg Center for Research in Black Culture,
The New York Public Library, Astor, Lenox, and
Tilden Foundations

These four portraits of Frederick Douglass (c. 1817–
1895), an engraved frontispiece, a narrative depiction
on a sheet music cover, a daguerreotype in a velvet-
lined case, and a carte-de-visite, are testaments to the
importance of Douglass's public presence in pre–Civil
War society as well as examples of the manner in
which imagery can reinforce the power of personality
and individuality.

The earliest image of the four was included as
the frontispiece in Douglass's first autobiography,
*Narrative of the Life of Frederick Douglass, an American
Slave, Written by Himself.* The book told the dramatic
story of his escape from slavery in 1838 and his travels
via the Underground Railroad from a Maryland
plantation to New England. The drama of Douglass's
escape was matched by the daring act of identifying
himself in this 1845 publication even though he was
subject to arrest under the Fugitive Slave Act. The
engraved portrait, presenting a well-dressed individual
who is self-possessed, self-confident, and thoughtful,
perhaps even a bit pensive, is a fitting match for the
book it introduces.

EPHRAIM W. BOUVÉ
(1817–1897)

BOTTOM

The Fugitive's Song.
Words by Frederick Douglass,
Published by Henry Prentiss, C. 1870

Lithograph on wove paper, sheet music
35 5/8 x 9 3/8 IN. (90.4 x 23.8 CM)
Library of Congress, Washington, D.C.

In 1847 Douglass returned to the United States
from self-imposed exile in Great Britain, his freedom
having been bought by a group of English abolitionists.
Shortly thereafter he sat for the portrait now owned
by the Art Institute of Chicago. Viewing this image,
one can well understand suffragette Elizabeth Cady
Stanton's first-hand observation that he was "majestic
in his wrath."[1] This remarkable image by a little-known
daguerreotypist from Akron, Ohio, captures all the
intensity, determination, and ambition of the thirty-
year-old Douglass as he was readying his contributions
to the cause of freedom from slavery and prejudice.
As historians have convincingly documented, Douglass
was well aware of the persuasive power of images and
of the collaborative interchange between photographer
and sitter in the creation of a likeness. One can only
conclude that Douglass's looming, brooding presence
in this daguerreotype was considered and intentional.

GDS

1. Quoted in Colin L. Westerbeck, "Frederick Douglass Chooses
His Moment," in *African Americans in Art: Selections from the
Art Institute of Chicago* (Chicago: Art Institute of Chicago, 1999),
p. 24.

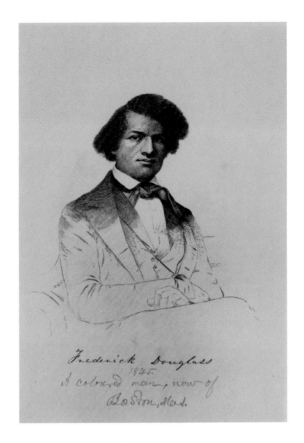

SAMUEL J. MILLER
(ACTIVE 19TH CENTURY)

W.E. BOWMAN
(1834–1915)

LEFT
Frederick Douglass, 1847–52
Daguerreotype
5 1/2 x 4 3/16 IN. (14 x 10.6 CM)
The Art Institute of Chicago,
Major Acquisitions Centennial Endowment

RIGHT
Frederick Douglass, N.D.
Albumen print on card
4 x 2 1/4 IN. (10.2 x 5.7 CM)
American Antiquarian Society, Worcester,
Massachusetts

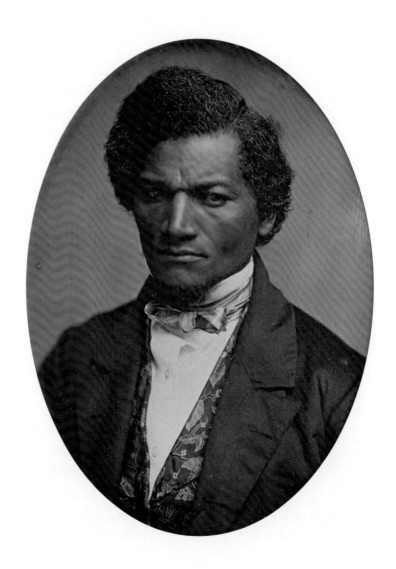

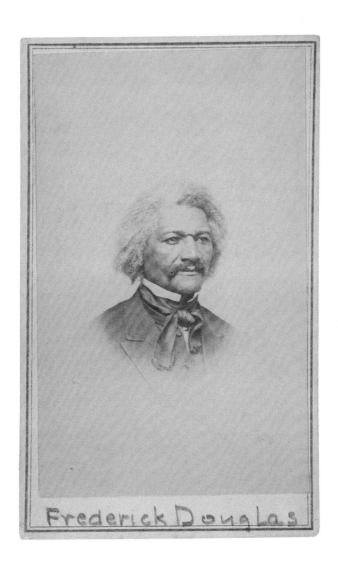

Patrick Henry Reason
(1817–1856)

Henry Bibb, frontispiece to *Narrative of the Life and Adventures of Henry Bibb, an American Slave*, PUBLISHED 1849

Lithograph
8 7/16 x 5 1/2 IN. (21.4 x 13.9 CM)
Widener Library, Harvard University, Cambridge, Massachusetts

Henry Walton Bibb (1815–1854) was born into slavery in Kentucky, but as a young adult he managed to escape north to freedom. As a self-freed man, he gained notoriety through his autobiography *Narrative of the Life and Adventures of Henry Bibb, An American Slave*. After settling in the North, Bibb worked with other abolitionists such as Frederick Douglass, lecturing and participating in the antebellum black convention movement. In 1849, with the help of his wife, Mary E. Miles, Bibb published *Narrative of the Life and Adventures of Henry Bibb, an American Slave,* detailing his experiences and condemning slavery. Because he published the book using his own name, he was forced to immigrate to Canada to avoid the strict Fugitive Slave Laws. Once there, he continued his abolitionist work, assisting countless runaway slaves and publishing Canada's first black newspaper, *Voice of the Fugitive*. Bibb favored the independent and separate growth of the black community, and though he viewed Canada as a temporary home, he stayed there until his death at the age of thirty-nine.

This lithograph by the Philadelphia-based African American artist Patrick Henry Reason served as the frontispiece to Bibb's autobiography, a visual complement to the descriptive portrait the author composes through his narrative. Reason was a prolific engraver, well known for his portraits of abolitionists and for imagery promoting the anti-slavery movement. Here he depicts Bibb as a serious young man, his body on the oblique and his head turned to center, eyes staring intently ahead. Formally attired with his hair parted on the side, he grasps a book with his right hand, balancing it vertically in his lap. The book is both a symbol of Bibb's literacy and of his agency in the propagation of his life story, a fact that is reiterated in the copyright inscription for the image, "Entered according to the Act of Congress in the year 1847 by H. Bibb, in the Clerk's Office of the District Court of the Southern District of New York," making clear to the viewer that Bibb both possessed himself and his own life story.

EKS and GDS

Engraved by P.H. Reason

Henry Bibb

Stop the runaway! where is he! $ K Reward for him

Daniel Lane after Henry Bibb in Louisville, Kentucky June 1811
The object was to sell Bibb in the Slave market but Bibb turned
the corner too quick for him & escaped

UNKNOWN

LEFT, CENTER, and RIGHT

Sojourner Truth, 1864

Albumen prints on cards
Each, approximately 4 x 2 1/4 IN. (10.2 x 5.7 CM)
Gladstone Collection, Prints and Photographs Division,
Library of Congress, Washington, D.C.

Beginning in the 1860s abolitionist and women's rights activist Sojourner Truth (1797?–1883) sat for a series of photographs, most of which were mounted on small pieces of paperboard, commonly called carte-de-visites, and often with the intriguing legend "I sell the Shadow to Support the Substance" printed beneath. The photographs were sold as souvenirs at events where Truth personally appeared or at other fundraisers held by her colleagues in the anti-slavery movement. Her celebrity status—gained in part from the popularity of her life story, which was first published 1850 and again in 1875, and her skills as a dramatic orator—enabled her to support herself after her emancipation from slavery in New York State in the 1840s. During the last thirty years of her life Truth found that the photographic image was a dynamic mode of marketing and moneymaking that enabled an illiterate former slave to control the sale of the representation of her body, a body that had one time been bought and sold by others.

While the majority of the photographs of Truth show her seated, often with a table next to her and either a book or some knitting in her hands, one image shows her standing against a blank background, her left hand gripping a walking stick. Her steely gaze is perceptible even through her wire-rimmed spectacles. A white head wrap gleams brightly as it is visually carried downward by the triangular forms of her neckerchief, shawl, and boldly striped jacket. In her recent biography of Truth, historian Nell Irvin Painter examines the circulation of these inexpensive images, their use as fundraising tools and as abolitionist propaganda during the Civil War, and the ways that they deviated from various contemporaraneous presentations of formerly enslaved African Americans. Painter asserts that unlike more prevalent popular constructions of emancipated slaves, which often showed them partially unclothed in order to reveal the scars of past whippings to evidence of the horrors of slavery, Truth was always careful to be portrayed as a well- and fully-dressed middle-class matron. Her head may have been covered with a scarf, but it was not the garish head wrap of one of Harriet Beecher Stowe's mammies. In this way the book that Truth might hold in her hand became more than just a random studio prop, one which the illiterate Truth may not have owned herself, one that was able to communicate to the viewer that the sitter was "intelligent" and "educated."[1] Coupled with the glasses (eyeglasses were still quite rare and expensive in the middle of the nineteenth century) and her finely tailored clothing, these images of Sojourner Truth convey a resolutely respectable persona, one in control of both her "substance" and her "shadow."

GDS

1. Nell Irvin Painter, *Sojourner Truth: A Life, A Symbol* (New York: W.W. Norton, 1996), p. 196.

I Sell the Shadow to Support the Substance.
SOJOURNER TRUTH.

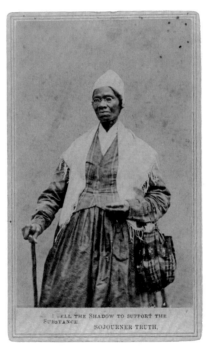

I SELL THE SHADOW TO SUPPORT THE
SUBSTANCE.
SOJOURNER TRUTH.

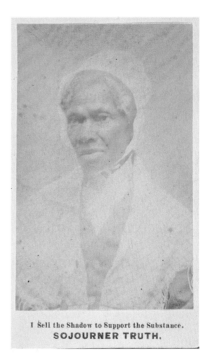

I Sell the Shadow to Support the Substance.
SOJOURNER TRUTH.

HENRY ROCHER
(B. 1824)

Edmonia Lewis, C. 1870

Albumen prints on cards
LEFT: 3 11/16 X 2 1/16 IN. (9.3 X 5.2 CM);
CENTER, RIGHT: 3 5/8 X 2 IN. (9.1 X 5.1 CM)
Courtesy of the Fogg Art Museum,
Harvard University Art Museums,
On loan from the Historical Photographs and
Special Collections Department, Fine Arts Library,
Bequest of Evert Jansen Wendell

In the history of American artistic production Edmonia Lewis is known as the first woman sculptor of African and Native American heritage to have made a name for herself in her own lifetime. Born around 1843 in New York State, her mother was a Chippewa Indian and her father a free African American. She was orphaned at an early age and raised by her mother's people, while her older brother went west and worked in the "digs" as a gold miner in California. With his strike he was able to provide tuition for her to attend Oberlin College in Ohio from 1860 to 1863. In her third year of study at the coeducational and interracial institution her academic education came to an abrupt end when she found herself accused of attempted murder. Following the dismissal of the case she moved to Boston at the behest of a community of white abolitionists there that included Lydia Maria Child and William Lloyd Garrison.

Lewis began her professional career as an artist in Boston, and in 1865, using money from sculpture sales, she moved to Rome, then the center of the sculptural activity in the Western art world. There she earned fame for her racially themed marble sculptures of idealized freed slaves, such as *Forever Free*, and of noble Indians, like *The Old Arrow Maker*. While she remained an expatriate for the rest of her life, Lewis did return to the United States several times during the 1860s and '70s, and at the zenith of her career in 1876 she showed a crowd pleasing, life-sized, dying *Cleopatra* at the Centennial Exposition in Philadelphia. Despite such success, the neoclassical style in which she worked soon fell out of favor, and with it her career went into an irreversible decline. Soon after 1900 Lewis vanished from the historical record, and the exact date and location of her death are a mystery.

Sometime around 1870, Lewis sat for a series of at least six formal portraits. The resulting images of the twenty-six-year-old artist were printed as carte-de-visites and used as promotional tools for her work and were distributed to potential patrons and admirers. A small number of these original photographs survive in private hands and in the collections of Harvard University and the National Gallery of Art in Washington, D.C. Because aside from her extant sculpture Lewis left no archive—her personal papers and belongings all vanished with her after she dropped out of sight—these photographs are the primary physical evidence of her appearance and are the chief images by which we know her today.

Of the six photographs, the image that most often represents Lewis is the one in which she is posed standing with one arm resting on a table covered by a cloth with a Greek key border (opposite, center). Her head is encircled by loosely curling dark locks of shortly cropped hair falling to just above her collar. Her heart-shaped face is distinguished by a broad forehead and firm brow. The nose beneath it is straight and wide, its nostrils flaring to points roughly in line with the inner rims of the pupils of her dark-rimmed eyes. The unsmiling lips are set purposely together, casting a faint shadow over a small, pointed chin.

The photograph embodies what philosopher Walter Benjamin has called a "spell of personality"[1] with its presentation of Lewis as a worldly woman, independent and liberated, artistic and original. From her cropped hair, cut short to stay out of her way while at work as well as in the style of a fellow American sculptor in Rome, Harriet Hosmer

continues on page 172

 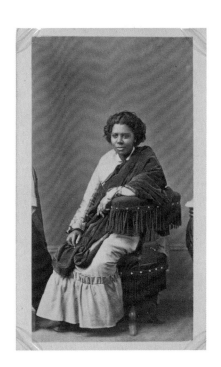

Henry Rocher
(B. 1824)

Edmonia Lewis, c. 1870

Albumen prints on cards
Each, 3 5/8 x 2 in. (9.1 x 5.1 cm)
Courtesy of the Fogg Art Museum,
Harvard University Art Museums,
On loan from the Historical Photographs and
Special Collections Department, Fine Arts Library,
Bequest of Evert Jansen Wendel

(1830–1908), to the exquisitely trimmed jacket and the unrestrictive cut of her clothes, all serve to identify her as a bohemian and an artist. At the same time they indicate that this was not the average image of a woman of color in the 1870s. Her clothing depicts the dominant and the avant-garde cultural ideologies of feminine and artistic dress as well as the artist's own relationship to these discourses.

Just as her costume can be read as conferring power on her, her comfort level within it also reveals her own uneasy relationship to its function as an extension of her selfhood and her visual identity. Her narrow shoulders slope down to sleeves decorated at the seams and hems with long elegant fringe. Her smooth hands peek out of the cuffs, revealing their backs, the palms hidden. Although Lewis is not known to have ever been married or to have had a life companion, the left hand, hanging at her side, is graced by a metal ring which glows against her dark skin. It is a ring that implies marriage, or possibly the artist's Catholic faith and her identification with Marian nuns.[2] The right hand, placed at the edge of the table, reveals a small bump and two faint dimples. They are understated hands, not hinting at the creative power they command. Curling up into themselves, they resist the exposure of the moment.

GDS

1. 1. See Walter Benjamin, "The Work of Art in the Age of Mechanical Reproduction," *Illuminations* (New York: Schocken Books, 1969), p. 233.

2. Marilyn Richardson, "Edmonia Lewis's *Forever Free*: Emancipation and Redemption," lecture, 27 October 2004, W.E.B. Du Bois Institute, Harvard University.

172 PROMINENCE AND INDIVIDUALITY

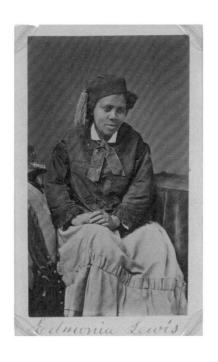 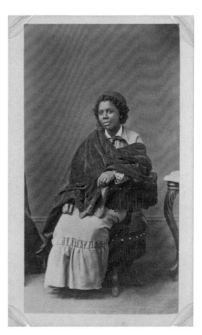

London Printing and Publishing Company

after a daguerreotype by William Paine, Islington, c. 1850

TOP

Ira Aldridge as Aaron in "Titus Andronicus"

Stipple and line engraving
10 3/4 x 7 1/8 in. (27.4 x 18.2 cm)
Prints and Photographs Division, Library of Congress, Washington, D.C.,

Thomas Fall

(BRITISH, ACTIVE LONDON, ENGLAND 1870s–1900s)

BOTTOM

Ira Aldridge as Othello, c. 1850

Albumen print on card
5 1/2 x 3 1/4 in. (14 x 8.3 cm)
Special Collection Research Center, Morris Library, Southern Illinois University, Carbondale

The expatriate African American actor Ira Aldridge, seen here in the title role of *Othello* and as Aaron in *Titus Andronicus*, was the best-known actor of African descent in Great Britain and Europe during the nineteenth century. In addition to specializing in Shakespearian roles, Aldridge also appeared in comedies, including Isaac Bickerstaff's *The Padlock*, in which he played the bold and subversive slave Mungo. He achieved fame in the United States despite only having appeared on the American stage a few times as a teenage amateur before leaving his native New York to pursue acting in what he hoped would be the more hospitable environment of London's West End. Mementos of his performances may be found in the many engravings of daguerreotypes and carte-de-visites that depict him onstage in the roles that made him famous.

This portrait of Aldridge in the role of Aaron, the scheming lover of the vengeful Goth queen Tamora, depicts him at the climax of play's arc. The quotation placed just below the image, "He dies upon my scimetar's sharp point, / That touches this my first-born son and heir!" places the moment in act 4, scene 2, as Aaron defends the product of his illicit relationship with Tamora from her sons Demetrius and Chiron, who are attempting to kill the child to preserve their mother's honor. Aldridge stands, one foot drawn back and the other placed nearly on top of the small body of his newborn son. His pose is echoed above by a vulture guarding a chick that nests in a crown. This juxtaposition highlights Aaron's role as an instigator of death who feeds on the suffering of others while attempting to protect his own. The image is surrounded by a decorative border of foliage interlaced with swords, alluding to the bloody nature of the play, which involves a rape, numerous murders, and the severing of many hands and at least one tongue. The print was adapted from a daguerreotype by William Payne, who photographed Aldridge in character and onstage several times. Because daguerreotypes are directly exposed onto a metal plate, they cannot be reprinted; the only way to reproduce them in large numbers during the 1850s was to translate them into engravings. Several examples of this engraving exist in collections in the United States and Great Britain.

It is ironic that in the lighter skin tones of the baby at Aaron's feet we see the implication of the mixed-race liaison that was not only at issue in the scene but was also a factor in the often negative reaction that Aldridge encountered when he first ventured onto the British stage. Prior to his arrival, there had been few black actors in London, and Aldridge found success and respect to be scarce until he began to tour the European continent in the 1840s and '50s. Occasionally reviewers railed against his portraying black characters such as Aaron and Othello, who had previously always been played by white actors in dark makeup, because of the interracial sexual relationships that were at the crux of their character's development and purpose. Touring with his own company throughout Russia and Eastern Europe in the late 1850s, Aldridge began to perform bilingually and to take on new roles, including Richard III and Macbeth, in which he transcended the superficiality of skin color. Known as the "Black Roscius," after the mythical Roman actor, he died in 1867 at the age of fifty-nine while performing in Lodz, Poland.

GDS

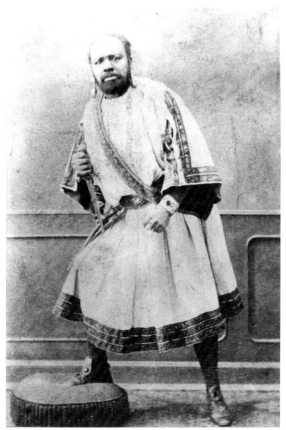

Thomas Cowperthwait Eakins
(1844–1916)

Portrait of Henry O. Tanner, 1897

Oil on canvas
24 x 20 in. (61 x 50.8 cm)
The Hyde Collection, Glens Falls, New York

In May 1897, American painter Henry Ossawa Tanner saw the awarding of a bronze medal to his painting *The Raising of Lazarus* at the Paris Salon and its subsequent purchase by the French government for the collection of the Musée du Luxembourg. Other important works from this productive period of Tanner's religious and genre painting, including *Daniel in the Lion's Den*, *The Bagpipe Lesson*, and *The Young Sabot Maker*, were shown in Munich, New York, and Philadelphia, respectively. Tanner had just begun to enter his mature production and to make an international name for himself, one which he had had to establish abroad due to continuing racism and limited opportunities in the United States' art world. The period of Reconstruction following the Civil War had been a particularly difficult one for African American artists, who, with the end of slavery, no longer had the financial support of the various abolitionist communities that had often sought to use black creative production as proof of the race's humanity and intelligence. Because of these difficulties, few African American artists had been able to thrive, and a limited number of black portrait painters served middle-class black communities, whose mode of commemoration had increasingly turned to the less-expensive medium of photography. Unlike his teacher at the Pennsylvania Academy of Fine Arts, Thomas Eakins, Tanner was not known for his portraits, of which he made few, and he preferred to concentrate on the genre scenes and religious paintings that garnered him fame and commissions.

Following his success at the Salon, Tanner visited England in June before crossing the Atlantic to return to the United States in July for his first visit in three years. He spent the summer in his hometown of Philadelphia before moving on to Kansas City, Kansas, where his parents had recently moved, and then went back to Paris (by way of Philadelphia) in September. While in Philadelphia he sat for a painting by Eakins, who at that time was experimenting with various modes of portraiture. Eakins' painting of Tanner presents the thirty-eight-year-old artist as a contemplative, well-dressed gentleman, wearing a fashionable dark suit and a starched collar. His delicate wire-rimmed glasses add to the impression of an introspective nature, as does his downcast gaze. Unlike some large-scale portraits of professional men by Eakins from the 1890s, such as the Addison Gallery's *Portrait of Professor Henry A. Rowland*, 1897, or the *Portrait of Frank Hamilton Cushing*, 1895 (Gilcrease Museum, Tulsa), which show their subjects surrounded by the tools of their trade, there is no hint at Tanner's occupation or success as a painter. He is pictured against a dark brown background, deep in thought, his forehead illuminated by a light source outside the frame.

Eakins's portrait was made before Tanner went to Kansas City to see his parents, and its dark palette and retrospective mood is witnessed in his own portrait of his father completed in September of 1897 (see p. 179) just before his scheduled return to Paris. It is signed and dated in the lower-right corner with a inscription that reads, "a hurried study of my dear father/H.O. Tanner/Kan. City/Sep. 1897." The bust-length portrait of Bishop Benjamin Tucker Tanner shows the aging cleric clad in the dark robes of his

continues on page 178

HENRY OSSAWA TANNER
(1859–1937)

TOP

Bishop Benjamin Tucker Tanner, 1897

Oil on canvas
16 1/8 x 11 3/4 IN. (41 x 29.9 CM)
Baltimore Museum of Art,
Partial and Promised Gift of Eddie C. Brown,
C. Sylvia Brown, and their Children,
Tonya Y. Brown Ingersol and Jennifer L. Brown,
Baltimore

BOTTOM

Portrait of the Artist's Mother, 1897

Oil on canvas
29 1/4 x 39 1/2 IN. (74.3 x 100.3 CM)
Philadelphia Museum of Art,
partial gift of Dr. Rae Alexander-Minter and
purchased with the W.P. Wilstach Fund,
the George W. Elkins Fund, the Edward and Althea
Budd Fund, and with funds contributed by
the Dietrich Foundation, 1993

office. On his head he wears a black cap, and a small metal cross gleams against the dark expanse of his solidly rendered chest. Like his son's, the Bishop's eyes also look deep in thought beneath a forehead that glows with the light of inspiration. He is shown as a serious man, one not easily swayed by worldly distractions.

In addition, Tanner completed a seated portrait of his mother, Sarah Elizabeth Miller Tanner. The painting's composition closely echoes that of James Abbott McNeill Whistler's notorious *Arrangement in Gray and Black No. 1: Portrait of the Artist's Mother*, 1871 (Musée d'Orsay, Paris) (see p. 16), but it subverts the earlier image's stark setting and pose by showing the sitter resting her cheek against her hand and, through the use of a light source to the left side of the canvas, implying a window out of which the sitter might be gazing. Sarah Tanner is shown as prosperous, yet conservative; a matron whose high-necked dark dress and shawl seem to contradict the presence of a fan, indicating the importance of proper dress despite the often unpleasant temperatures of a Midwestern summer. Despite her age, she is depicted as poised and still beautiful, her gold wedding band, the symbol of her marriage to Bishop Tanner nearly forty years before, glowing brightly on her elegant hand. In Tanner's portrait of his mother, the rocking chair becomes a throne, her shawl a royal robe. The inscription in the lower right, which joins sentiment with the date and artist's signature, reads "To my dear Mother/H.O. Tanner/1897."

GDS

INDEX

Page numbers in italics refer to illustrations.

IMAGE CREDITS

Addison Gallery of American, Phillips
Academy, Andover, Massachusetts: 81;
photo by Frank E. Graham, cover
and 95

© Courtesy, American Antiquarian Society,
front cover flap, 60, 83, 123, 155, 157,
159 left, 161, 165, back cover flap

© The American Museum in Britain,
Bath, 103

Photography © The Art Institute of
Chicago, 12, 164

Courtesy of the Atwater Kent Museum of
Philadelphia, The Historical Society
of Pennsylvania, 79, 109, 115, 117

The Baltimore Museum of Art, 20, 179 top

Beinecke Rare Book and Manuscript
Library, Yale University, 127, 129

Bishop Museum Archives, Honolulu,
Hawai'i, 48, 77

Boston Public Library/Rare Book
Department, 119, 121

Bowdoin College Museum of Art,
Brunswick, Maine, 101

Delaware Art Museum, 93

Diplomatic Reception Rooms,
U.S. Department of State, Washington,
D.C.; photo, Will Brown, 75

Fenimore Museum, The New York State
Historical Association, Cooperstown, 107

Hallmark Fine Art Collection, Hallmark
Cards, Inc., Kansas City, Missouri, 153

© 2004 President and Fellows of Harvard
College: photo, Allan Macintyre, 156
left, 158, 159 right, 171 left and right, 173;
photo, Katya Kallsen, 171 center

Courtesy Weidner Library, Harvard
University, Cambridge, Massachusetts,
167

Department of Printing and Graphic Arts,
Houghton Library, Harvard College
Library, 35

The Historical Society of Pennsylvania,
67, 105

The Hyde Collection, Glens Falls,
New York, 177

Courtesy of the Herbert F. Johnson Museum
of Art, Cornell University, 137

Courtesy of Kenkeleba Gallery, New York,
145, 147

© The Library Company of Philadelphia,
frontispiece, 44, 50 top left, 69, 71, 89, 99

Courtesy Library of Congress, Washington,
D.C., 49 bottom, 89, 97, 111, 113, 156
right, 163 bottom, 169, 175 top

Louisiana State Museum, New Orleans, 87

The Maryland Historical Society, Baltimore,
17 top, 21, 22, 23, 50, 63

Images © The Massachusetts Historical
Society, Boston, Massachusetts, USA;
photo by The Massachusetts Historical
Society, Boston/Bridgeman Art Library,
26, 59, 133–35, 149 left and center

Photograph © 1991 The Metropolitan
Museum of Art, 19 top

© Museo Thyssen-Bornemisza, Madrid:
photo by Pepe Loren, 73

The Museum of Afro-American History,
Boston and Nantucket; photo courtesy
The Massachusetts Historical Society,
Boston, 149

Image © 2005 Museum of Fine Arts,
Boston, 34 bottom right, 36 top left, 139

Courtesy of the Nantucket Historical
Association, 141

Image © 2005 Board of Trustees, National
Gallery of Art, Washington, 17 bottom,
27 top

© National Portrait Gallery, London, 19
bottom, 33, 34 top, 36 right, 37, 38 top, 39

National Portrait Gallery, Smithsonian
Institution, 13

The New Haven Colony Historical Society,
125

Newport Art Museum, 151

Pennsylvania Academy of the Fine Arts,
Philadelphia, 47

© Philadelphia Museum of Art, 16 left,
179 bottom

© Réunion des Musées Nationaux/
Art Resource, NY, Musee d'Orsay, Paris:
photo by J.B. Berizzi, 16 right

Courtesy Manuscript, Archives and Rare
Books Division, Schomburg Center for
Research in Black Culture, The New
York Public Library, Astor, Lenox and
Tilden Foundations, 31, 32, 163 top

Courtesy Prints and Photographs Division,
Schomburg Center for Research in
Black Culture, The New York Public
Library, Astor, Lenox and Tilden
Foundations, 61, 91

Photo by Don Sepulvado, 85

Photo by Gwendolyn DuBois Shaw,
50 bottom left

© Shelburne Museum, Shelburne, Vermont,
15, 143

© The Stratford Historical Society,
Stratford, Connecticut, 49 top right

Special Collections Research Center,
Morris Library, Southern Illinois
University, Carbondale, 175 bottom

Stanley-Whitman House, Farmington,
Connecticut, 131

Special Collections, University of Virginia
Library, Charlottesville, 50 bottom right

V&A Images/Victoria and Albert
Museum, 14

Valentine Richmond History Center,
65 bottom

Virginia Historical Society, Richmond,
65 top

The Henry Francis DuPont Winterthur
Museum, 51